Edwin Howland Blashfield

MASTER AMERICAN MURALIST

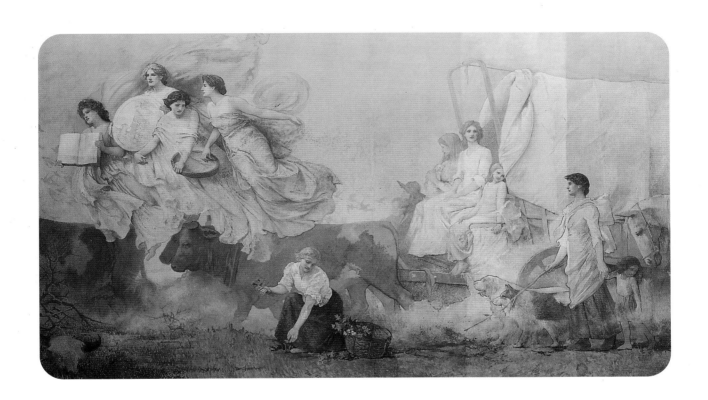

EDITED BY MINA RIEUR WEINER

Contributors

ANNE E. SAMUEL • GILLIAN BRITTA RANDELL • JEFF GREENE

Principal Photography by Anne Day

In Association with
Institute of Classical Architecture & Classical America

W. W. Norton & Company
New York • London

This book is made possible in part with the generous support of
Furthermore: A Program of the J.M. Kaplan Fund

Additional support was provided by
The Orville Gordon Browne Foundation
The Robert Lehman Foundation
The Arthur Ross Foundation

•

Marshall Allan
Appleton & Associates
Harrison Design Associates
Clem Labine
Elizabeth Plater-Zyberk
Qian Yi and Leonard Porter
Henry Hope Reed
Barbara and Robert Sallick
Anne Fairfax and Richard Sammons
Suzanne and David Santry
Steven Semes

Page 2: Detail, *Washington Surrendering His Commission*, 1902: Courtroom mural,
Clarence M. Mitchell Jr. Courthouse, Baltimore, Maryland. (Anne Day, photographer)

Page 3: Detail, *Westward*, 1905: Grand staircase landing, Iowa State Capitol,
Des Moines, Iowa. (Anne Day, photographer)

Page 6: Detail, *The Law in Modern Times*, 1910: Main dome pendentives,
Mahoning County Courthouse, Youngstown, Ohio. (Anne Day, photographer)

Page 8: Detail, *The Edict of Toleration of Lord Baltimore*, 1904: Courtroom mural,
Clarence M. Mitchell Jr. Courthouse, Baltimore, Maryland. (Anne Day, photographer)

Page 16: Detail, *The Law*, 1909: Circuit courtroom mural, Howard M. Metzenbaum Courthouse,
Cleveland, Ohio. (Eric Vaughn Photography)

For information about permission to reproduce selections from this book, write to
Permissions, W. W. Norton & Company, Inc., 500 Fifth Avenue, New York, NY 10110

For information about special discounts for bulk purchases, please contact
W. W. Norton Special Sales at specialsales@wwnorton.com or 800-233-4830

Manufacturing by Colorprint Offset
Book design by Jonathan D. Lippincott
Production manager: Leeann Graham

Library of Congress Cataloging-in-Publication Data

Edwin Howland Blashfield : master American muralist / edited by Mina
Rieur Weiner ; contributors, Anne E. Samuel, Gillian Britta Randell,
Jeff Greene. — 1st ed.
p. cm. — (The classical America series in art and architecture)
Includes bibliographical references and index.
ISBN 978-0-393-73281-8 (hardcover)
1. Blashfield, Edwin Howland, 1848–1936—Criticism and interpretation.
2. Mural painting and decoration, American—19th century. 3. Mural
painting and decoration, American—20th century. I. Weiner, Mina Rieur.

ND237.B62E38 2009
759.13—dc22

2009004504

ISBN: 978-0-393-73281-8

W. W. Norton & Company, Inc., 500 Fifth Avenue, New York, N.Y. 10110
www.wwnorton.com

W. W. Norton & Company Ltd., Castle House, 75/76 Wells Street, London W1T 3QT

2 4 6 8 0 9 7 5 3 1

The Classical America Series in Art and Architecture

The Golden City by Henry Hope Reed
The American Vignola by William R. Ware
The Architecture of Humanism by Geoffrey Scott
The Decoration of Houses by Edith Wharton and Ogden Codman, Jr.
Italian Villas and Their Gardens by Edith Wharton
The Classic Point of View by Kenyon Cox
What Is Painting? by Kenyon Cox
Man as Hero: The Human Figure in Western Art by Pierce Rice
Greek and Roman Architecture in Classic Drawings by Hector d'Espouy
Monumental Classic Architecture in Great Britain and Ireland by Albert E. Richardson
Monograph of the Work of McKim, Mead & White, 1879–1915, Student Edition
The Library of Congress: Its Architecture and Decoration by Herbert Small
Letarouilly on Renaissance Rome by John Barrington Bayley
The New York Public Library: Its Architecture and Decoration by Henry Hope Reed
The Elements of Classical Architecture by George Gromort
Palaces of the Sun King: Versailles, Trianon, Marly, the Chateaux of Louis XIV
by Berndt Dams and Andrew Zega
Bricks and Brownstone: The New York Row House 1783–1929 by Charles Lockwood
The Architecture of the Classical Interior by Steven W. Semes
Classical Architecture for the Twenty-First Century: An Introduction to Design
by J. François Gabriel
The United States Capitol: Its Architecture and Decoration by Henry Hope Reed
Arthur Brown Jr.: Progressive Classicist by Jeffrey T. Tillman
Classical Swedish Architecture and Interiors 1650–1840 by Johan Cederlund
Carolands by Michael Middleton Dwyer; produced by Charles Davey
Theory of Mouldings by C. Howard Walker; new foreword by Richard Sammons
Building Details by Frank M. Snyder, new introduction by Peter Pennoyer and Anne Walker
Antiquities of Athens by James Stuart and Nicholas Revett, new introduction by Frank Salmon
Get Your House Right, Architectural Elements to Use & Avoid
by Marianne Cusato & Ben Pentreath with Richard Sammons and Léon Krier
The Study of Architectural Design by John F. Harbeson,
with new introduction by John Blatteau, and Sandra L. Tatman

The Institute of Classical Architecture & Classical America (ICA&CA) is dedicated to the classical tradition in architecture and the allied arts in the United States. Inquiries about the ICA&CA mission and programs are welcome and should be addressed to:

Institute of Classical Architecture & Classical America
www.classicist.org

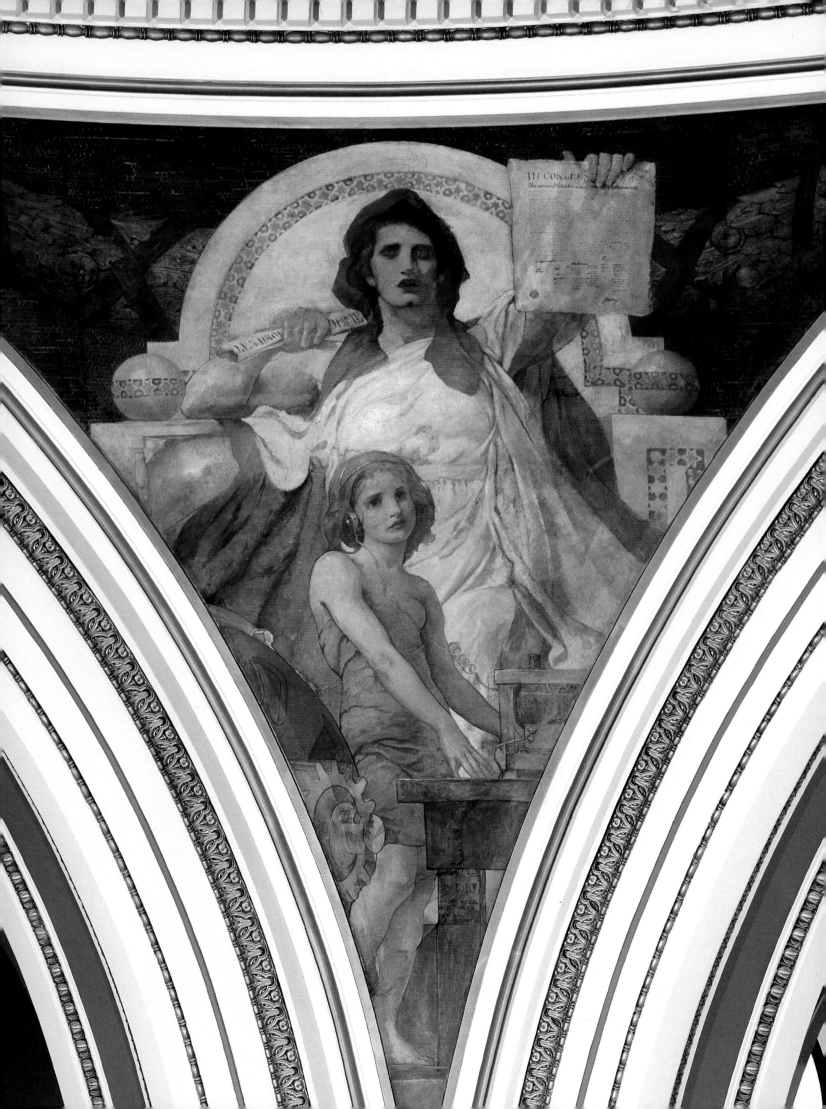

This book is dedicated to Constance Culbertson Feeley Reed (1932–2007), journalist, author, and civic gadfly, whose husband and fellow classicist, Henry Hope Reed, was the foremost champion of this book over many years.

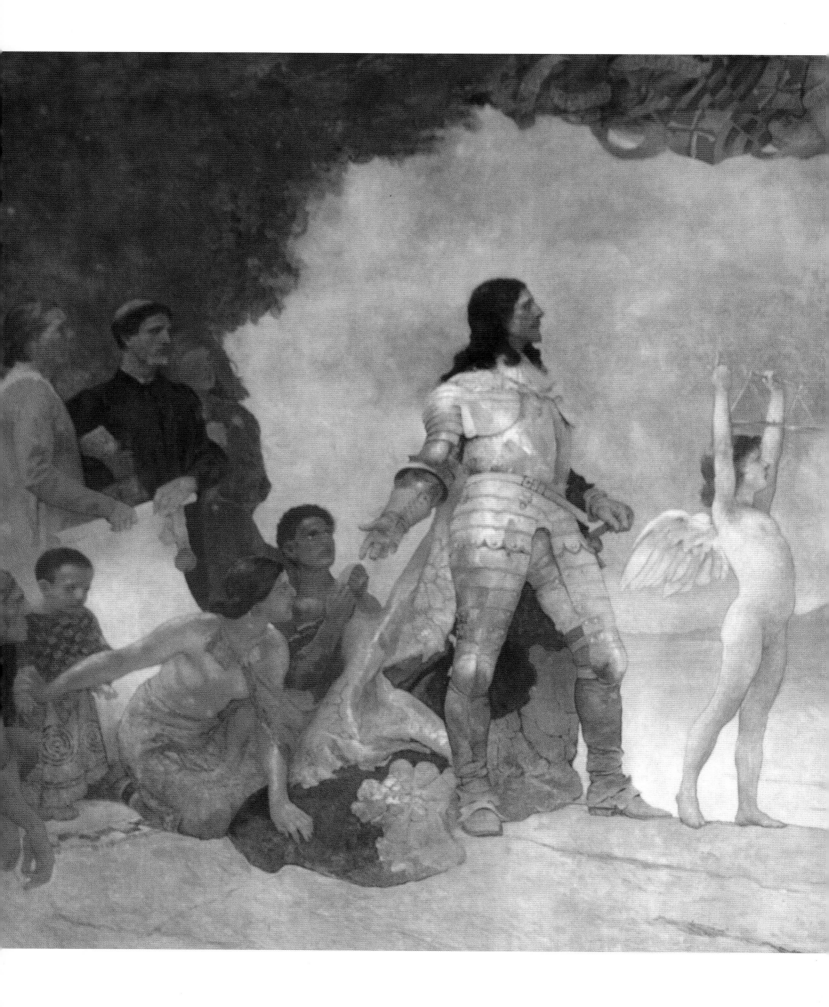

Contents

Foreword 11
PAUL GUNTHER, president, ICA&CA

1. *Edwin Howland Blashfield: Defender of the Classic Tradition* 19
MINA RIEUR WEINER

2. *Mural Painting for America:*
 The Artistic Production of Edwin Howland Blashfield 55
ANNE E. SAMUEL

3. *Observations from a Conservator's Perspective* 109
GILLIAN BRITTA RANDELL

4. *The Legacy of Edwin Howland Blashfield,*
 Dean of American Mural Painters 121
JEFF GREENE

Chronological List of Known Murals 135
Edwin Howland Blashfield: A Chronology 143
Selected Bibliography 147
Acknowledgments 153
About the Contributors 155
Index 156

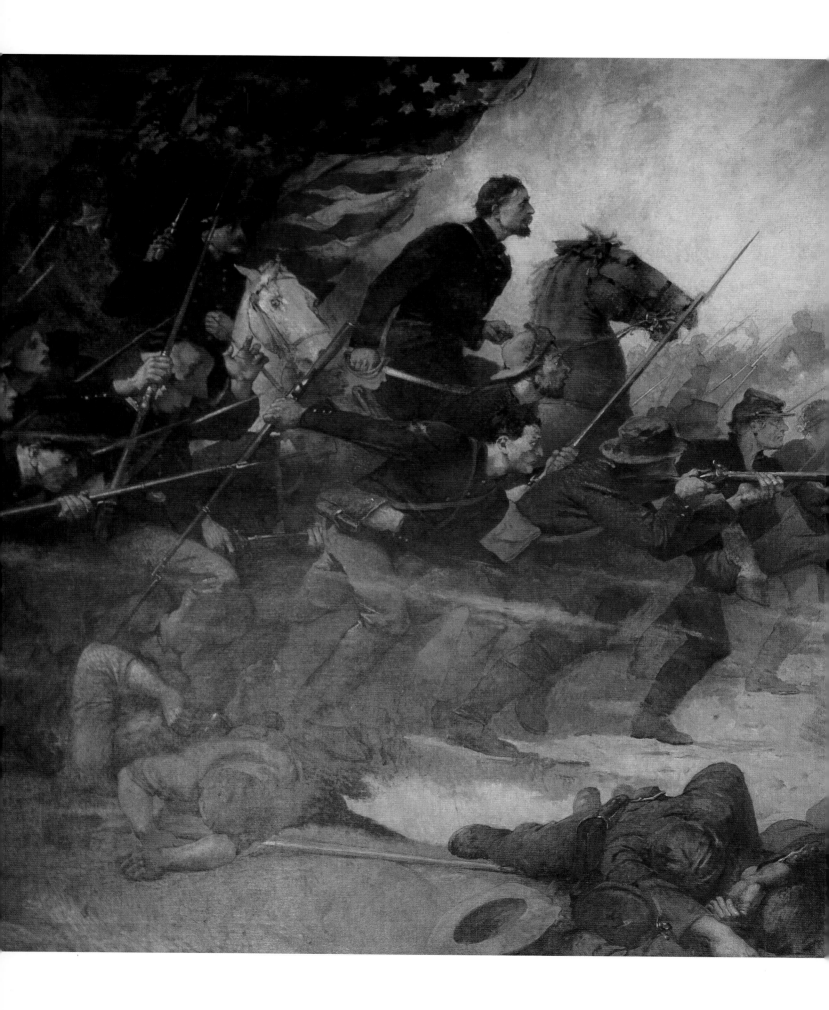

Foreword

PAUL GUNTHER

The Classical America Series in Art and Architecture began in 1968 as a central programmatic element of Classical America concurrent with its official incorporation as a nonprofit educational organization devoted to the understanding and contemporary promulgation of the classical tradition in art and architecture.

After Classical America joined forces with the Institute of Classical Architecture in 2002, the resulting eleemosynary confederation embraced this publishing program as an essential one and integrated it into its general operations and according annual budget. At the time of this book's advent in the year 2009, there have been more than thirty Series titles resulting from the Publication Committee's collective review and the shared affirmation of enlightened imprimaturs like W. W. Norton & Company. There are presently ten other titles under way. Whenever you discover this book, there will no doubt be many more, as outlined and described on the Web site: www.classicist.org. When and if the World Wide Web is superseded during this century, it is my sincere hope that whatever communications network comes in its place makes it easier still to discover the Institute of Classical Architecture & Classical America's (ICA&CA) enduring commitment to the written word and attendant pedagogy.

When the suggestion for a new book on the work and writings of Edwin Howland Blashfield was first made in 2004 by scholar-in-residence and Classical America cofounder Henry Hope Reed (the last and only book about Blashfield was Scribner's austere, color-free, and architecturally illiterate 1937 *The Works of Edwin Howland Blashfield*), I took stock of the fact that there had never been a *Classical America Series* volume dedicated to an artist—American or otherwise.

(opposite) Detail, *The Fifth Minnesota Regiment at Corinth,* 1912: Governor's Suite, Minnesota State Capitol, St. Paul, Minnesota. (Anne Day, photographer)

Reed's pioneering classical artist colleague, Pierce Rice, wrote about classical painting in his 1987 W. W. Norton & Company book, *Man as Hero: The Human Figure in Western Art,* while two works by American muralist and polemicist Kenyon Cox—*The Classic Point of View* and *What Is Painting?*—were reprinted by Norton in the 1970s, again with Classical America's encouragement. Likewise in Reed's books on the New York Public Library (1985) and the United States Capitol (2005), the many muralists and sculptors who decorated these landmarks of collaboration are well documented. Yet despite these important volumes, none took as its central subject a single practitioner or group of associated artists, even though the ICA&CA's mission and varied academic programs emphatically embrace the allied fine arts.

Clearly, it was time to fill that void and set an example for the *Classical America Series* to come. And what better subject for doing so than this great, yet nearly forgotten American classical master whose bountiful public works still decorate civic buildings and houses of worship across the United States—from St. Paul, Minnesota, to Cambridge, Massachusetts? The institute does so in honor of Mr. Reed.

Further in this grateful spirit, the institute is pleased to dedicate this book to Constance Feeley Reed, the wife of Henry Hope, who died on May 30, 2007. She was a loyal partisan of his work and its central role in defining and sustaining the institute's mission. A combined contribution made in Mrs. Reed's honor by generous donations from the board of directors and fellows, concurrently in place, helped in part to make this project possible.

In commissioning *Edwin Howland Blashfield: Master American Muralist,* the institute's objective is above all to reveal Blashfield's role as a classicist. He did so by conceiving and executing his work as part of a seamless architectural and decorative whole—a *gesamtkunstwerk* among creative peers. This guiding theme differs from more traditional art history with its primary focus on individual artistic achievement.

In 1972, Pierce Rice wrote an essay about Blashfield in the period following the 1893 World's Columbian Exposition in Chicago, where American mural painting secured its essential, fully integrated place in modern architectural achievement until the onset of the World War II.

In it, Rice summarizes well Cox's *classic point of view*: "The architect must be the master of the scheme but the painter lends himself to the architect's purposes rather than follows instructions. The architect, in turn, must adapt those purposes to the painter's contribution. Only in eras when these collaborations were everyday affairs was this end approached." He continues, "For the United States nothing held more promise than this union of architecture, sculpture and painting. The compact was a boon for architecture because by merging itself with the other arts it could come to its fullest flower."

12 PAUL GUNTHER

A thorough examination of Blashfield's murals allows ipso facto an examination of such magnificent, classically driven collaboration. Everything he did as a mature master was accomplished in this way; it was the essential creative impulse that drove form, subject, and medium.

It is the ICA&CA's goal with this book (as with all we do) not merely to forge a historic record but also to sustain a classical methodology of enduring relevance made accessible to both contemporary practitioners and those who commission them. This text and the accompanying illustrations thus serve as a textbook.

When considering this collaborative model, it is interesting to contrast it with what has perhaps been the predominate Modernist model for the marriage of art and architecture—at least in the realm of public structures in the world's most developed nations, namely the ubiquitous white cube. Art historian Brian O'Doherty wrote a renowned critical examination of this ideology of gallery space in a 1976 series of *Artforum* essays, later published as *Inside the White Cube*.

In this formal and functional equation, the artist working independently must intuitively construe his or her work in anticipated relation to the realities of the modern museum or commercial gallery (or even civic building with a dedicated gallery space for changing exhibitions) designed distinctly yet superimposing de facto a standard of interdisciplinary coexistence. Even when the exterior of such public structures is characterized by new forms and materials as found, for example, at Frank Gehry's 1997 Guggenheim Museum Bilbao, the resulting interior where most of the art and architecture actually converge is often a sequence of rectilinear white rooms. Formal collaborations between architects and artists (or craftspeople) have been increasingly supplanted by a system of distinct artistic endeavors that ultimately "merge" according to a set of expectations, which function as tacit and mutually accepted conceptual parameters. Different rules, but rules nonetheless.

With this volume, another, earlier, multidisciplinary artistic integration is acknowledged and reconsidered. The intent is not critical but a theoretical resource for consideration of future formal alternatives among both art and design professionals. The formative universality of such collaborations across cultures prior to the eighteenth-century advent of the art museum also enriches this book's hopeful purpose.

I gratefully acknowledge historian Mina Weiner, who served as the book's lead researcher, editor, and contributing author, and the accomplished photographer Anne Day, who documented Blashfield's public works in situ as their predetermined architectural settings dictate. Their combined work describes his oeuvre magnificently as is so long overdue.

This effort was forged for the institute initially by the research and text of Dr. Jan Ramirez, an American cultural historian who at the time of writing is the chief curator and director of collections for the Museum of the World Trade Center Memorial Foundation unfolding at New York's benighted Ground Zero. She prepared a preliminary project blueprint and led the way in identifying themes and scholarly resources for the task at hand. Dr. Annette Blaugrund, then director of the National Academy Museum and School of the Fine Arts, assisted with lively good will and shared the academy's Blashfield holdings for guiding inspection.

When Dr. Jan Ramirez began her research, she, like me, was pleased to make the serendipitous discovery of the concurrent thesis project of University of Delaware PhD candidate in art history Anne E. Samuel, whose chosen topic was the career and contemporary American Renaissance milieu of Blashfield. As a result, her contribution to this volume as essayist and consultant effectively fell into our lucky laps.

It was also plain from the start that the accomplished photographer Anne Day fit the bill ideally as book illustrator. Her past collaborations with Mr. Reed on *The United States Capitol: Its Architecture and Decoration*, as well as his earlier *The Library of Congress* and *The New York Public Library*, revealed to us her particular skill in recording architecture and its integrated artistic decoration.

We were fortunate to secure an essay by Gillian Britta Randell, a fine arts conservator specializing in murals, who in recent years participated in several major Blashfield conservation projects and became intimately involved with his technique and materials. Jeff Greene, currently president of the National Society of Mural Painters, a position held by Blashfield 1909–1914, provides the much-needed final essay celebrating Blashfield's influence on American mural painters from his day until the present.

I also commend the valuable participation of Nancy Green, a member of the ICA&CA's Council of Advisors and an editor at W. W. Norton & Company who, from the book's inception, understood Blashfield's cultural significance and the need to document it. We are grateful for her expertise and care as has so often been the case with the Series' volumes. New York–based architect Brian Connolly, who is a Fellow of the ICA&CA and chairman at this juncture of the Publications Committee, worked tirelessly to make this book a reality. Likewise, nothing here would happen without the wisdom and high standards of Managing Director Henrika Taylor.

Besides the dedicatory donations of the board and fellows, generous support of this book was provided by the Arthur Ross Foundation and its extraordinary late president and institute honorary chairman, Arthur Ross. His example has led the way since the organization's inception. Support came also from Furthermore, Grants in Publishing, a program of the J.M. Kaplan Fund and its enlightened president, Joan Davidson. Ms. Davidson's

passionate regard for the cultural and civic well-being of New York and beyond is second to none. We also thank the Robert Lehman Foundation, whose grant for diverse educational initiatives in 2007 was tied in part to the Blashfield enterprise, as well as The Orville Gordon Browne Foundation and its stewards, trustee Chris Browne and Andrew Gordon, whose great generosity toward the institute allows all our endeavors to flourish.

I herald *Edwin Howland Blashfield: Master American Muralist* with pride and hope.

Paul Gunther
President

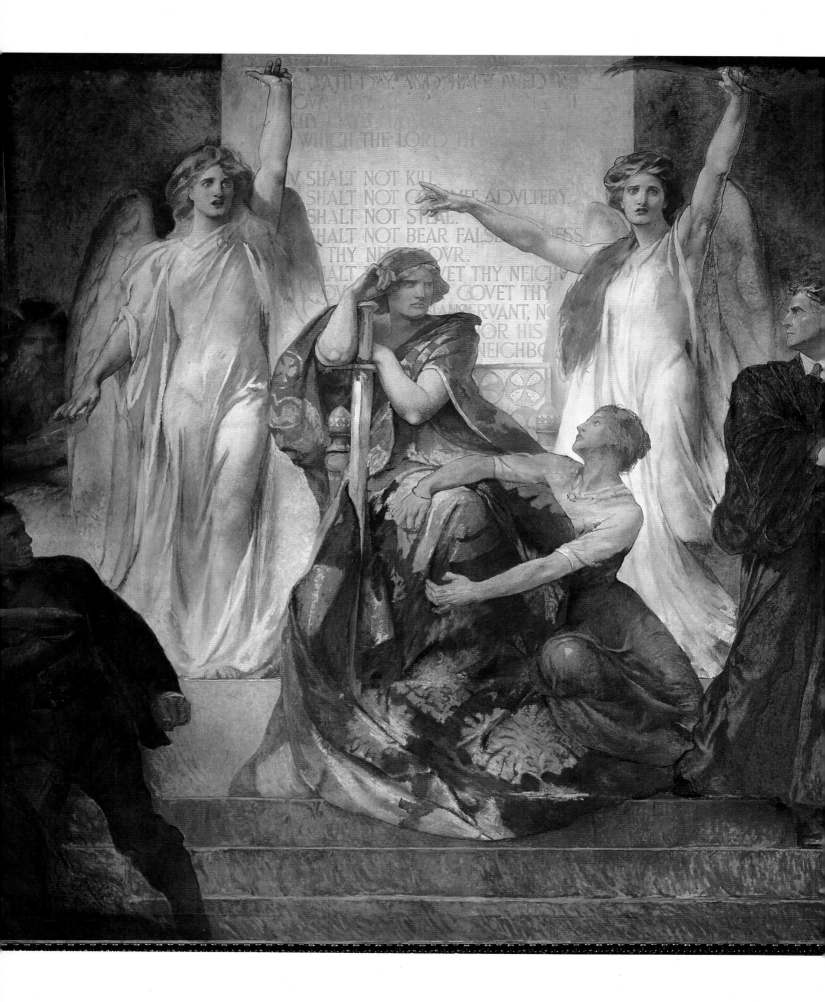

Edwin Howland Blashfield

MASTER AMERICAN MURALIST

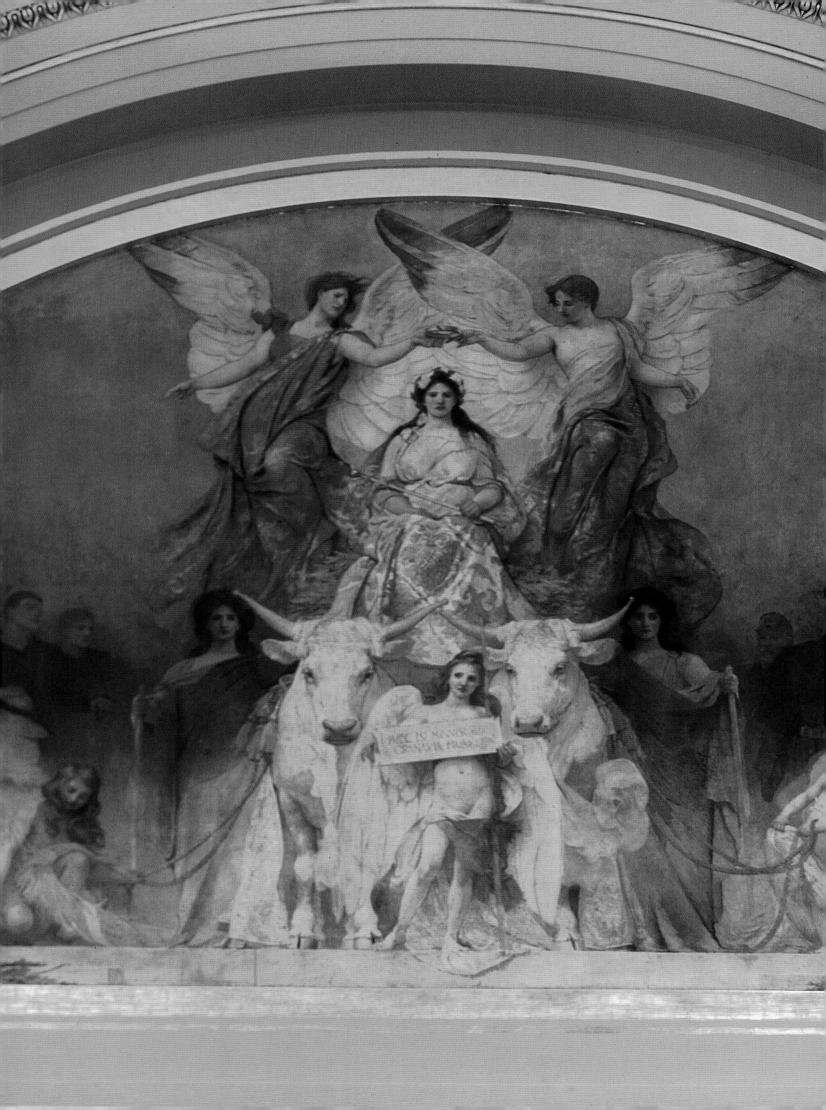

1

Edwin Howland Blashfield:
Defender of the Classic Tradition

MINA RIEUR WEINER

If America is truly to profit by the unparalleled opportunity which social, industrial and geographical conditions are to offer the artist in the future we must demand the ultimate—the ultimate in talent and experience—from the artist. He must know the art of bygone times thoroughly in order that he may utilize its happenings and processes in meeting the needs of the present. He must sympathize with the branches of art which are sisters of his own; and in sum, he must be a veritable Janus, looking backward for all that the past may teach him, yet not forgetting that he is an American among Americans looking forward to the threshold of no one knows how potential a future.[1]

Edwin Howland Blashfield, exemplar and advocate of the classic tradition in America, rose to prominence as a muralist during the period between the 1893 World's Columbian Exposition in Chicago and the 1917 United States entry into World War I. When he and his wife, Evangeline, settled in Gilded Age New York after many years of study and travel abroad, he established his studio in Manhattan, the epicenter of the nation's art world. There Blashfield was able to develop associations, promote and administer his career, launch a crusade to elevate the critical value of decorative painting, and demonstrate its capacity for beautiful imagery, optimistic and didactic iconography, and democratic uplift. Even when opportunities for his style of mural painting waned after the war, and his work was eclipsed by various artistic movements that challenged his academic style and definition of beauty, Blashfield continued to advocate for the art form and for classicism. To contextualize his career, this essay will cite selective biographical and historical milestones

(opposite) Detail, *Minnesota, Granary of the World* (1904). Senate Chamber lunette, Minnesota State Capitol, St. Paul, Minnesota. (Anne Day, photographer)

as well as cultural aspects of New York City' that influenced Blashfield's art and writing.

Edwin Howland Blashfield was born in 1848 in Brooklyn, New York. At an early age he showed an interest in art and a talent for drawing. His parents, William Henry Blashfield and Eliza Dodd Blashfield, hoped that he would utilize his natural abilities in the study of engineering or architecture. When he was thirteen, they sent him to live in Boston with his maternal grandparents so that he could attend the humanities-based program of the Boston Latin School, the oldest public high school in America. Following his graduation from high school, Blashfield entered the Massachusetts Institute of Technology (MIT) with the class of 1869. However, an inheritance of $10,000 following the unexpected death of his godfather Edwin Howland provided him with an annual income of $700 and the financial independence that would allow him to pursue a career in art.

As Blashfield recalled, "In 1866, I went to Boston to ask William Morris Hunt how I might best study art. 'Go abroad at once,' he said, 'there are no schools here.'"[2] Following Hunt's advice, Blashfield left MIT after his second year and sought acceptance at the popular atelier of painter and sculptor Jean-Léon Gérôme (1824–1904), a well-known and admired proponent of classical standards and techniques as taught at the École des Beaux-Arts, the publicly financed art academy in Paris. Gérôme's atelier was patterned on studios of the Renaissance where, through teaching and apprenticeships, master painters transmitted their knowledge to the next generation. The curriculum incorporated life drawing and painting, cast drawing and painting, portraiture, and composition.[3]

According to Blashfield, his father had been opposed to his pursuing a career as an artist. However, he relented after hearing that a cousin, encouraged by Blashfield's mother, had given Gérôme in Paris a battle-scene drawing that Blashfield had completed while he was still a student at the Boston Latin School and that the master had recognized a talent that should be supported.[4] Forty years later, Blashfield recalled that Gérôme had accepted him as a pupil at once. While indicating that the routine formalities required for entrance to the École des Beaux-Arts would take at least three months, Gérôme suggested that Blashfield not lose that time and study with Léon Bonnat (1833–1922), who ran an open school, an independent atelier. Gérôme said, "There is not a better man in France to study with."[5] Obeying Gérôme's direction, Blashfield said, "I went to Bonnat and admired him so much that I never left him. Gérôme continued to be kind to me, and from time to time permitted me to take sketches or other work to him."[6] "He was always more than kind in giving time and attention to young men, talking by the half-hour with enthusiasm for classical antiquity, saying 'Surround yourself with everything you can,—casts, photographs, terra-cottas, vase paintings—and look at them constantly with all your might.'"[7]

Blashfield reported that not all his early experiences were positive. "Bon-

Battle Scene, c. 1861–65: Drawing. (Courtesy of the Edwin H. Blashfield papers 1850–1980, Archives of American Art, Smithsonian Institution)

This action-packed image of battle was drawn by Blashfield while he was still a teenager and student at the Boston Latin School and was submitted as part of his application to Jean-Léon Gérôme's atelier at the École des Beaux-Arts in Paris.

nat kept us Americans drawing for a good two years before he let us paint. My first effort was made in my own studio with my chums [Milne] Ramsey and [Charles Walker] Lind looking on. The subject was an apple in a saucer and when rendered, Ramsey said afterwards, it superinduced anxiety in both of them, anxiety for me. My second effort included a wine glass and two eggs, one of which being broke accidentally, contributed to the colorfulness of the composition; this time my chums gave me up as absolutely hopeless."[8]

Despite the rigorous program and his early inadequacies, Blashfield studied with Bonnat from 1867 to 1870 and again from 1874 to 1880, his tenure having been interrupted by the Franco-Prussian War. Bonnat, a French-born portrait painter, had spent his teenage years, from 1846 to 1853, in Madrid. His oeuvre combined a devotion to classical training with an admiration of Velasquez and the Spanish tradition of realism, chiaroscuro, and rich surfaces. However, he encouraged his students to study a variety of styles and not to simply emulate his. During his own career, Blashfield promulgated the classical dictums and pursuit of beauty he acquired under the tutelage of Bonnat and Gérôme. "In all that I have to say to students there is nothing half so close to my heart as the desire to impress the absolute necessity for hard, careful, close drawing and modeling from nature, before they permit themselves to loosen their surface and handle vigorously."[9]

While studying in Paris, Blashfield took advantage of its central location and enjoyed numerous backpacking trips across Europe, coming in contact with and making sketches of art in thousands of places. His exposure to centuries of achievement in public architecture, painting, and sculpture—representing generations of famous schools of art in France, Italy, Spain, Germany, Holland, and elsewhere—opened his eyes to art as a visual language understood and enjoyed by general audiences. During those Euro-

pean jaunts, Blashfield was captivated by the democratic use of decorative art and architecture that integrated imagery and beauty into the life of every man.

Blashfield traveled abroad periodically for the rest of his life and recorded his astute observations in voluminous notes and letters. He responded emotionally and intellectually to the beauty, grandeur, and spectacle of European cities in which the names of many public buildings such as the Parthenon, the Tower of Pisa, and the Duomo of Florence appeared to him as "century marks of the ages."[10] His European experiences helped formulate his lifelong opinion that "Art was the property of all men; it belonged to every citizen who had eyes to see. It was 'of the people, for the people, by the people.' The history of the commonwealth was not shut up in libraries; it was made living upon the walls, so that the humblest and least educated citizens knew its principal and worthiest events. Every one is more or less impressed through the eyes, especially so are the masses."[11]

Blashfield met his future wife, Evangeline Wilbour (1857–1918), in Paris in 1876. A writer and feminist, she shared his love of history, travel, beauty, and visual harmony. She was the daughter of socially connected Charlotte Beebe Wilbour, a founder of the Colony Club in New York, and noted American Egyptologist Charles Edwin Wilbour. (The nucleus of the Wilbour Library of Egyptology at the Brooklyn Museum, one of the world's most comprehensive research libraries for the study of ancient Egypt, came from the personal library of Charles Edwin Wilbour, who also assembled the museum's extensive Egyptian antiquities collection.) In the 1880s and early 1890s, Evangeline and Edwin traveled to Greece and Egypt with her parents, providing Blashfield, who venerated the ancient roots of Western art, opportunities to study and sketch artifacts from those ancient cultures. The couple collaborated on numerous magazine articles and books based on their extensive travels.

Edwin and Evangeline married in 1881 and settled in a New York City neighborhood they called "our little Bohemia."[12] Their apartment in the Sherwood, a building located at 58 West 57th Street (demolished in 1960), featured a studio with a fifteen-foot-high ceiling. Blashfield thought that the Sherwood "was to the eighties what the Tenth Street Studio Building had been to the sixties and seventies, namely at one time or another, the home of pretty nearly every painter of the moment and of many sculptors, too."[13] (The Tenth Street Studio, to which Blashfield refers, was a building on the north side of Tenth Street, between Fifth and Sixth Avenues, designed by Richard Morris Hunt to serve artists' needs. Built in 1857, it attracted artists from all over the country, whose receptions were attended by wealthy patrons, influential critics, and the interested public.) Blashfield cultivated these connections and developed networks that eventually helped him with future commissions. Initially, he established himself as an easel painter, portraitist, and magazine illustrator.

MINA RIEUR WEINER

Blashfield's homecoming coincided with the growing popularity of his acquired style of classical European–inspired art during the period defined as the American Renaissance. "The term 'American Renaissance' concerns the identification of many Americans—painters, sculptors, architects, craftsmen, scholars, collectors, politicians, financiers, and industrialists—with the period of the European Renaissance," and admiration of its original sources in Greece and Rome.[14] Proponents believed that classical art "projected an image of culture and civilization that many people approved of. Partaking of the air of genteel idealism and higher service, the art also gave a sense of release from the stuffy confines of Victorianism. . . . [It was] an art and architecture of superb craftsmanship . . . , one of wealth with tinges of exoticism that delighted in ornamental richness for its own sake. . . . People felt it implied a special connection with the grand tradition of history."[15]

The Brooklyn Museum catalogue for its 1979 exhibition broadly defined the American Renaissance: it spanned the last decades of the nineteenth century and early decades of the twentieth, and it produced an unparalleled birth of contrasting trends, from the Prairie houses of Frank Lloyd Wright to the Renaissance palazzos of McKim, Mead & White; from the futuristic compositions of Joseph Stella to the tradition-laden paintings of Kenyon Cox; from the simple oak furniture of Gustave Stickley to the Colonial Revival highbacks of A. H. Davenport. The standard interpretation of the differences in these works is that one side represents the nativistic, progressive spirit, while the other is tied to Old World traditions having little relation to American civilization's identity and vision. Yet it was the traditional art and architecture that had the greatest impact, was overwhelmingly popular with the public,[16] and enjoyed the confidence of the corporate community.

The vocabulary of the American Renaissance, with its beautiful and noble images removed from the mundane, appealed to growing optimism about post–Civil War American cohesiveness. Pride in America's past, especially the colonial and founding eras, had been awakened during the nation's centennial celebrations of 1876. Then, as memories of the ravages of the Civil War faded, heroes of the nation's reunification joined the pantheon of acceptable idealized images that initially featured puritans, pioneers, Revolutionary War heroes, and particularly the iconic figure of George Washington.

The classical idiom, emphasizing the human figure and utilizing allegories and historic references, was considered comprehensible to the average worker and the newest immigrant and could be used to promote universal values and engender a sense of patriotism. Blashfield argued that art brought beauty and knowledge to the public through stories that are "graphic presentations of traditions."[17] He suggested that the idealized figures, symbols, and allegories found on Greek vases, Egyptian walls, Roman friezes, fifteenth-century frescoes, Venetian canvases, and the like all dramatized familiar stories for their particular audiences. He believed that "mas-

ters of the Italian Renaissance who studied both antiquity and the trecento [fourteenth-century Italian art], have prescribed to all time the decorative formula for some of the most important and what we may perhaps call the architectural parts of a public building. It is a formula within which wide liberty is possible, as wide indeed as is the gamut run from Giotto through Masaccio to Raphael, even to Veronese and his late descendant Tiepolo."[18] At the same time, Blashfield recognized that "the present is the past of tomorrow and is worth providing for."[19]

An impressive manifestation of the American Renaissance, national pride, and optimism was the World's Columbian Exposition of 1893, held in Chicago to celebrate the 400th anniversary of the European discovery of America by Christopher Columbus. That event served as a seminal moment in Blashfield's career, initiating two decades of prolific mural activity. Blashfield's early career, characterized by studies abroad and his development as an illustrator and easel painter and an advocate of Beaux-Arts ideals in the United States, was preparation and prologue to his debut as a muralist at the exposition, where the public possibilities for art and architecture became fully recognized and classicism in image and composition were the overriding principles.[20]

Daniel Hudson Burnham and his partner John Wellborn Root had been appointed by the World's Columbian Exposition Corporation, composed of Chicago's business leaders, to oversee one of the nation's first large-scale, government-sponsored landscape design and architectural projects. Burnham, an architect, city planner, businessman, and civic leader, emerged as the overall chief of construction and supervisor of consultants. He summoned several East Coast architects and artists to join in the planning. Burnham recalled, "My plan was to bring together the men of greatest experience. I was forty four and a half years old, and knew who the men were. I went to New York and met the architects at the Players' Club. . . ."[21] When Root died suddenly, Beaux-Arts–trained Charles Follen McKim, of the New York firm McKim, Mead & White, stepped in as consulting architect. Among the other easterners who guided this enormous venture were architect Charles Atwood, originally from Boston and New York and subsequently a member of Burnham's Chicago firm; landscape designer Frederick Law Olmsted, joined by his assistant Henry Codman; sculptor Augustus Saint-Gaudens; and painter Francis D. (Frank) Millet. According to Burnham, Saint-Gaudens's enthusiasm for the group was characterized by his remark, "Look here, old fellow, do you realize that this is the greatest meeting of artists since the Fifteenth Century?"[22]

All "agreed that the Italian Renaissance style of architecture should be adopted for the Court of Honor."[23] Therefore, architects who had studied at the École des Beaux-Arts in Paris or with other exponents of classical discipline were hired to design the signature buildings. Richard Morris Hunt, the first American architect to have studied at the École, was tapped to design

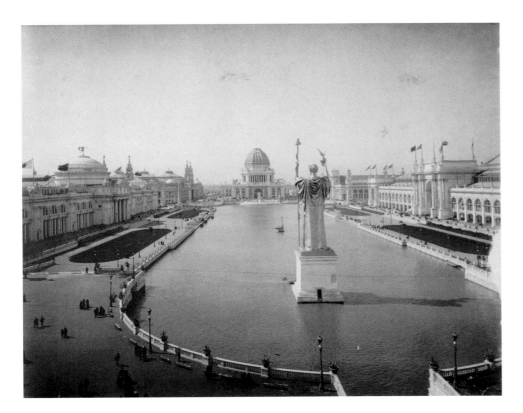

Court of Honor, World's Columbian Exposition, Chicago, 1893. (Photograph: Chicago History Museum)

Blashfield painted a ceiling mural in situ for one of the eight entrance domes of the Manufactures and Liberal Arts building that is shown bordering the lagoon on the right.

the main administration building; George B. Post, who had studied with Hunt, was assigned the Manufactures and Liberal Arts Building; the Boston firm of Robert Swain Peabody (another Beaux-Arts graduate) and John Goddard Stearns Jr. was given Machinery Hall. McKim was asked to design the Agriculture Building, and Atwood took on the Palace of Fine Arts. Their temporary, symmetrically designed, classical buildings alongside Venetian-inspired lagoons became known as the "White City." Its grandeur fulfilled the organizers' aspirations to present America as a republic of power and substance.

The decision to grant major assignments to predominantly classically trained eastern architects, painters, and sculptors was controversial. Supporters were those who believed in civilization's evolutionary process and envisioned the young United States as the beneficiary of the wisdom of preceding cultures. They accepted classicism as the paradigm of beauty, high ideals, noble thoughts, and universal meaning. Detractors such as the famed architect Louis Sullivan—one of only five Chicago architects to design a building at the exposition—complained that the "White City" ignored new ideas, was an unnecessary backward glance, and would set back modern American architecture by a half-century if not longer.[24]

As the buildings rose, so did nationalistic expectations. The Columbian Exposition's stately derivative style, embracing columned edifices and panoramic vistas, evoked comparisons with ancient Rome and invited the world to consider the United States as a rising power. Serving as a coda to

the patriotic fervor generated less than two decades earlier at the time of the country's Centennial, the fair was an expression of national pride in its wealth and accomplishments. Many ascribed the orderly behavior of the crowds of visitors to its morally uplifting environment. The organization of the exposition served as a lesson in civic planning; its dominant architecture stimulated a trend of Beaux-Arts classicism for public buildings.[25] Its successful unification of the three Beaux-Arts disciplines—architecture, painting, and sculpture—inspired subsequent collaborations on commissions for major public buildings and palatial homes. The confluence of a commitment to European standards; government sponsorship; collaboration of architects, painters, sculptors, and landscape designers; and displays of scientific and manufacturing advances yielded a far-reaching legacy, establishing a paradigm for numerous expositions that would bring the American Renaissance to people of all classes in all parts of the country.[26]

The Blashfields were in Florence, Italy, when Edwin received a cable from Francis D. Millet, director of decorations for the exposition, that would change the course of his artistic career. As Blashfield tells the story, Millet, whom Blashfield had befriended in 1886 while summering with his wife among artists in Broadway, England, asked, "Would I come to Chicago and execute a mural for the Columbian Exposition? Would I? Would a duck swim?!"[27] Blashfield recognized that being one of eight American artists chosen to work on the Manufactures and Liberal Arts Building, designed by noted architect George B. Post, was both a prestigious commission and a unique opportunity. After a brief detour to Venice, "in the hope that some of Veronese's or Tintoretto's secret would look out on to the inspiration of such a very green hand as I was,"[28] the Blashfields wended their way to Chicago. In a 1933 speech before the American Academy in Rome, when Blashfield was the lone survivor of the group, he recalled, "Frank Millet gathered eight of us to paint eight domes at the Fair. The men were [Kenyon] Cox, [J. Alden] Weir, [Edward] Simmons, [Robert] Reid, [Walter] Shirlaw, [J. Carroll] Beckwith, [Charles S.] Reinhart and myself."[29]

Blashfield arrived at the heady environment of the World's Columbian Exposition prepared to complete a mural in the enormous Manufactures and Liberal Arts Building. Blashfield recalled, "We were to paint the domes in sixtus [sic] on plaster that fairly broke your heart and skinned your knuckles and was like a relief map of Switzerland for bumpiness."[30] The task was made even more daunting by its scale; the domes measured approximately 25 feet in diameter and were situated over 50 feet above the pavement. To complicate matters, the working model sent to each artist in advance to inspire his composition had been improperly scaled.[31] Blashfield noted, "Scale and foreshortening were redoubtable to us as problems. To foreshortening in the long run we wisely paid little attention, but to scale, still more wisely, we paid a great deal. Colossal paper dolls, with plenty of thumb-tacks, helped us out, and, though our scales varied, none was noticeably unsuited. . . ."[32] Blashfield's

mural, *The Arts of Metalworking* (see page 71), is discussed in Anne E. Samuel's chapter. The successful fair, visited by twenty-six million people, offered national exposure to a classical style of civic architecture and decoration, enhanced the reputation of participating architects and artists, and afforded Blashfield, now forty-five years old, a place in a nascent and influential mural movement. Following this assignment, he was commissioned by architect Post and others to paint murals in private homes, educational institutions, public libraries, state capitols, courthouses, and churches. According to the *New York Times,* he became "a raconteur in color and form on a grand scale."[33] (In 1886, Blashfield had completed his first mural, *Allegory of Good and Bad Dreams,* composed of three ceiling panels, for the Fifth Avenue New York residence of Hamilton McKown Twombly. Twombly, a financier and president of the New York Central Railroad, and Blashfield had been classmates at the Boston Latin School. This commission, in an art form in which he had little experience, preceded by several years his Chicago assignment and his emergence as a major mural painter.)

Blashfield wrote extensively about the significance of the World's Columbian Exposition of 1893, where "the Government of the United States on a large scale had recognized art for the first time."[34] Decades later, he remained persuaded that the exposition's impressive vistas and grand, columned, and decorated buildings—an American interpretation of the Italian Renaissance and classic design—continued to be a potent influence on American art. In a speech before the American Academy in Rome, he said, "You who are working now, if you will follow backward the threads of your inspiration, will find them closely interwoven with that tapestry of art effort which was unrolled at the Columbian Exposition. . . . With 1893 and the Chicago Fair, the gates of wider experience in American art seemed to swing open. Mural painting, almost a novelty on this side of the Atlantic, caught the public attention."[35] Blashfield optimistically declared that "by the time that the World's Fair of Chicago closed its gates, it was evident that America would attempt to take up the succession of the older nations in mural painting."[36]

Two additional trends were given strength by the exposition and were of great benefit to Blashfield and his muralist colleagues. The first was the fair's stylistic influence on a new class of extraordinarily wealthy patrons who, during the late nineteenth and early twentieth centuries, had accumulated great fortunes in the mushrooming industrial, manufacturing, railroad, and shipping sectors. Believing that European architecture and decor represented the best of taste, and that its adoption would help elevate their social standing, they sought European-trained and classically disciplined architects and artists who could emulate European architecture for their grand domiciles, office buildings, clubs, and churches. "In 1892, critic Charles DeKay heralded the beginnings of the American mural movement when he spoke of a 'spread of the fashion for superior decorative work among the well-to-do.'"[37]

Allegory of Good and Bad Dreams, 1886: Ceiling panels, residence of Hamilton McKown Twombly, New York City. (Courtesy of the Edwin H. Blashfield papers 1850-1980, Archives of American Art, Smithsonian Institution)

Blashfield's first mural was completed for the Manhattan residence of Hamilton McKown Twombly, a former classmate from the Boston Latin School, and his wife, Florence Vanderbilt, a granddaughter of Commodore Cornelius Vanderbilt.

MINA RIEUR WEINER

New York architects Hunt, Post, and Brunner, among others, designed numerous Renaissance-inspired houses for their wealthy clients and commissioned Blashfield and other classically trained artists to decorate the interiors. In Boston, Blashfield was contracted by his friend Everett Morss to create colorful and lively murals to decorate his home.

The second trend that gained popularity with the Chicago exposition was the City Beautiful movement. Initially conceived by reformers, the City Beautiful movement proposed to utilize architecture and urban planning to replace urban blight with harmonious municipal art. The movement's premise was that proper city planning and beauty would bring social order, replacing the moral decay and ugliness evident in cities overcrowded with increased immigration from rural areas and abroad. A second, more subtle goal for the artistic elite and politically powerful was to provide a visual environment of calming beauty to uplift the immigrant and working-class sectors of the late nineteenth-century populations. While the latter may not have fully understood all the symbolic and literary references in the murals of this period, they would probably sense that these murals were there for inspiration and informal instruction and to signal the importance of the activity contained within an architectural venue. Despite acknowledging the nation's diversity, the predominant imagery was decidedly western in concept, and the figures were, with few exceptions, Caucasian, fair-haired, and even-featured. Black and ethnic minorities were generally not portrayed, and Native Americans were pictured either as uncivilized but noble or as obstacles to the progress of civilization.

Encouraged by the positive response to the Columbian Exposition, planners decided that classical Beaux-Arts design was the appropriate idiom to

Lord of the Isles (aka *The Meeting*), 1913: Overmantel mural, residence of Mrs. Charles Keith, Kansas City, Missouri. (© Christie's Images Limited, 2002)

This mural incorporates Blashfield's interest in historical costume, particularly medieval armor, and demonstrates his brilliance as an illustrator. The canvas is based on an episode in the 1815 poem *Lord of the Isles* by Sir Walter Scott.

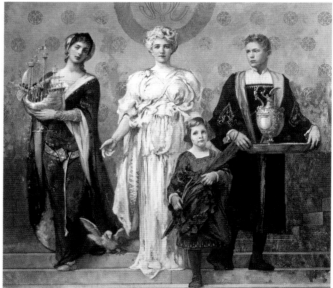

Music, Hospitality, Books, 1914: Three murals for the residence of Everett Morss, Boston, Massachusetts. (Peter A. Juley & Son Collection, Smithsonian American Art Museum, J0045753, J0045760, J0045768)

The house and murals were destroyed, but one panel and two roundels were transferred to private collections. Portraits of Mrs. Morss and her children appear on the figures in *Hospitality*.

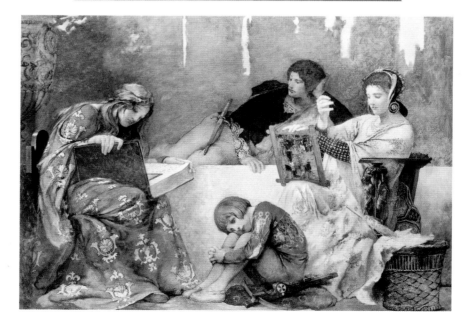

achieve their ends, and they made Washington, DC, the test case for the City Beautiful movement's aspirations. They determined to replace slum areas with a stirring, elegant, unifying, and gleaming capital city that would compare favorably with those of Europe. Among the planners were Burnham, Saint-Gaudens, McKim, and Olmsted—the same individuals, primarily New Yorkers, responsible for the design of the Chicago fair. The visually successful Washington, DC, plan, which included the development of the majestic and dignified National Mall and Union Station, influenced a proliferation of civic construction across the country, much of which continued to embrace the classical tradition.

"The next major milestone in the burgeoning mural movement" was the decoration of the interior of the Library of Congress Jefferson Building in Washington, DC.[38] Blashfield was given the plum assignment of decorating the cupola and dome collar for the main reading room. This project is discussed at length in Anne Samuel's chapter. However, it is interesting to note a practice that Blashfield began here and continued on future mural projects. According to custom, live male and female models posed for the figures. Blashfield went further and integrated portraits of real people taken from photographs for several

Detail: *Evolution of Civilization,* 1895–96: Dome collar, Thomas Jefferson Building of the Library of Congress, Washington, DC. (Anne Day, photographer)

Among the portraits on the dome collar is the head of President Abraham Lincoln, which appears on the figure representing America.

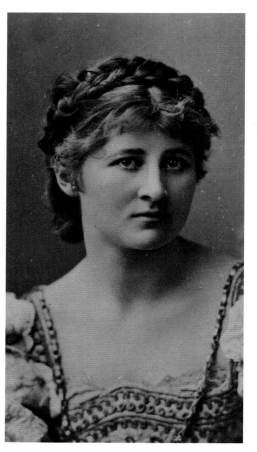

Mary Anderson, (1859–1940) (George Arents Collection, The New York Public Library, Astor, Lenox and Tilden Foundations)

of the heads. General Thomas Lincoln Casey, chief of the Army Corps of Engineers who supervised the construction of the library building, was chosen to represent Germany; actresses Ellen Terry and Mary Anderson personified England and the Middle Ages, respectively; Blashfield's friend William Faxon was Spain; and President Lincoln's visage was used to represent America.[39]

Like most European-trained artists, Blashfield shared an academic preference for figure painting and for idealized images of women, especially classical personifications based on Greek and Roman mythology. The women were either nude or clothed in "vaguely antique costumes, their features were idealized, and the settings were generalized."[40] Initially, especially in easel paintings and home decorations, Blashfield used soft, feminine, and lyrical images. Much like the idealized female figures associated with Greek myths, the lithe and elegant women who danced on the walls and ceilings of private homes and even hotel ballrooms were "light and festive" representations of "floral, seasonal and musical metaphors, and symbols familiar from easel paintings."[41] "The increased role of murals in the official public sphere led [him and others] to move away from passive women in a poetic mood or lyrical role. Women became public persons, official representatives of ideals of the institutions they decorated. . . . Personifications [of] Justice, Law, Government, Tradition, Commerce, Religious Liberty, and even Minnesota or Wisconsin became rhetorical symbols; they were identities chosen to inspire respect and emulation."[42] These epic female figures in classical robes appeared to be commanding rather than softly feminine, and they bore serious expressions on chiseled countenances. Actress Mary Anderson's face was clearly Blashfield's ideal. In addition to the Middle Ages personification in the Library of Congress, her image appears again on the central figure in his 1904 *Granary of the World* mural for the Minnesota State Capitol (see page 18). Indeed, her Anglo-Saxon features—auburn hair, deep-set eyes, straight nose, and strong chin—are recognizable on many of his women. (For an in-depth discussion of the female form in American mural imagery during the American Renaissance, refer to the excellent van Hook article cited.)

MINA RIEUR WEINER

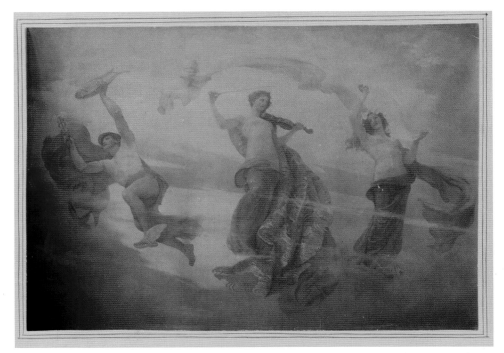

Allegory, 1895: Music room ceiling, residence of Robert Ives Gammell, Providence, Rhode Island. (Courtesy of the Edwin H. Blashfield papers 1850–1980, Archives of American Art, Smithsonian Institution)

For many years, this mural could not be found. Picture research for this book led to the discovery that *Allegory* currently graces the master bedroom of a private residence.

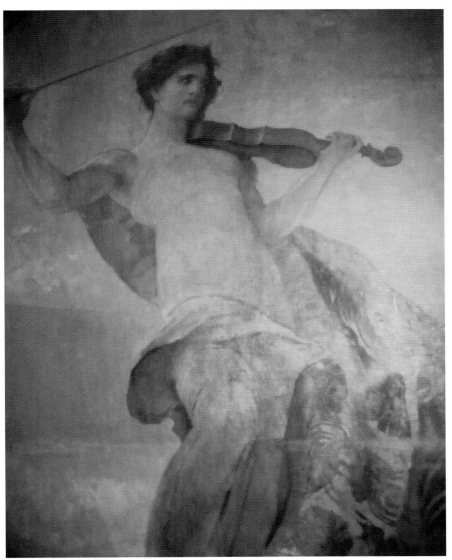

Detail: Central figure of *Allegory*, 1895. (Private collection)

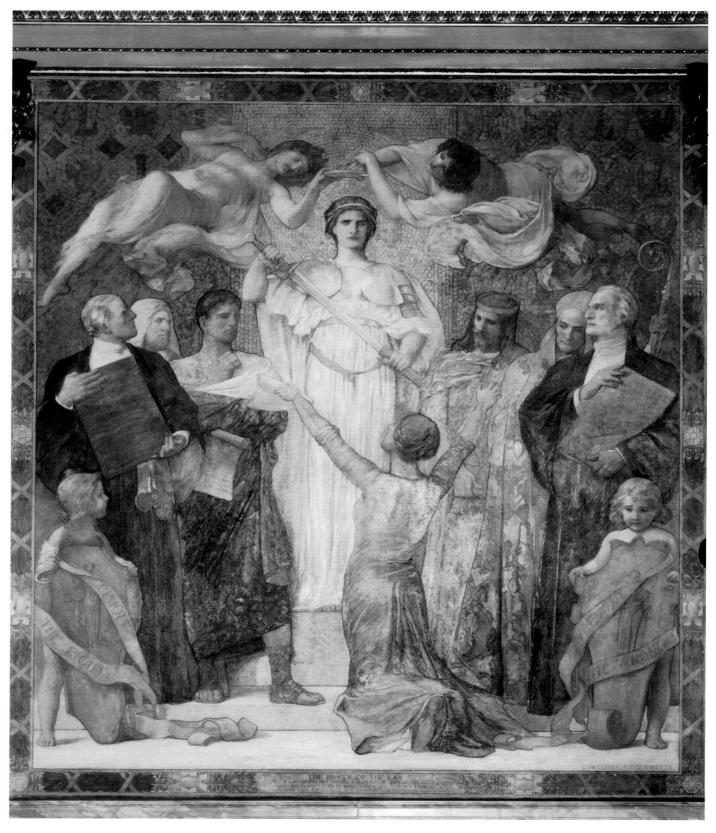

Power of the Law, 1899: Appellate Division, First Judicial Department Courthouse, New York City. (Whitney Cox, photographer)

A description below the painting reads: "The law draws her sword in behalf of appeal, on either side she is supported by magistrates and figures typifying Roman Law, Canon Law, and Common (Anglo-Saxon) Law." In the foreground, two youths hold shields bearing the seal of the Appellate Division.

MINA RIEUR WEINER

ANNAPOLIS DEC. 23, 1783

The long shadow of the Colonial Revival movement influenced Blashfield to wrap idealized versions of American history in classical draperies by incorporating American historical figures in his presentations. Blashfield's *Washington Surrendering His Commission*, painted for the Baltimore Courthouse in 1902, "effectively harmonizes two competing forces in the art of the American Renaissance. . . . [His] eclectic combination of colonial subject and Renaissance composition provides a surprisingly potent means of representing an important event in Maryland history."[43]

Another example of Blashfield's dramatization of a founding-era legend can be seen in his mural *Proclaim Liberty Throughout the Land* (1923), now installed in the old Lehigh County Courthouse. The narrative commemorates the patriots' successful effort to protect Philadelphia's Liberty Bell by hiding it from the British during the War of Independence. The iconic bell is depicted being hauled atop a lowly hay wagon, accompanied by farmers, citizens, and Revolutionary War soldiers, on its journey to a hiding place under the floorboards of the Zion Church in Northampton (now Allentown) in Lehigh County, Pennsylvania. Witnessing the scene is a commanding female figure representing Liberty, which dominates the center of the canvas. *Proclaim Liberty Throughout the Land* was "rediscovered" in the course of research for this book. Initially commissioned by the now-defunct Liberty Trust Company of Allentown, Pennsylvania, it had been widely believed to have been destroyed when the bank closed. Fortunately, the mural had been saved from demolition, and in 1976 it was reinstalled in the nearby Old Lehigh County Courthouse.

The heroism of Union forces during the Civil War and the nineteenth-century movement opening the American West are two other popular patriotic themes that were successfully incorporated into several Blashfield

Washington Surrendering His Commission, 1902: Courtroom mural, Clarence M. Mitchell Jr. Courthouse, Baltimore, Maryland. (Anne Day, photographer)

General George Washington places his commission at the feet of Columbia, who is depicted as a heroic woman seated on a throne and wearing a liberty cap. Opposite Washington stands a figure representing the state of Maryland. Soldiers of the Continental Army, a French officer in white, and citizens populate the end panels.

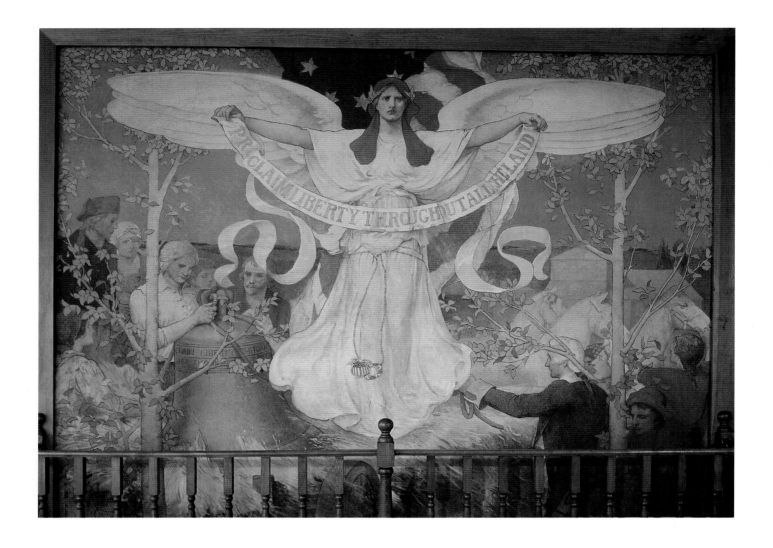

Proclaim Liberty Throughout the Land, 1923: Old Lehigh County Courthouse, Room 200, Allentown, Pennsylvania. (Anne Day, photographer)

The mural's narrative is based on a real event: the removal of the Liberty Bell from Philadelphia to Allentown to safeguard it during the Revolutionary War.

murals. Blashfield was one of several artists invited to interpret the Civil War exploits of the Fifth Minnesota Regiment for the Governor's Suite in the Minnesota Capitol building. Recalling his early interest in battle scenes, and the detailed history paintings of his Beaux-Arts mentor, Jean-Léon Gérôme, Blashfield contributed *The Fifth Minnesota Regiment at Corinth*, which portrays a critical moment in the October 1862 Battle of Corinth, Mississippi, when the Minnesotans repulsed a Confederate attack and recaptured Union cannons.

Interestingly, one such American-themed mural has met with contemporary political criticism. At the time of its creation, Blashfield's mural for the South Dakota State Capitol, *Spirit of the West* (see page 38), interpreted the widely held perception that our nation's "manifest destiny" was to keep expanding its territory and spreading democracy westward. The resulting displacement of Native Americans was generally regarded as an unfortunate consequence of the inevitable settlement of the West. Blashfield portrays Civilization as a serene female clad in classical white drapery, and he places her in the center of the mural. She is embracing a book that represents western culture and is longingly gazing westward. Around her is violence; armed male

MINA RIEUR WEINER

pioneers appear to be trampling whoever is in their way (the fallen figures have been interpreted by many to be Native Americans) as a female figure floating above the fray urges them to persevere in their civilizing mission. Around 1980, the painting was apologetically renamed *Only by Contemplating Our Mistakes Do We Learn* in the belief that the new title, by recognizing mistreatment of Native Americans, would make the composition less offensive. However, in 1997, responding to a 1994 act of the South Dakota legislature, a false wall was built in front of the mural, and it can no longer be viewed by the public. Even covered, it remains a source of controversy.[44]

In another challenge to contemporary sensibilities and the current debate on appropriate subjects for public buildings, Blashfield's splendid mural in the Circuit Court Room of the Cleveland Federal Courthouse includes an image of the Ten Commandments carved on a stone tablet. While several recent court cases have considered the legality of decorating government buildings with biblical references, this 1909 mural appears to acknowledge the Decalogue's influence on our legal system. The Ten Commandments fill the center of the panel and serve as a backdrop for the seated female figure that symbolizes "The Law" (see pages 16 and 39).

As Blashfield accepted commissions from New York to South Dakota, he traveled within the United States for the first time. He was not impressed! In a letter to his wife from Des Moines, Iowa, he wrote, "It is not merely lack of beauty but accretion of hideousness that fairly makes you sick in American cities. It is heart-breaking. The eyes of Americans are *turned* in toward the inside of his house or store . . . and yet these prosperous, self-respecting people have appropriated and spent for the decoration of their state capitol what must seem to them a great sum. . . . I can't figure it out."[45] He often

The Fifth Minnesota Regiment at Corinth, 1912: Governor's Suite, Minnesota State Capitol, St. Paul, Minnesota. (Anne Day, photographer)

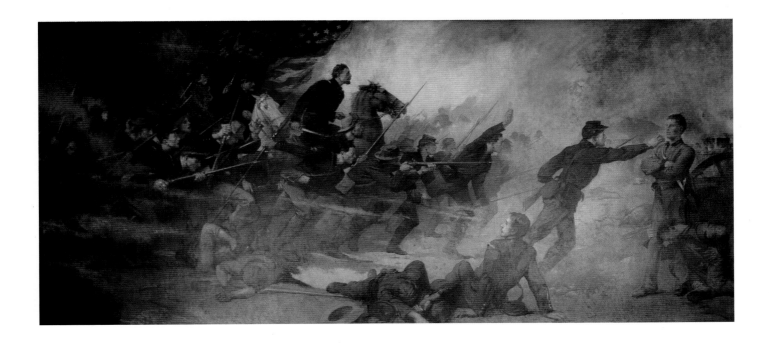

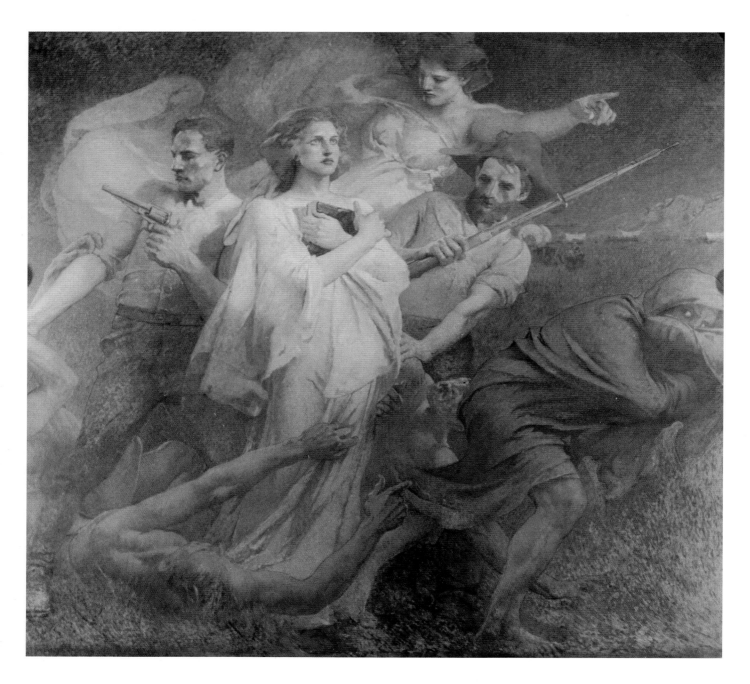

Dakota Struggling towards the Light (aka Spirit of the West), 1910: Governor's Room, South Dakota State Capitol, Pierre, South Dakota. (Photograph courtesy of the South Dakota State Historical Society–State Archives)

Currently, this mural cannot be viewed by the public. In response to an act of the South Dakota legislature and an opinion of the attorney general dated November 29, 1994, the governor had the mural covered by a false wall because it does not represent contemporary South Dakotans' attitudes toward Native Americans.

posed the rhetorical question of why we have done so much less well than Europe, and responded that Americans have never made beauty a priority.

His wife, Evangeline, shared his disappointment in the appearance of American cities. Blashfield reminisced that "All through her life, the beauty of European Cities and a comparison with our American lack of civic ordering as manifested in brick and mortar . . . [prompted an enthusiasm for civic improvement]."[46] Evangeline Blashfield became a key promoter of New York's Municipal Art Society, which was founded at a meeting of artists and architects held in their Sherwood apartment. A devotee of the City Beautiful movement and an advocate of public art and civic amenities, Evangeline remained active in that organization for many years and campaigned for projects that would "ennoble the public realm."[47] The society's motto was "To

MINA RIEUR WEINER

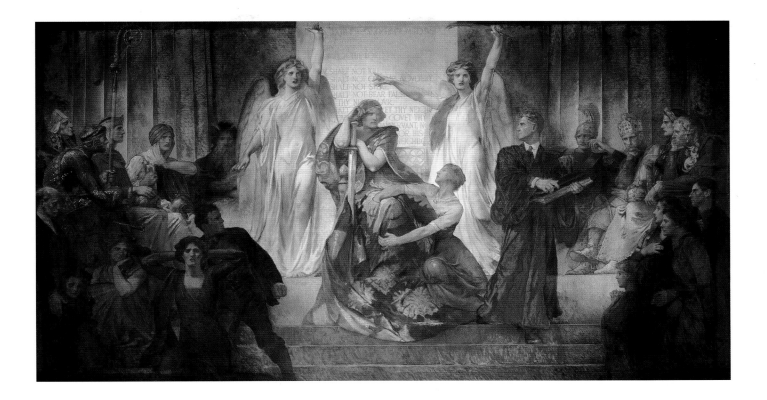

make us love our city, we must make our city lovely."[48] Led by its first president, architect Richard Morris Hunt, the society's modest plans were to collect dues with which to make a yearly purchase of a painting or a sculpture that would be presented to the city. For example, in 1918, Evangeline commissioned her husband, together with the architect Charles Stoughton, to design a fountain for the Queensboro Bridge Market, and the following year the Municipal Art Society gave the fountain to the city. The fountain's central feature is a mosaic of brilliantly colored glass depicting the allegorical figure of Abundance. Sadly, Evangeline Blashfield died before the fountain was presented to the city. (When, in 2003, the fountain was restored, it was rededicated by the Municipal Art Society in memory of Evangeline Blashfield for her contributions to the society and to the beautification of the city. The Municipal Art Society also presents an Evangeline Blashfield Award, "inspired by the woman who, in 1893 at the age of 36, rallied a group of influential architects, sculptors and artists to establish the MAS. . . . The award is bestowed annually on an individual in mid-career who has demonstrated these ideals through his or her civic activism."[49])

"A Plea for Municipal Art," Blashfield's stirring 1892 address at the first meeting of the society, expressed his abiding interest in the cultivation of beauty in the public square in general, and in New York in particular. He said, "New York, more enterprising than any other city, rich, prosperous, generous and proud, as she should be, of her greatness, is yet far behind not only Paris and London, but even tiny provincial towns of France, Italy, Germany, in the possession of an art which should dignify and illustrate the his-

The Law, 1909: Circuit courtroom mural, Howard M. Metzenbaum Courthouse, Cleveland, Ohio. (Eric Vaughn Photography)

The mural summarizes the artist's ideas about the foundation of our laws. In the center is the Decalogue framed by two angels gesturing heavenward. The Law, represented by a seated woman, is holding the sword of justice. At her left, a lawyer holds a book and argues a case. Seated are historical figures that have stood for law through the ages, including at the left Moses, Muhammad, Justinian, and the Archbishop of Canterbury—who, with others, forced King John to sign the Magna Carta in 1215—and at the right Alexander the Great, Charlemagne, Napoleon, and Lord Mansfield.

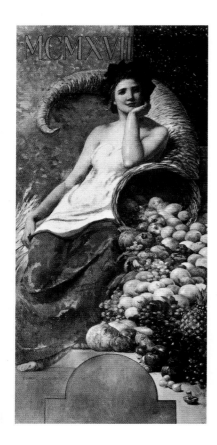

(above) Cartoon for the mosaic *Abundance*, 1918-19: Mosaic for Queensborough Bridge Market Fountain, New York City. (Peter A. Juley & Son Collection, Smithsonian American Art Museum J0045771)

(right) *Abundance*, 1919: The Evangeline Wilbour Blashfield Memorial Fountain, Queensborough Bridge Market, New York City. (Anne Day, photographer)

Evangeline Wilbour Blashfield, a champion of public art, founding member and first woman board member of the Municipal Arts Society, urged the construction of the fountain that would supply market vendors with water. The mosaic centerpiece figure designed by her husband represents the allegorical figure of Abundance, who leans on a cornucopia laden with the same fruits and vegetables sold in the market. Below the mosaic is a basin that fills with water flowing from the mouth of an ox head sculpted by Eli Harvey. Charles Stoughton created the architectural setting for the fountain, which was presented as a gift to the city in 1919. The fountain was restored in 2002.

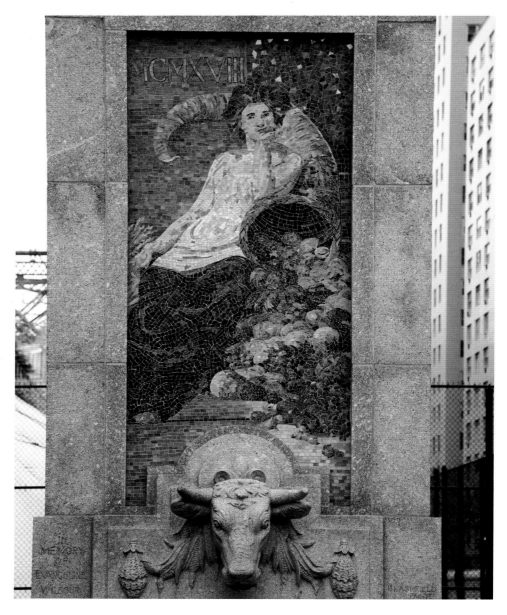

tory of her past and present. . . . The commonwealths of Athens, Florence, Venice, the free burgs of Germany, the great trading towns of Flanders, the cities which have passed through a period of natural evolution in art, considered it a national glory, and used it both as a means and as an end in a truly democratic sprit, *pro bono publico*. They believed that certain benefits arose from the cultivation of beauty, that the pleasures of private life, the dignity of public life were increased by the aid of the arts."[50]

"Blashfield had issued several ringing endorsements of municipal art, praising its democratic nature, its educational purpose, and its commercial benefits."[51] He asserted that "good national art is a good national asset,"[52] a good investment. Providing as examples places in Europe such as Athens and Perugia, where art installed in public sites had attracted countless visitors over the years, he declared that "the money brought to Italy by visitors to Michael Angelo's [*sic*] Sistine Chapel, for instance or to Titian's canvases

would build navies. The sums spent on casts, photographs, literature relating to the Venus de Milo would pay for railways."[53] "The patriot gave the country its existence and preserved it, developed its resources as farmer and merchant and defended it as soldier. The artist set up the landmarks by which the city was known; he gave it the distinctive shape which is dear to each townsman; he made the familiar skyline which told the returning traveler he was home; he gave character to the well-known streets, and set town hall, church and court-house in their places."[54]

Throughout history, patrons of the arts have provided funds for the decoration of their houses of worship. Thus it was that Blashfield was invited to participate in numerous church-related projects, such as the chancel of the Drexel Memorial in the Church of Our Saviour in Philadelphia. His most ambitious undertaking was designing the decoration behind the main altar, four pendentives, and two lunettes in the main sanctuary of the Cathedral of Saint Matthew the Apostle, a Roman Catholic Church in Washington, DC, designed by New York architect Chester Grant LaFarge in 1893. The architect, a one-time president of the Architectural League, was the son of artist John LaFarge, often called America's first muralist. (In 1876, John LaFarge had been hired by architect Henry Hobson Richardson, the designer of Trin-

Drexel Memorial semi-dome, 1906: Chancel of Church of the Saviour, Philadelphia, Pennsylvania. (Anne Day, photographer)

Painted in Sienese Trecento style, the mural features an Angel bearing the holy grail. She is flanked by groups of adoring angels, thirty-six in all.

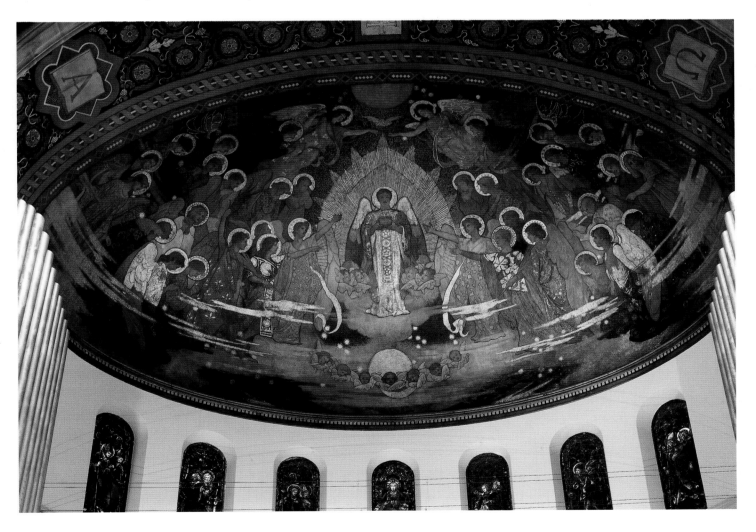

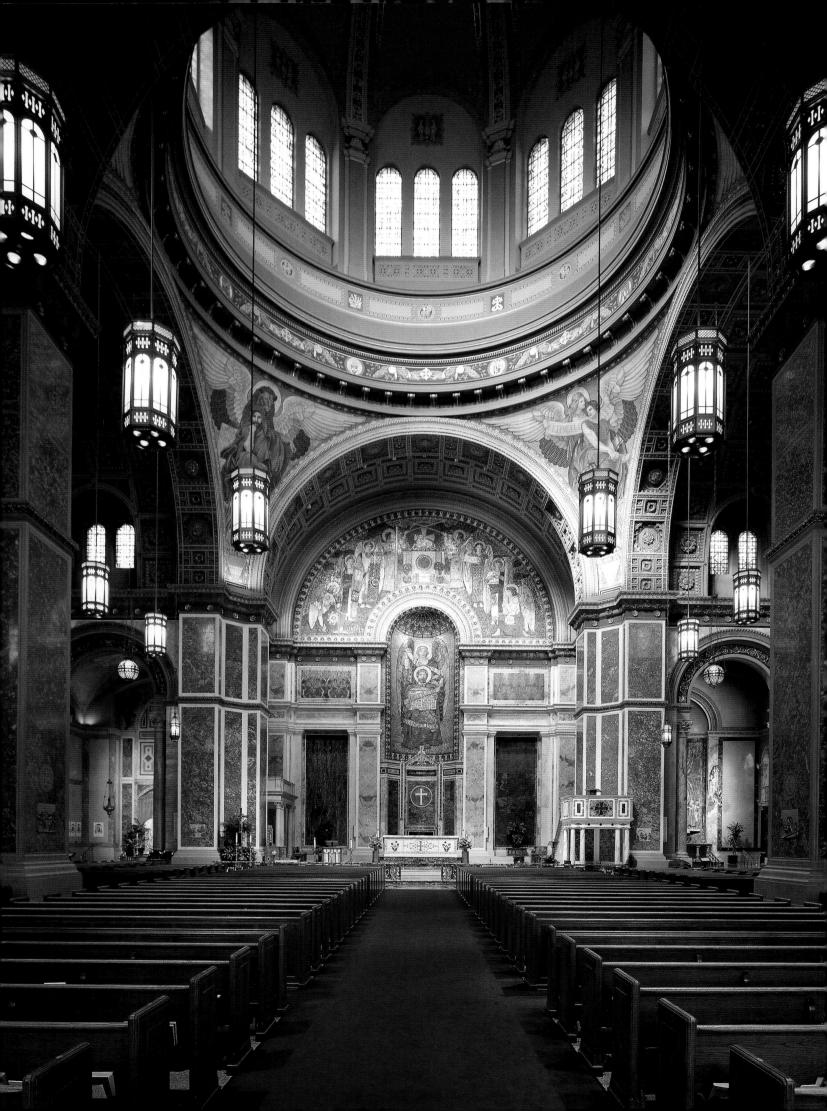

ity Church in Boston, to take charge of the interior. LaFarge's completed work covered 21,500 square feet inside that landmark building, a startling achievement that is considered the first real mural painting in America and established his reputation. Blashfield and John LaFarge had been colleagues on numerous projects including the Minnesota state capitol and the Baltimore courthouse.) The cathedral's decoration, which combines Byzantine and Romanesque architectural elements, is quintessential American Renaissance. Its beautiful narrative exemplifies the breadth of Blashfield's decorating talent and his extensive knowledge and respect for Italian Renaissance art, and demonstrates his ability to harmonize with the architect's vision and to create decorations that effectively conform to architectural details.

New civic construction and commissions for murals were not the only outgrowth of the 1893 World's Columbian Exposition. "Accompanying the

(opposite) Cathedral of Saint Matthew the Apostle, Sanctuary, Washington, DC. (Anne Day, photographer)

The Cathedral has become an important historic site in the nation's capital. Every president since Eisenhower has worshipped there. It was the site of the funeral of President John F. Kennedy, November 25, 1963, and was visited by Pope John Paul II in 1974.

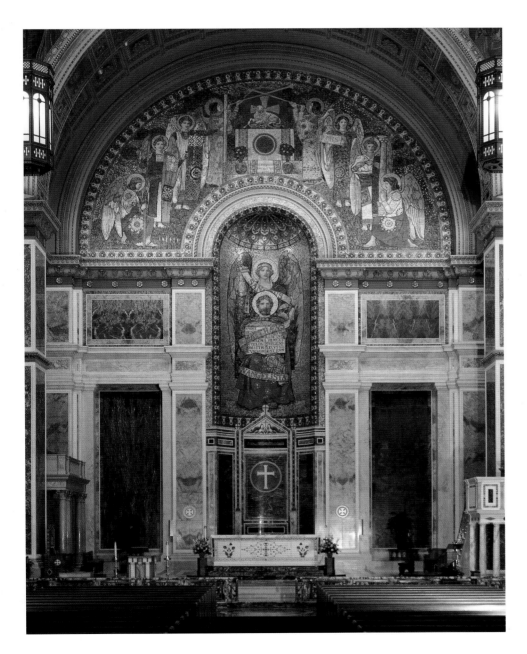

Saint Matthew and Angel; Angels of the Crucifixion, 1914–18: Mosaic and lunette above the main altar designed by Edwin H. Blashfield, Cathedral of Saint Matthew the Apostle, Washington, DC. (Anne Day, photographer)

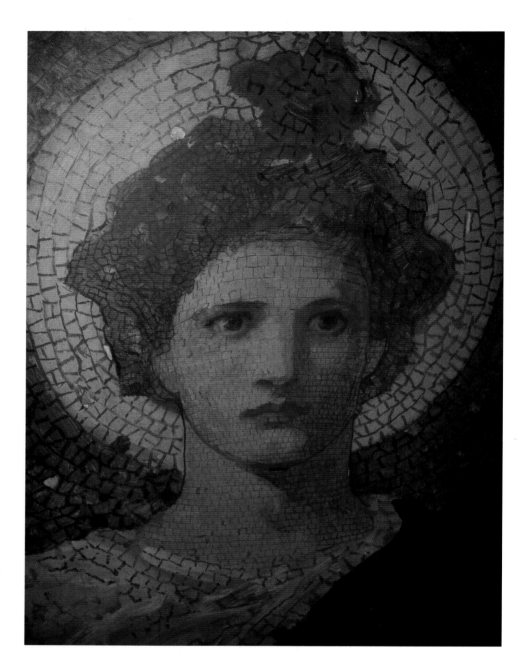

Cartoon for angel, n.d. (Hermitage Foundation, Sloane Collection, Nashville, Tennessee)

This is one of several preparatory cartoons for angels in the large lunette mosaic *Angels of the Crucifixion* that were recently rediscovered in the Hermitage Foundation, Sloane Collection.

Exposition mania was the formation of organizations and institutions that advanced the American Renaissance."[55] The president of Columbia University, Nicholas Murray Butler, provided a rationale for this flurry of organizational activity in a letter to Blashfield, "I have felt that one of our first needs is to build up among ourselves a feeling of comradeship and academic solidarity. We gain this perhaps more by social contact than by public meetings and the reading of papers."[56] The missions of these new associations varied. The study and promotion of a particular art medium was the force behind the founding of the National Sculpture Society (1893), the National Society of Mural Painters (1895), and the Society of Beaux-Arts Architects (1916); a dedication to advancing all the arts was the purpose of the Fine Arts Federation of New York (1897) and the American Federation of the Arts (1909); while the promotion of civic art was the motivation for establishing the

MINA RIEUR WEINER

Municipal Art Society of New York (1893). Although the societies often had national ambitions, most of the members were New Yorkers who already belonged to some arts-related groups like the National Academy of Design (established in 1825 and one of the oldest arts organizations in the country) and clubs like the Century Association, founded in 1869 by painters Asher Durand, John Kensett, and others, and The Players, a "gentlemen's club" founded in 1888. Counterpart associations sprang up in other cities. "Likewise, the American Academy in Rome was first established [1894] to expose distinguished student architects to the antique models from which the 'White City's' architecture had been derived. Later a sculpture and painting section complemented that of architecture."[57]

While New York was the port of entry for many immigrants and was an increasingly diverse city, its early twentieth-century art establishment represented a small, closed, well-connected, white, genteel clique of men who belonged to the same clubs, entertained each other in the city and at their summer houses, and praised each other's work. They generally opposed the granting of commissions based on competition—although that might have opened doors to newcomers. In addition to obvious self-serving reasons, Blashfield and most of the others embraced the concern that even a dazzling application would not necessarily result in a successful final product. As long as this tight New York network of primarily Beaux-Arts adherents remained unchallenged, they influenced the design of most civic projects in New York and beyond. New York–based architecture firms were sought across the country. They in turn selected artists from a limited list, primarily New Yorkers with whom they had either worked or socialized, to collaborate on their buildings. Occasionally an out-of-state sponsor would insist that local artists be hired, but more often it was accepted that the experienced New York contingent was the best. Blashfield commented, "New York . . . [had] become both a magnet and distributing station [for artists.]"[58]

Membership in most of the arts organizations was limited and required sponsorship. While some arts groups had come into being earlier, these new affiliations appeared to fill a void where there had been little or no American standard. With the exception of the American Academy in Rome, most of the newer organizations represented a break with the previous generation's preference for European study and sought to establish studios, salon-style competitions, and exhibitions in the United States. Blashfield described this movement in an undated address on the state of the arts in New York: "In the last ten years, the wave of enthusiasm for the arts has been rolling up with gathering volume and impetus, bearing upon it those institutions which are its concrete symbols and so many guarantees of its power for fertilizing good—the National Academy of Design, the Metropolitan Museum of Art, the Municipal Art Commission, the School Art League. The Academy in which artists learn to create and where painters, sculptors, architects gather together in friendly rivalry . . . all these are *New York's own*."[59]

Blashfield was clearly a recognized leader and a spokesperson for mural painters and traditional artists. He became president of the National Society of Mural Painters in 1909, president of the Institute of Arts and Letters in 1915, and president of the Fine Arts Federation of New York in 1916. That same year he was elected a director of the prestigious American Academy of Arts and Letters. He was president of the National Academy of Design from 1920 to 1926, was a lay member of the National Sculpture Society and the Architectural League, and was an ardent supporter of the American Academy in Rome. His memberships included several other arts-related organizations such as the Society of American Artists and private clubs such as the Century Association.

Blashfield's stewardship went beyond the boundaries of New York City. He was appointed by President Taft in 1912 and reappointed by President Wilson to the National Commission of Fine Arts in Washington, DC. Composed of seven well-qualified judges of fine arts, the commission had been established by an Act of Congress in 1910 to advise the president, Congress, and heads of departments on matters of design and aesthetics in the nation's capital.[60] During World War I Blashfield served in the Division for Pictorial Publicity of the Committee of Public Information, a consortium of artists who created propaganda posters for the government. In 1921 he was invited to join the National Gallery of Art Commission that was to consider how to increase the collections and usefulness of the National Gallery.

Blashfield was astute in the business of art and carried on a voluminous correspondence promoting himself, his ideas, his organizations, and his peers. He kept a detailed list of important letters received during the period from 1886 to 1919. This handwritten inventory and the letters on file at The New-York Historical Society provide valuable clues to all the connecting links of his relationships in New York and elsewhere, and the manner in which he nurtured a wide circle of acquaintances in many fields. His extensive correspondence with contemporary artists is evidence of his generous yet formal relationships. For example, a 1932 letter from Vincent Aderente, an assistant for more than three decades, most recently for a 1930 mural at MIT, reveals that Aderente continued to address him deferentially as "Mr. Blashfield" when thanking him for attending his recent exhibition.[61] A selection of names from the impressive correspondents list represents many of the recognized talents of his day: painters Cecilia Beaux, Sadakichi Hartmann, Childe Hassam, John LaFarge, Will Low, Francis D. Millet, and Violet Oakley; illustrators J. C. Leyendecker and Howard Pyle; sculptors Daniel Chester French, Malvina Hoffman, Paul Manship, and John Quincy Adams Ward; architects Arnold Brunner and Cass Gilbert; art critics Bernard Berenson, Royal Cortissoz, and Charles DeKay; art patrons A. E. Gallatin and Isabella Stewart Gardner; lawyer Elihu Root; novelist and interior design authority Edith Wharton; university president Nicholas Murray Butler; and actress Ellen Terry.

MINA RIEUR WEINER

Blashfield wrote articles and made speeches about mural painting, about the state of the arts, or in praise of one of his peers. His papers reveal a meticulous, urbane, disciplined intellectual who could spend as much time honing a speech as perfecting a painting; a man who maintained high standards for himself and for his colleagues. After attending an exhibition or learning of an honor awarded, Blashfield would write a thoughtful note of congratulations. Kenyon Cox, responding to one of his complimentary letters, wrote, "From no one else have I so often received encouragement, either in my proper work as an artist or in my attempts at criticism, as from yourself. As a painter and a writer you know the difficulties of both arts, and your unfailing sympathy with my aims and appreciation of my efforts has been a frequent help when I most needed it."[62] We learn from these letters that Blashfield was held in great esteem by his peers as they sought his advice and often indicated how honored they were to receive compliments from him. Edwin Abbey asked, "Can you from the depths of your vast experience recommend a man or some men—capable of sticking up four lunettes—(22 ft x 38 ft)—and some round things—(4 ft in diameter)—the latter slightly convex—(6 in. in the centre—) I don't know whether this last detail offers difficulties—so slight a depression should not offer many—However, I don't know—I am asking! . . ."[63] Gari Melchers thanked Blashfield for his help with the proportions in a mural and said that he would adopt his suggestions about taping paper to the wall to test the scale of figures.[64]

In 1912, Blashfield presented the Scammon lectures at the Chicago Art Institute based on his view that traditional training was essential to the mastery of the complex art form of mural painting. These talks, enlarged by Blashfield and published in 1913 by Scribner's in the book *Mural Painting in America*, synthesized Blashfield's highly cultivated personal experiences and oft-repeated opinions. In addition to explaining his passion for the past, he outlined a plan for the dissemination of beauty, history, patriotism, and universal truths through the installation of murals in public buildings in this country.

Despite his generally optimistic overview of the influential role of decorative art in a developing American culture, Blashfield, a rigid proponent of the disciplined study of drawing and nature in the classic tradition, expressed concerns about the challenges ahead. He anticipated that the emerging multiplicity of methods would shake artistic consciousness, and he feared that art students, overwhelmed by many so-called movements, might not seek proper training. Jeff Greene's chapter on Blashfield's legacy expands on some of the themes found in this important book about mural painting in America.

To the end of his long life, Blashfield remained committed to his style of artistic endeavor. He campaigned, both in his art and in organizations, to promote the understanding and acceptance of traditional discipline and classically inspired art as allied to architecture. His large circle of like-minded

artists and their conservative arts groups reinforced his view that classical technique and subject matter were the correct basis of all painting and sculpture in America. His advocacy is best summarized in a letter from architect Cass Gilbert, who succeeded him as president of the National Academy of Design: "We have each in our own way kept up the good fight for a good cause and I know that the influence which *you* especially have had upon the Fine Arts has been of the most important character for everything that is right and fine and beautiful. . . ."[65]

At the same time, pre–World War I New York City was fast becoming a center for introducing new trends in art. From 1905 to 1917, photographer Alfred Stieglitz and painter/photographer Edward Steichen ran the Little Gallery of the Photo-Secession at 291 Fifth Avenue, which became known as "291." The word "secession" signified a rebellion against the cultural status quo and the conventional art represented by Blashfield. The gallery showcased European and American vanguard artists, including cubist Max Weber and anti-realists Arthur Dove and Marsden Hartley. In 1908, a group of eight artists, a few of whom were members of the National Academy of Design, were led by artist and gifted teacher Robert Henri to mount their own independent, nonjuried art show exhibiting a variety of styles and subjects that disregarded rules of academic correctness. Among the works of "The Eight" was a search for truth rather than beauty, their realistic cityscapes evoking images of the seedier side of urban life.

Ironically, the greatest challenge to the entrenched establishment occurred in 1913, the year of the publication of Blashfield's book *Mural Painting in America*. The First International Exhibition of Modern Art in America opened in New York and showcased the work of more than three hundred European and American artists. It presented a survey of modern art from the early nineteenth century—including the art of Eugène Delacroix and Jean Auguste Dominique Ingres—to the twentieth century, culminating in Picasso and the cubist revolution. Better known as the Armory Show, the exhibition alienated tradition-bound artists and audiences. Just as the Columbian Exposition launched the popularity of Beaux-Arts–style art and architecture, the Armory Show galvanized the acceptance of modern stylistic differences and began a revolution in New York's art making. New galleries representing a variety of artists and styles were established and led a developing art market to consider and appreciate nontraditional artistic styles commensurate with contemporary thought.

Blashfield responded to the Armory Show in an article in the *Century* of April 1914, entitled "The Painting of To-Day." He wrote, "The works shown last season at the Armory were not homogeneous; indeed were sometimes opposed as to qualities. Many of them seemed to have virtually no relation to art; others seemed beautiful . . . in the example of certain 'advanced' Frenchmen who exhibited at the armory, there may be an influence nothing short of deplorable; a license to omit painstaking care, coherent thinking, an incite-

ment to violence as compelling attention. . . . I believe that the new move-ment [has] potential for great good in its concentration on color and light, its development through experiment of effects produced by broken color and the novel manipulation of material. But there is no excuse whatever for other tendencies which occasionally seem to accompany the new movement that [are] dangerous. . . . Once the experiments [are] made, the best effects of color and light found, there is no reason why the vigor and freshness should not be applied to correct proportion, correct forms and correct values."[66]

The predominance of Blashfield and his ilk ended with World War I. While New York City construction had been stilled by the hostilities, it began anew after the war and produced higher, sleeker buildings. Symbolic of the new trend was William Van Alen's Chrysler Building (1928–30), an Art Deco masterpiece that celebrated the increasing popularity of the automobile by incorporating an architectural simulation of overlapping hubcaps on its tower. In some neighborhoods, luxurious private homes, a few containing Blashfield's murals, were destroyed to make way for apartment houses and commercial buildings. Members of the arts establishment who had partici-pated in the first significant American mural movement, and brought Beaux-Arts training and the integration of painting and sculpture with architecture to the forefront, were aging. In his final address as president of the National Academy of Design, Blashfield recalled those members who had passed away and said that "Academicians die but the Academy lives and will live,"[67] ignoring the fact that the academic approach to art and architecture was being marginalized. The postwar release of energy and change during the Roaring Twenties challenged and confounded the classicists. Their style of buildings and murals was now considered old-fashioned and inappropriate for the dynamic, new, modern America.

Stylistic diversity abounded, reflecting changing attitudes toward what constituted art. A number of American artists who returned from European study immediately before the war were not like the previous generation who had served as acolytes of the academies there, but were proponents of the avant-garde and the depiction of ideas, thoughts, and concepts, not just nar-ratives. Likewise, a number of European modernists who had escaped the war and settled in New York furthered the acceptance of post-impressionism, abstraction, constructivism, futurism, dada, and other forms of artistic expres-sion by increasingly receptive audiences.

Near the end of his life, Blashfield witnessed the installation of public art that did not adhere to his ideas of beauty, harmony, and universal truths. As an institution builder, Blashfield composed mural subjects that had consis-tently affirmed the importance and ideals of the institutions in which they were installed, and he was willing to modify details in his murals to please his patrons. His commitment to murals that expressed positive, optimistic images of institutions and history was antithetical to the newer projects com-missioned by the government under the Works Progress Administration

The Graduate, 1908: Great Hall lunette, City College/City University of New York, New York City. (Anne Day, photographer)

The Graduate is depicted receiving his diploma from a figure symbolizing Alma Mater. They are surrounded by personifications of the Universities of Alexandria, Rome, Córdoba, Bologna, Athens, Uppsala, Leyden, Paris, Heidelberg, and Oxford and joined by figures of well-known scholars in the arts and sciences. Presiding over all is the gigantic figure of Wisdom, who holds the earth in her lap.

(WPA) in the 1930s. Some of the WPA muralists found their inspiration in the compositions of contemporary Mexican social realists Diego Rivera, José Clemente Orozco, David Alfaro Siqueiros, and others. Their paintings generally interpreted political and social realities, especially the excesses of the 1920s and the desperate economic and social conditions resulting from the Great Depression. Urban-scene painters who documented the high and low life of the city, and regionalists such as Thomas Hart Benton, who illustrated life among the Midwestern farmers and others far removed from urban centers, were also gaining popularity. Blashfield wrote, "There has been a government movement (undoubtedly sincere) which is said to be not 'Relief' but acquisition of first rate American Art for American public buildings. Unless there is more reconciliation between so called new ideas and fundamental procedure, I fear it will be long before adequate execution can be had in adequate quantity."[68] "In Washington last week I saw a gallery, beautiful with the work of artists painting between 1870 and 1914—on the other side of the partition were scenes of projects for mural panels and quite new.

I was *bewildered* by the chasm which existed between the two kinds of work—not that the young men lacked talent & lots of talent there is in them no doubt, but oh so misdirected. . . . They had flung away drawing—color, composition—discipline in a word. . . . I am not for destroying modernism— one can't destroy it—but I'm for getting back our invaluable baggage, and the heads full of technique and tradition."[69]

Today, nearly a century later, there is a renewed interest in Beaux-Arts buildings and decorative interiors of the American Renaissance. Numerous individuals and organizations, including the Municipal Art Society of New York, are dedicated to restoring and preserving them. Likewise, the Institute of Classical Architecture & Classical America is examining anew how their underlying pedagogy can enhance contemporary practice.

Many of Blashfield's murals continue to bestow harmony and dignity on numerous public spaces. His paean to New York, the city that nurtured his talents and his leadership, remains accessible in the magnificent monumental mural *The Graduate*, which dominates the Great Hall of the City College of the City University of New York. Using a classical vocabulary and larger-than-life figures personifying Wisdom and Alma Mater, Blashfield celebrates City College as a center of culture with standing among the great universities of the world, and he depicts its symbolic graduate preparing to join illustrious representatives of the arts and sciences, past and present.

Blashfield closed his New York studio in 1933 and retired with his second wife, Grace Hall, to his summer home on Cape Cod in Massachusetts where he died in 1936. While Blashfield's oeuvre illustrates a traditional

Edwin Howland Blashfield and his wife in his studio, c. 1932–33. (Archival photograph: Peter A. Juley & Son Collection, Smithsonian American Art Museum)

Blashfield and his second wife, Grace Hall, are seated in his cavernous studio in front of four of his most well-known easel paintings. From left to right are *Christmas Bells* (1890), now in the collection of the Brooklyn Museum; *Angel with the Flaming Sword* (1891), now in the Church of the Ascension in New York City; *Portrait of Evangeline Blashfield* (1889), now in private hands; and *Fuga* (1932), now in the collection of the National Academy of Design.

European-influenced era in art, his high-minded, disciplined, and hard-working ethic and his dedication to beauty and classical ideals remain important elements in the cultural dialogue, and are relevant lessons for the twenty-first century. His extensive legacy and a selection of muralists who may be considered his artistic descendants are considered in greater detail in this book's final chapter.

NOTES

1. Anne Lee, "Our Dean of Mural Painters Toils On," *New York Times Magazine,* December 9, 1928.
2. Edwin Howland Blashfield Papers, The New-York Historical Society. Draft of a speech given at the American Academy in Rome, 1933.
3. DeWitt McClellan Lockman Interviews and Biographical Sketches, Archives of American Art, Smithsonian Institution, microfilm roll 503, Blashfield interview, p. 17.
4. Ibid.
5. Edwin H. Blashfield Papers, Archives of American Art, Smithsonian Institution, microfilm roll 1117, frame 86.
6. Ibid.
7. Edwin H. Blashfield, "An Open Letter," *Century illustrated monthly magazine,* February 3, 1889, p. 635.
8. Edwin Howland Blashfield Papers, The New-York Historical Society.
9. Edwin H. Blashfield, *Mural Painting in America* (New York: Charles Scribner's Sons, 1913), p. 227.
10. Ibid, p. 18.
11. Pauline King, *American Mural Painting. A study of the important decorations by distinguished artists in the United States* (Boston: Noyes, Platt & Company, 1902), p. 146.
12. Edwin Howland Blashfield Papers, The New-York Historical Society, Box 6, folder 5. Biography of Evangeline Wilbour Blashfield, undated. The file includes numerous, almost identical versions of a draft essay about his wife of thirty-eight years written after her death on November 15, 1918.
13. Ibid.
14. *The American Renaissance 1876–1917.* Catalogue for an exhibition at the Brooklyn Museum, 1979, distributed by Pantheon Books, p. 11.
15. Ibid.
16. Ibid.
17. Blashfield, *Mural Painting in America,* p. 176.
18. Ibid., pp. 180–81.
19. Ibid., p. 23.
20. *American Renaissance 1876–1917,* p. 68.
21. "Daniel H. Burnham on the Chicago World's Fair, 1893: An Interview with the late Daniel H. Burnham," *Architectural Record,* January 1913.
22. Ibid.
23. Ibid.
24. Louis Sullivan, *The Autobiography of an Idea* (New York: Press of the American Institute of Architects, 1924), pp. 324–25.
25. Kirsten Shaffer, *Daniel H. Burnham: Visionary Architect and Planner* (New York: Rizzoli, 2003), pp. 68–71.
26. *The American Renaissance, 1876–1917,* p. 68.
27. Edwin H. Blashfield, "A Painter's Reminiscences of a World's Fair," *New York Times Magazine,* March 18, 1923, p. 13. This article was taken from his speech before the Society of Mural Painters when he was honored on March 6, 1923.
28. Ibid.
29. Edwin Howland Blashfield Papers, The New-York Historical Society.
30. Blashfield, "A Painter's Reminiscences of a World's Fair."
31. Derrick R. Cartwright, "J. Alden Weir's Allegorical Figure of 'Goldsmith's Art' for the Dome of the Manufactures and Liberal Arts Building, 1892," *University of Michigan Museums of Art and Archaeology Bulletin,* vol. IX, , p. 64.

32. Blashfield, "A Painter's Reminiscences of a World's Fair."

33. Lee, "Our Dean of Mural Painters Toils On."

34. Blashfield, "A Painter's Reminiscences of a World's Fair."

35. Edwin Howland Blashfield Papers, The New-York Historical Society. Draft of a speech given at the American Academy in Rome, 1933.

36. Blashfield, *Mural Painting in America,* p. 261.

37. Bailey Van Hook, "From the Lyrical to the Epic: Images of Women in American Murals at the Turn of the Century," *Winterthur Portfolio*, vol. 26, no. 1 (Spring 1991), p. 65.

38. Bailey Van Hook, *The Virgin & the Dynamo* (Athens, Ohio: Ohio University Press, 2003), p. 27.

39. DeWitt McClellan Lockman Interviews and Biographical Sketches, p. 49.

40. Van Hook, "From the Lyrical to the Epic," p. 64.

41. Ibid., p. 65.

42. Ibid., p. 70.

43. Anne E. Samuel, "Blashfield's Washington Surrendering His Commission: A Colonial Revival *Sacre Conversazione*." paper presented at The Colonial Revival in America Conference, Charlottesville, Va., November 2000, p. 1.

44. Blog by P. P. dated October 18, 2007, on the South Dakota War College Web site: "If we cover it, does it exist? The Mural that South Dakota Hides," www.dakotawarcollege.com/?p=3024.

45. Edwin Howland Blashfield Papers, The New-York Historical Society. Box 5, folder 1, Travels to American cities. Penciled letter to "Dear Bun," March 5, 1910, p. 11.

46. Edwin Howland Blashfield Papers, The New-York Historical Society. Box 6, folder 5, Biography of Evangeline Wilbour Blashfield, undated.

47. Municipal Art Society of New York Web site, www.mas.org. About us: MAS awards, 2006 Blashfield Award http://mas.org/2006-blashfield-award-presented.

48. Municipal Art Society of New York Web site, www.mas.org. "A History of the Municipal Art Society of New York," 1893.

49. Municipal Art Society of New York, 2006 Blashfield award presented.

50. King, *American Mural Paintings*, pp. 145–46.

51. Van Hook, *The Virgin & the Dynamo*, p. 43.

52. DeWitt McClellan Lockman Interviews and Biographical Sketches, p. 30.

53. Brochure of the Mural Painters, A National Society: The Society, 1916.

54. Blashfield, *Mural Painting in America,* p. 309–10.

55. *The American Renaissance 1876–1917*, p. 68.

56. Letter from Nicholas Murray Butler to Dear Mr. Blashfield, November 13, 1916. Edwin Howland Blashfield correspondence, Nicholas M. Butler file, The New-York Historical Society.

57. Leonard Amico, *The Mural Decoration of Edwin Howland Blashfield*. Catalogue for an exhibition at the Sterling and Francis Clark Art Institute, Williamstown, Mass., April 1–May 7, 1978, p. 5.

58. Edwin H. Blashfield papers, The New-York Historical Society.

59. Ibid.

60. National Commission of Fine Arts Web site: www.cfa.gov/about.

61. Letter from Vincent Aderente, May 9, 1932. Edwin Howland Blashfield correspondence, Vincent Aderente file, The New-York Historical Society.

62. Letter from Kenyon Cox, March 30, 1907. Edwin Howland Blashfield correspondence, Kenyon Cox file, The New-York Historical Society.

63. Letter from Edwin Abbey, February 18, 1908. Edwin Howland Blashfield correspondence, Edwin Abbey file, The New-York Historical Society.

64. Letter from Gari Melchers, February 2, 1921. Edwin Howland Blashfield correspondence, Gari Melchers file, The New-York Historical Society.

65. Letter from Cass Gilbert, February 2, 1931. Edwin Howland Blashfield correspondence, Cass Gilbert file, The New-York Historical Society.

66. Edwin Howland Blashfield, "The Painting of To-Day," *Century illustrated monthly magazine*, April 1914, pp. 837–40.

67. Eliot Clark, *History of the National Academy of Design, 1825–1953* (New York: Columbia University Press, 1954), p. 209.

68. Edwin Howland Blashfield papers, The New-York Historical Society, Letter to Mr. Poore, November 29, 1935.

69. Ibid. Mr. Poore is probably the artist and critic Henry Rankin Poore (1859–1940).

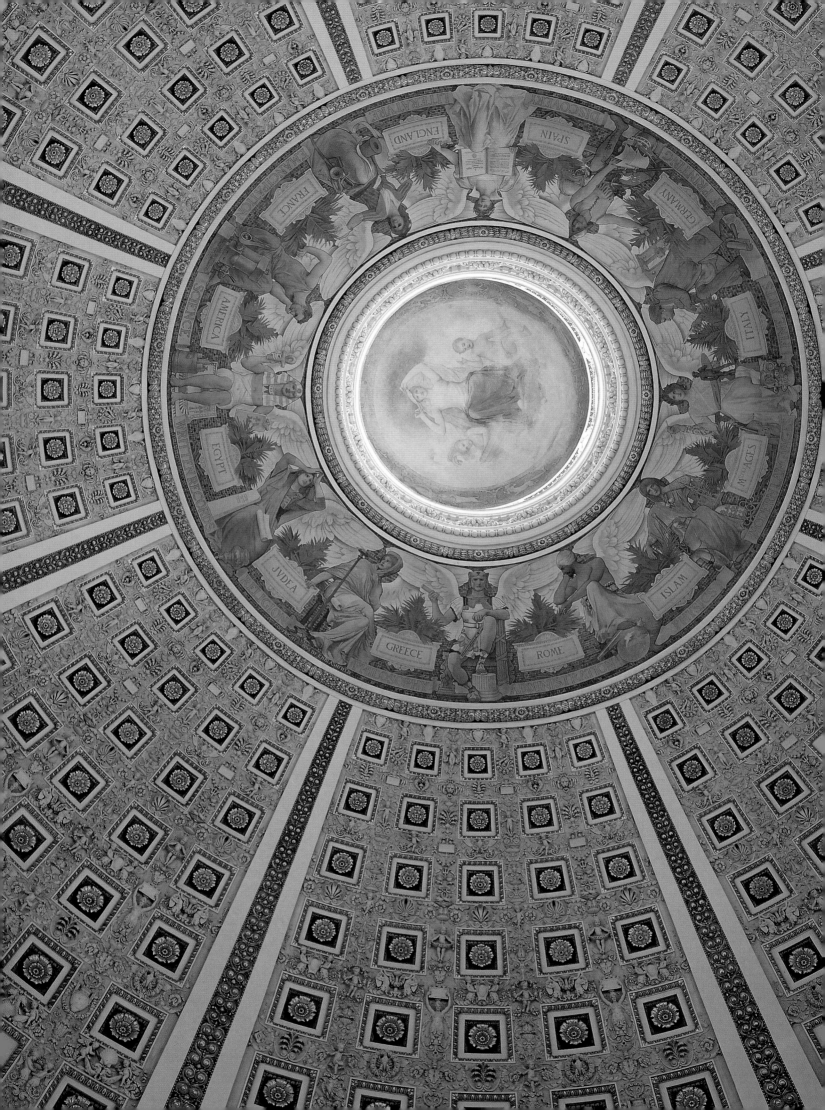

2

Mural Painting for America: The Artistic Production of Edwin Howland Blashfield

ANNE E. SAMUEL

Every civilization of the past has turned to the fine arts to make a nobler setting for its daily life.[1]

Attendees of the annual meeting of The Mural Painters in 1910, listening to Edwin Howland Blashfield's address, heard from one of America's leading muralists that their art form "is an *immensely* difficult branch of art." Along with "all the ordinary difficulties of drawing, color, composition inherent to every sort of art," muralists must realize that "modelling must be treated in just such a way or it won't carry, the color is absolutely governed by incidental conditions of lighting, the composition must be composition not only of a few or many figures, but of a whole room." In addition to aesthetic properties, murals for public buildings require "significance, meaning. 'Pure color unspoiled by meaning' will not go down with the public."[2] With visual requirements imposed by architectural context and expectations for content formed by mural patrons, mural painting, in Blashfield's words, is "rooted even upon and in *Sacrifice*."[3]

Blashfield is chiefly remembered as a muralist who consistently correlated his works with their architectural context and promoted collaboration and "mutuality" between muralist, architect, decorator, and patron. However, he spent a quarter-century as an easel painter and illustrator before painting his first public mural for the World's Columbian Exposition in 1893.

As Mina Weiner's chapter describes, Blashfield studied art formally in Paris with Léon Bonnat and often received guidance from Jean-Leon Gérôme. Blashfield admired Bonnat's vigorous, robust application of thick paint, and he was surprised when his teacher advised him to study the com-

(opposite) Evolution of Civilization, dome collar, *Human Understanding,* oculus, 1895-96: Thomas Jefferson Building of the Library of Congress, Washington, DC. (Anne Day, photographer)

Beginning with Egypt and viewed counterclockwise, the twelve figures in the dome collar represent Egypt, signifying written records; Judea: religion, Greece: philosophy; Rome: administration; Islam: physics, Middle Ages: modern languages; Italy: fine arts; Germany: printing; Spain: discovery; England: literature; France: emancipation; America: science.

paratively thin painting of Jean Auguste Dominique Ingres.[4] Bonnat's lessons were more general than a particular application of paint:

> Construction and values, values and construction, how often did the student hear those mysterious words, until he learned that, with the addition of color, these made up a formula which, if properly followed in an art work, meant life. Breadth and simplicity were fundamental doctrines with the master, and there was constant iteration of the order "half close your eyes," that the pupil might see planes of light and shadow more broadly.[5]

The easel paintings Blashfield created in the 1860s and 1870s are indebted to Gérôme's style, subjects, and emphasis on historic specificity, but as Blashfield began painting more decorative canvases in the 1880s, with larger-scale figures and simpler subjects, the influence from Bonnat became more evident.

Blashfield's Salon entry of 1878, *The Emperor Commodus Leaving the Arena at the Head of the Gladiators*, is representative of many of his works of the 1870s, with a subject drawn from ancient history, and balanced attention given to the figures, objects, and architectural setting. In handwritten notes, he acknowledged his mentor, saying, "Probably my admiration for Gérôme led me to try to paint ancient Romans."[6] A decade later, it was described as the painting that "secured him his first real recognition. . . . It stamped him as a painter of strong technique and admirable color, and as a student and an intellectual creator of the first order."[7] *Commodus* was ambitious both in its size of 9 feet by 5 feet and in its subject, with numerous gladiators and spec-

The Emperor Commodus Leaving the Arena at the Head of the Gladiators, 1878: Oil on canvas, 44 x 91 inches, Hermitage Foundation, Sloane Collection, Nashville, Tennessee. (Hermitage Foundation)

This oversized painting, Blashfield's entry in the Paris Salon of 1878, was among the first to introduce his talents to the public.

ANNE E. SAMUEL

tators. The massive architecture of the coliseum brings order to the aftermath of the barbaric entertainment and highlights Commodus, who stands before an unadorned wall, in a pool of light at the center of the procession.

Press accounts of the painting identified Blashfield as a student of both Bonnat and Gérôme but drew stylistic comparisons only with the latter. "[C]lever painting on these helmets and basnets, targes and tridents, breech-clouts and buskins, as well as a most commendable knowledge of archaeol-ogy" served as evidence that Blashfield, like Gérôme, closely studied period costumes and objects.[8] Student-teacher relationships were not noted by critic Edward Strahan, but *Commodus* was described as "a crowded amphitheatre-scene in the manner of Gérôme's anecdote pictures—the dif-ference being that Gérôme's anecdotes are typical and define a civilization, while Blashfield's was not worth the telling."[9]

Comparison to the French master didn't assure unstinting praise, as related strengths and weaknesses are identified in *Commodus* and in Gérôme's works: "The picture is simply Gérôme carried out by his disciple. We find the same passion for the archaeologically exact, for a variety of grotesque arms, and for a semi-historical style, or, to speak more closely, for the genre style aim-ing to be historical. Gérôme's strength is here in Gérôme's pupil, and Gérôme's weakness is here too. The figures of Commodus and his half-naked men are weakest in their flesh textures—just where Gérôme fails."[10] Despite flawed handling of the flesh, Blashfield's academic study of the human form was noted: "The Emperor and his attendant gladiators are modern-looking men, evidently studied at great pains and care from living models."[11]

Blashfield's paintings of the 1880s would further develop the "genre style aiming to be historical" noted in *Commodus*, fusing historic settings and sub-jects with gestures and informal interactions observed from modern models. According to C. M. Hilliard, writing in 1880, Blashfield "paints Roman scenes exclusively, and shows wonderful talent in depicting the luxurious life of the Caesarian epoch." Such paintings addressed more pleasurable and decorative subjects than *Commodus*; for example, in *The Music Lesson* (exhibited 1880), "the classical draperies, exquisite tones, the background, interior of a court, broad-leaved foliage, fountains, and rare marbles, are ren-dered with the true poetic sentiment necessary to the subject, and at the same time one feels that these personages have really existed, with such life-like power do they appeal to us after so many centuries."[12] An ideal young woman in classical garb sits in the foreground, posed in profile and playing a flute. Though her portrayal is relatively conventional, the three toddlers at her feet, holding their flutes and looking attentively at their teacher, present a range of types. The lean nude boy, the plump partially clothed child with a topknot, and the demure child in the background, almost entirely covered in blue and white, are a visual counterpart to Blashfield's frequent descriptions of picturesque children in his letters to his mother and his proclamation that "I want to paint every one of them."[13] The historic dress of the foreground

The Music Lesson, Paris, 1880: Private collection. (Photograph courtesy of private collector)

and background figures and the classical architectural setting, combined with the intimate, anecdotal portrayal of the young flute students, suggests that childhood behaviors and types are timeless.

The juxtaposition of carefully observed architectural and historic details with informal activities and interpersonal interactions in *The Music Lesson* translated successfully to Blashfield's illustrations for books and, most notably, magazine articles coauthored with his wife, Evangeline Wilbour Blashfield. In ten articles published primarily in *Scribner's Magazine* between 1887 and 1896, they integrated historical information and anecdotal observation based on recent travel to bring the past to life in France, Italy, and Egypt. *On the Ramparts*, a grisaille painting created for illustration in the Blashfields' 1889 article "Castle Life in the Middle Ages," supports the text's emphasis on the architectural evolution of European castles and the

ANNE E. SAMUEL

On the Ramparts, 1888: Oil on canvas (grisaille), 12⅛ x 20⅛ inches, Delaware Art Museum, Gift of Helen Farr Sloan, 1981. (Photograph: Delaware Art Museum)

accommodations and protection they offered. A group of women and girls stroll along the ramparts of an unnamed castle, as an armored archer in the background protects them from an elevated position. Much like the picturesque groups of local citizens that figure prominently in his murals, the variation in costume suggests a range of social classes in the group, from the relatively simply dressed figures in the background, just exiting the tower, to the contemplative woman in a conical hat and the more animated woman to her right, dressed in intricate brocade. A somber little girl in the foreground cradles a doll in a miniaturized conical hat, implying that the girl is fated to follow the path of the woman behind her.

The broad distribution of illustrated magazines may have buttressed Blashfield's artistic reputation with future patrons. The late nineteenth-century practice of magazines and newspapers publicizing one another's cur-

rent articles and illustrations extended his name beyond the pages of *Scribner's*. Years later, Blashfield asserted the importance of the three major media of his artistic career, writing that "[r]ight at the side of our painters and at least abreast of them stand the American illustrators, at once virile and significant in their art. . . . To me there are few things more preposterous, or more hurtful to American art, than the imaginary line of cleavage which has been established between the illustrator and the easel painter and between them both and the mural painter."[14] Blashfield advocated for mutual respect and a sense of shared purpose among practitioners of all three arts, and at the height of his own illustration career the art form was well-regarded. In 1891, art critic C. M. Fairbanks declared that "among our notable painters in black and white are to be found artists of the first rank, in whose pictures is shown a thorough mastery of drawing and composition, and originality in a degree not always to be observed in more ambitious and pretentious works in color."[15]

Blashfield's pursuit of illustration may have been, in part, a practical decision; illustration was a viable and attractive artistic outlet when travel prevented him from undertaking Salon-scale paintings. In 1886, he explained to his editor at *Scribner's* that Evangeline's "health has so much interfered with regular work upon any large pictures that we shall have the more time for articles, & into the bargain they interest me absorbingly, when I start on them."[16] Letters written to his family in Brooklyn indicate that Evangeline and Edwin Blashfield were studious travelers, documenting and comparing picturesque city streets, local people, art, and architecture. In the late 1880s, they spent "nearly three consecutive years abroad," traveling extensively in Italy as well as in Egypt with the Wilbour family.[17] Two months spent in Broadway, Worcestershire, England, during the summer of 1886 were pivotal to Blashfield's development as an illustrator and later as a mural painter. The couple socialized with members of the intimate artists' colony, and Blashfield painted alongside Edwin Austin Abbey, Francis D. Millet, and John Singer Sargent.[18] Blashfield talked to Abbey about black-and-white drawing and "noticed that he used the most delicate lines & great complication of them & that the process seemed to render all & not lose anything." Abbey's example demonstrated that intricate details could be successfully translated to printed illustrations, prompting Blashfield to ask his *Scribner's* editor, "Do you prefer broader pen handling than in my drawings—sharper blacks & less complication of delicate lines—if so I can follow your wishes."[19] Blashfield's subsequent illustrations, including *On the Ramparts*, and other art created for reproduction, such as his design for the $50 bill in 1895 (see page 122), show increased confidence in the engraver's ability to translate fine details and gradations of tone.

Blashfield's expatriate life in the 1880s often intertwined with that of Evangeline's family, in both Paris and Egypt. The Wilbours were socially prominent among American expatriates in Europe; notably, Evangeline's father, Charles Wilbour, knew Victor Hugo and wrote a widely published

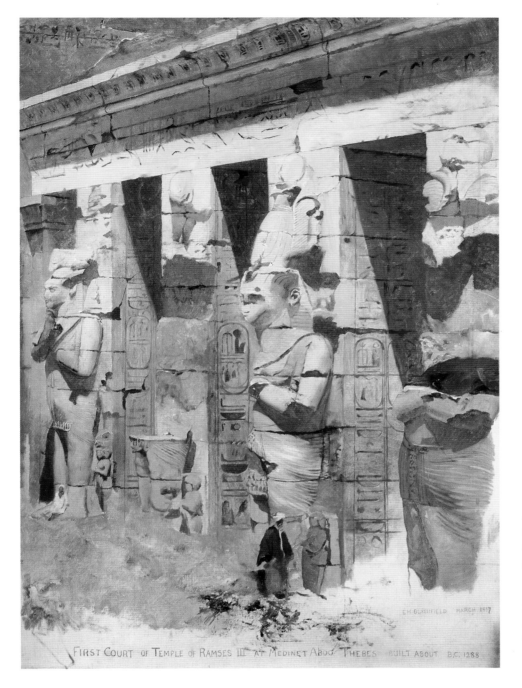

First Court of Temple of Ramses III, 1887: Oil on canvas, 35 x 25⁵/₈ inches, Chrysler Museum of Art, Norfolk, Virginia. Gift of Walter P. Chrysler Jr. 71.834. (Chrysler Museum of Art)

Blashfield accompanied lectures and articles on his Egyptian travels with paintings and sketches.

translation of *Les Miserables*.[20] Furthermore, Wilbour was a distinguished Egyptologist, remembered in the field through Wilbour Hall at Brown University and his significant contributions to the Brooklyn Museum, described in Mina Weiner's chapter. During journeys in Egypt with the Wilbours between 1886 and 1890, Blashfield industriously worked on sketches and watercolors of Egyptian subjects. On the 1886–87 *dahabiya* (houseboat) journey that yielded Blashfield's painting, *First Court of Temple of Ramses III*, Wilbour described how his family members spent their time, including his son-in-law Ned who "has work for forty-four hours a day."[21] *First Court of Temple of Ramses III* emphasizes the monumental scale of the mortuary

temple, with Egyptian men standing beside the grand columnar representations of Osiris.[22] Blashfield displayed paintings and sketches of Egyptian subjects in conjunction with lectures on Egypt, as well as at the 1889 exhibition of the Architectural League of New York. Such presentations, along with the *Scribner's* articles and subsequent publications, contributed to his reputation as a learned artist.[23]

When painting Evangeline's portrait in 1889, Blashfield integrated emblems of the family's immersion in Egyptology, including a gilded sphinx ornamenting the divan's frame and a coin serving as a clasp on her sleeve. Art historian Karen Zukowski connected these features with Charles Wilbour, and associated Evangeline's loose dress with dress reform, an important issue to

Portrait of Evangeline Blashfield, May 1889: Oil on canvas, private collection. (Photograph courtesy of Berry-Hill Galleries, New York)

This portrait won a bronze medal at the Universal Exposition in Paris, 1889, and was exhibited in Chicago at the World's Columbian Exposition of 1893.

ANNE E. SAMUEL

Evangeline's mother, Charlotte Beebe Wilbour.[24] The painting functioned both as a family portrait in the Wilbours' collection and as an important exhibition piece for Blashfield, winning a bronze medal at the Universal Exposition in Paris in 1889 and appearing again at the World's Columbian Exposition in 1893. The portrait of Evangeline also represents a significant shift in Blashfield's easel painting in the 1880s toward life-sized figures and a decorative aesthetic, elements that he would transfer to his mural paintings. Evangeline's life-sized representation on the divan gives her an insistent presence, which could potentially function as an illusionistic counterpart to real furnishings and people in the room in which it was displayed. Although complex patterns adorn her dress, the upholstery, and the carpet, these and other intricate features, such as Evangeline's jewelry and fan, are suffused with a golden tonality that unifies the painting. The simplification of the composition to a dominant figure and color, with surface details subordinate to the whole, shows that Blashfield had integrated Bonnat's lessons of "breadth and simplicity." It also exemplifies Blashfield's recommendation that a room's interior decoration be "composed as an easel picture is composed, with regard to masses, groups, color, line, and lighting. How easily can an artist fritter away and dissipate the unity of his painting by bestrewing it with objects! Instead of doing this, he gathers them into masses, and then disposes of his groups with reference to one another. He may be guided in these by consideration for line or for color. The most important he sets forth, the others fall into subordinate places."[25]

Angel with the Flaming Sword, 1890-91: Church of the Ascension, New York City. (Anne Day, photographer)

Ethereal light dominates Blashfield's single life-size figure, *Angel with the Flaming Sword,* exhibited in the Salon of 1891. The angel is presented with strict symmetry, with wings flanking the frontal view of his body and arms thrust forward, positioning the sword to emphasize the vertical axis of the painting. Light alleviates the severity of the presentation and imparts drama to the simple composition. According to a *New York Times* critic, this may have been a successful strategy for attracting attention at the Salon: "Mr. Blashfield has represented this sword as if it were molten, or at any rate red and white hot. Seen against the maroon robes and dusky background, this sword calls the attention to the picture by its startling color in a way that must be the envy of artists whose pictures have nothing in them which com-

pels the eyes of weary picture viewers to stop and examine."[26] Close examination of the details of the painting reveals stippled handling of the paint, much like the *taches* of impressionism, particularly in large masses of relatively uniform color, such as the ground plane. Blashfield would use such stippling in murals painted throughout his career, likely to prevent large areas of uniform color from assuming undue weight or prominence in his compositions.

Blashfield began studying mural painting precedents long before receiving his first public commissions. He sought permission to paint a study of Puvis de Chavannes's murals at the Panthéon in Paris in 1883, as well as the murals of Jean-Paul Laurens.[27] The resulting study of Puvis's 1877 murals of the life of Sainte Genevieve is somewhat perplexing, as it faithfully records the architectural setting, including a massive pilaster that functions as both frame and obstruction to views of murals throughout the building, yet two noncontiguous panels from Puvis's mural are shown and the fluting of the columns and pilasters is omitted in the sketch. Blashfield's departure from what could be seen in the building indicates that the canvas is a working sketch, recording artistic ideas for future reference. Later writ-

Study after Puvis de Chavannes in the Panthéon in Paris, 1880: Private collection. (Photograph courtesy of private collector)

"The most casual visitor to the Pantheon in Paris cannot fail to be impressed with what the art of the modern natural painter has gained by simplification. Here in the three panels of Puvis de Chavannes the uncontestable superiority of his method over that of all the other painters who have been called to decorate the walls of this national monument was made evident to the art world."—Notes from the Edwin Howland Blashfield Papers, The New-York Historical Society.

ANNE E. SAMUEL

ings about Puvis identify aspects of his art that Blashfield may have wished to capture in the sketch and later emulate. He praised the "repeating or re-echoing in his work the cool light-colored masonry of which the whole building was constructed," adding that American muralists achieved disappointing results when they emulated Puvis's palette without understanding its necessary relationship to the architectural setting. For example, Puvis's light palette would look washed out if it were surrounded by rich wood paneling or even darker masonry.[28] Particularly at the onset of the American Renaissance mural movement, artists enthusiastically embraced the notion, derived from Puvis, that muralists should not "paint a hole in the wall." According to this rule, painted views into landscapes or other deep illusionistic space would prove unsettling and violate the real wall's apparent structural integrity. In the Pantheon murals, Blashfield wrote that Puvis maintained the illusionistic flatness of the wall, painting "a work which clung like a tapestry to the wall, neither passing through it nor advancing from it."[29] Although the diminishing scale of background landscape features indicates illusionistic depth in both Puvis's murals and Blashfield's sketch, the decorative arrangement of areas of flat color, including correspondences of color in foreground and background, maintains the surface emphasis admired by Blashfield and other American muralists.

A scholarly project published in 1896, a translation and annotation of Giorgio Vasari's *Lives of the Artists*, likely reinforced Blashfield's familiarity with Italian Renaissance mural precedents. Edwin and Evangeline Blashfield, along with *Scientific American* editor A. A. Hopkins, surveyed recent scholarship on Italian art, annotating Vasari's accounts to identify the location and offer new insights into specific works of art. Following publication and positive reception of their edition of Vasari, the Blashfields compiled, expanded, and supplemented the articles they had written about Italian subjects for *Scribner's* into two volumes entitled *Italian Cities,* published in

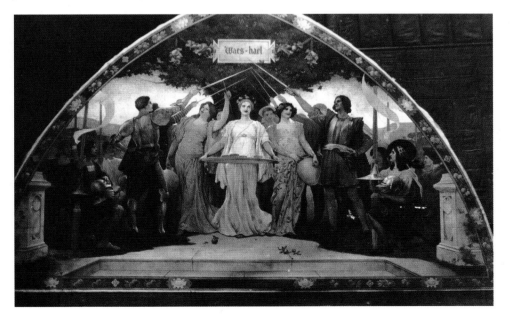

Sword Dance, 1896–97: Dining room lunette, residence of William K. Vanderbilt, New York City. (Photograph courtesy of the Richard Murray research material regarding mural painting in the United States, 1970–2006, Archives of American Art, Smithsonian Institution)

Sword Dance is one of three murals created for Vanderbilt's Gothic dining room.

The Genius of Music, 1899: Drawing for Music room ceiling, residence of Adolph Lewisohn, New York City. (Photograph courtesy of the Edwin H. Blashfield papers 1850–1980, Archives of American Art, Smithsonian Institution)

In the completed mural, the genius of music, depicted as a winged horse presiding over nymphs and spirits, dominates the center. From the left, figures symbolize different kinds of music: Greek, Egyptian, Pastoral, Dramatic, Popular, Military. At the right are three figures: Modern Classical Music is entwined in drapery with Melody and Harmony. The completed mural also included a little child, perhaps depicting Ragtime, scampering in the foreground.

1900. Consequently Blashfield was immersed in Italian art and culture at the outset of his career painting public murals for major American buildings.

Blashfield's generation of muralists drew on their familiarity with important mural projects in Europe and knowledge of academic easel painting to initiate the American Renaissance mural movement. The potential for figure-painting specialists to transfer their skills to murals was recognized by the *Art Amateur* in 1885, as it urged potential residential mural patrons to hire American figure-painting specialists who could visit their homes, instead of established French decorative painters who would not be familiar with the particular architectural context.[30] As noted earlier, Blashfield painted his first residential murals in 1886 for Hamilton McKown Twombly. Unfortunately the desirable location of Twombly's Manhattan mansion led to eventual redevelopment of the site and destruction of the murals. Other commissions for Manhattan residences met a similar fate, including *Sword Dance, Fortitude,* and *Vigilance* (1896–97) for the Gothic dining room of the William K. Vanderbilt house and the music room ceiling mural *The Genius of Music* and hall panel *Dance* (1899) for the Adolph Lewisohn house. Although the Collis P. Huntington house in Manhattan was destroyed, Blashfield's 1894 murals *Cupid with Bow and Arrows, Female Figure (Terpsichore), Dancing Female Figures,* and the overmantel of a goddess were removed and donated to the Yale University Art Gallery. Blashfield's 1890 mural *Allegory,* for the music

ANNE E. SAMUEL

Dance, 1899: Hall panel, residence of Adolph Lewisohn, New York City. (Photograph courtesy of the Edwin H. Blashfield papers 1850–1980, Archives of American Art, Smithsonian Institution)

Terpsichore, 1894: Drawing for residence of Collis P. Huntington, New York City. (Photograph courtesy of the Edwin H. Blashfield papers 1850–1980, Archives of American Art, Smithsonian Institution)

This and several other works for the Huntington house are now in the collection of the Yale University Art Museum.

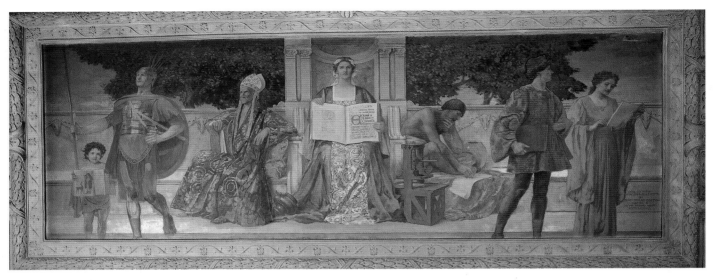

Prose, 1898: Ceiling panel, residence of George W. Childs Drexel, Philadelphia, Pennsylvania. Present-day Curtis Institute of Music. (Anne Day, photographer)

Poetry, 1898: Ceiling panel, residence of George W. Childs, Drexel, Philadelphia, Pennsylvania. Present-day Curtis Institute of Music. (Anne Day, photographer)

Illustrated are the panels on either side of the center ceiling medallion.

room ceiling at the R. I. Gammell house in Providence, Rhode Island, was recently located, during the pursuit of illustrations for this book, gracing the bedroom of another residence. Blashfield's only residential commission that remains in situ was painted in 1898 for the George W. C. Drexel house in Philadelphia (now occupied by the Curtis Institute of Music). Blashfield decorated a piano with a medallion and four panels depicting Sacred, Pastoral, Dramatic, Military, and Classical Music, in addition to three ceiling panels depicting symbolic figures as well as a circle of eight historic figures selected by Mrs. Drexel. The central circular mural contains figures embodying a field of study or virtue: Law (Portia), Poetry (Sappho), Philosophy (Plato), Music

ANNE E. SAMUEL

Music, 1898: Detail of pianoforte side medallions, commissioned by George W. Childs Drexel. On permanent loan to the Curtis Institute of Music from the Philadelphia Museum of Art. (Anne Day, photographer)

Blashfield hoped that this modern example of applied art would herald a revival of decorative arts.

(Saint Cecilia), Painting (Raphael), Religion (Saint Francis), Conquest (Harold), and Patriotism (Joan of Arc); the side panels represent Prose and Poetry respectively.[31]

The destruction or relocation of the majority of Blashfield's and other contemporary residential murals poses challenges to their study today. Even at the time they were created, the patron's desire for privacy limited audiences for such murals and hence exposure for their artists. For example, Pauline King wrote that Blashfield and other artists painted murals for the Collis P. Huntington residence but regretted that "his success, and that of his confreres, owing to the wishes of the family, cannot be described in this book."[32] King was permitted to describe and illustrate the Drexel murals and describe the Twombly and Vanderbilt murals. Despite limited publicity, residential murals provided important opportunities to practice the coordination of mural compositions and palettes with architectural and decorative features. Although residential murals were not necessarily much larger than Blashfield's most ambitious Salon paintings, ceiling panels presented challenges regarding orientation of the picture plane and variable viewing angles and directions that muralists encountered at the World's Columbian Exposition, where, in the words of Royal Cortissoz, muralists confronted "pioneer spaces, structures upon which they were permitted for the first time to carry out some really ambitious ideas."[33]

As Mina Weiner's chapter details, in 1892 Blashfield was one of eight figure painters with limited mural experience commissioned to paint an entrance dome to the Manufactures and Liberal Arts Building. Although the deadline was tight and compensation limited, artists welcomed the opportu-

nity to paint murals of monumental scale for an international audience. One of the greatest challenges they faced was composing appropriately scaled figures and legible details for a viewing distance that far surpassed residential mural projects; each dome rose to a height of 55 feet and was 25 feet in diameter. The artists agreed to a common approach, concentrating their efforts on figures for the pendentives that extended down from the four corners of the dome. For his space, Blashfield painted *The Arts of Metalworking*, in which he alternated male and female ideal figures symbolizing the art of the goldsmith, armorer, ironworker, and brass worker. The dome itself was painted blue, to suggest the sky, with a few birds in flight to add variety.

The Manufactures and Liberal Arts Building was designed as a temporary structure, and after the exposition the building and its murals were destroyed by fire. However, elements that warranted special praise in Blashfield's dome would reappear in his earliest extant public mural, the collar mural *The Evolution of Civilization* (1895–96), which together with the lantern mural *Human Understanding* (see page 54) crowns the dome of the Main Reading Room at the Library of Congress. In both the Library of Congress collar and the Chicago dome, wings spread behind the figures, elevating them to symbolic figures, giving them breadth, and unifying the sequence of alternating male and female forms. Behind the wings, Blashfield painted a mosaic background which, with its small areas of variegated color, represents an architectural setting and avoids conveying undue visual weight. Blashfield's success accounting for viewing distance and composing legible figures in Chicago contributed to his being awarded the commission for the most prominent murals in the Library of Congress, and though undocumented, it may have also guided the expectations his patrons had for the collar.

Throughout his correspondence and published writings, Blashfield asserted the importance of coordinating murals with their architectural context. This required analysis of the color and complexity of other architectural ornament in the room, natural and artificial lighting of the space, and, particularly, the distance at which the mural would be viewed. Viewing distance determined treatment of color, the desired level of detail and contour lines, and the size figures should be painted if they were to appear to be life-size. Just as Giorgio Vasari and his contemporaries referred to life-size figures as a norm for indicating the size of Renaissance paintings, so too did Blashfield suggest that figures in American murals should appear to be life-size.[34] He explained that "the figures in the ceiling of a drawing-room 16 feet high would but little exceed the size of life, whereas the figures painted upon the vaulting of a chapel 60 feet high or upon a dome at 150 feet would necessarily be of much greater size."[35]

The Library of Congress commission presented daunting challenges and an unprecedented opportunity. With the collar 125 feet above the Reading Room floor, Blashfield needed to make the figures as large as possible within the confines of the collar; by painting seated figures he maximized their size.

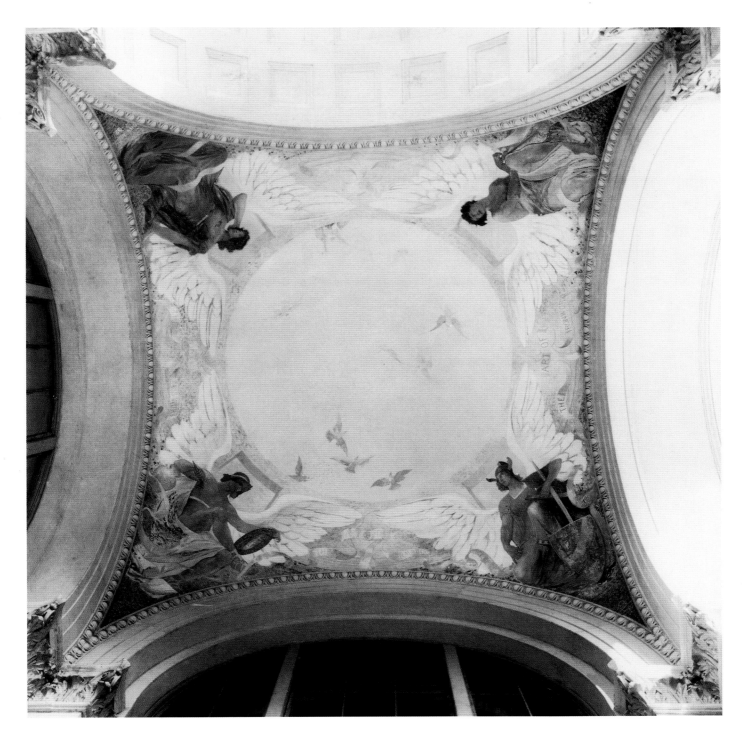

The twelve evenly spaced figures, each representing both a Western culture and a field of study, are arranged chronologically, from Egypt and Written Records to America and Science. Between the figures, ornate white plaques identify the various nationalities or cultures, with a decorative ribbon running along the base of the collar, naming the fields of study. These direct labels provide clues for identifying the attributes surrounding each figure and their significance. Blashfield calibrated his palette to the color scheme of the room, which becomes progressively lighter as decorative elements ascend from the floor to the dome. The lantern mural *Human Understand-*

The Arts of Metalworking, 1893: Entrance dome, World's Columbian Exposition, Manufactures and Liberal Arts Building, Chicago. (Library of Congress)

Blashfield's first public mural, *The Arts of Metalworking*, featured four idealized figures symbolizing the goldsmith, armorer, ironworker, and brass worker.

ing, another 35 feet above the collar, contains a medallion composition of three figures painted in pastels against an ethereal sky. This suggestion of a view beyond the confines of the building is appropriate to the subject Blashfield describes: "The female figure being meant to represent the Human Understanding lifting her veil and looking upward from finite intellectual achievement (represented by the cycle of figures in the collar below) to that which is beyond."[36]

The lantern's rise above the cupola prevents unobstructed views of *Human Understanding* from any location except the center of the Reading Room floor, near the librarian's desk. Consequently, the mural is accessible to researchers but not to tourists, who have always been barred from the Reading Room floor. Instead, tourists were relegated to a Visitors' Gallery that permitted movement around the circumference of the room. Mural viewers could follow the chronology of the collar mural, using their elevated perspective to better identify the costumes and attributes of each culture and field of inquiry.

Both the Chicago dome and the Library of Congress collar were painted from the scaffold, directly on the wall surface, with assistance from Arthur R. Willett, who would soon establish himself as a decorative painter and muralist. Bernard Green, superintendent of construction, designed a multi-level revolving scaffold for the decoration of the dome, which merited an article and detailed diagrams in *Scientific American* and drew praise from Blashfield: "The immense advantage of this scaffold or 'traveller', [*sic*] was that by moving it from the place on which he had been working, the artist going down to the pavement could look up and see exactly what he had done and what changes he must make."[37] Though Blashfield and Willett benefited from the opportunity to see their work from the Reading Room floor, they still suffered with extreme temperatures at the construction site and the awkwardness of leaning back to paint on a curved surface. For the lantern mural and all but one of his subsequent mural commissions, Blashfield would decline to paint his murals on site. Instead, he adopted the French mural painting technique *marouflage,* in which murals are painted in oil on canvas in the studio and the completed canvas is later adhered to the wall. Marouflage permitted Blashfield and other artists who were trained as easel painters to adapt a familiar medium to a new space.

Pauline King, sister-in-law of Blashfield's friend and fellow muralist Kenyon Cox, described the technique: "It is usually the custom of mural painters of the present day to work on large, carefully prepared canvases, which, when completed, are taken off the stretchers, rolled up, and transported to the destination, where they are fastened in place by being rolled flat upon the wall or ceiling, which has been covered with a thickness of white lead and varnish; this method being commended for durability, since the cracking of plaster and the extremes of heat and cold cause decay and ruin."[38] Marouflage offered muralists numerous conveniences; they could

ANNE E. SAMUEL

Evolution of Civilization. Dome Collar of Rotunda, Library of Congress, Washington, DC. (Peter A. Juley & Son, Smithsonian American Art Museum, J0044063)

"The traveller" was the name given to the extraordinary moving truss above the central scaffold that was designed and built so that the dome collar and oculus could be completed in situ.

work in their studios, painting only minor alterations and touch-ups on site after installation. Painting on high scaffolds could be dangerous, not to mention unpleasant, if work on the building was ongoing or temperatures were extreme. Furthermore, when painting was done on site, progress could be delayed by changes in the construction schedule or if access to the mural wall was blocked. As Blashfield's mural practice expanded beyond East Coast urban centers, marouflage offered another advantage: the completed mural could be exhibited in his studio before it was packed and shipped to a distant locale. Blashfield typically invited friends, fellow artists, and local art critics to private studio receptions to exhibit new murals. Both Blashfield and his patrons realized benefits from the resulting coverage in the New York press; Blashfield was able to buttress his status in the art world, and the locality that was to receive the mural could boast that its new work of art was being celebrated in New York.

Marouflage did present artists with the challenge of projecting how their murals would look once installed. To expedite experimentation with scale in his murals, Blashfield used photographic projection as an enlargement device for mural compositions. Recent scholarship suggests that artists from the fifteenth century to Blashfield's contemporary and acquaintance, Thomas Eakins, hid their dependence on photography. Hector MacLean, the late-nineteenth-century author of *Photography for Artists,* supports such ideas, claiming that artists lack the courage to publicly acknowledge their use of photography as a source of visual information.[39] However, Blashfield publicly embraced the modern enlargement technique, which was also adopted by panorama painters.[40] If there truly was a taboo against working directly from photographic sources at the turn of the twentieth century, perhaps it did not apply if artists were photographing their own work and reusing it to update the traditional reproduction and enlargement technique of grid transfer. The slides that Blashfield projected were not taken from life, but instead from his own artistic creation, his sketches.

In *Harper's Weekly,* Arthur R. Willett described and illustrated how stereopticon projection expedited and improved the creation of Blashfield's mural for the Astoria Hotel, New York (1897; that same year the Astoria was combined with the Waldorf to create the Waldorf=Astoria).[41] *Music and Dance,* a 65- by 44-foot ceiling painting, together with two side panels, covered the better part of the 65- by 95-foot hotel ballroom's ceiling with more than forty partially draped figures.[42] The idealized dancers and musicians fill an ethereal space, bathed in pastels. Willett's illustration shows a dark studio, with the stereopticon providing the sole visible light source. An assistant perches midway up the movable stairs in the foreground, projecting the stereopticon image onto the canvas on the back wall of the studio. Another flight of movable stairs is pulled close to the canvas, enabling two artists to trace the projected image on the canvas. Willett presented Blashfield's use of stereopticon projection as an advantageous, modern alternative to the traditional but tedious method of grid transfer to enlarge sketches to mural scale. Stereopticon projection was said to take only one-tenth of the time required by grid transfer, particularly if modifications to the composition were necessary. Instead of elaborate regridding of the compositional changes, the lantern projection could simply be shifted.[43] In contrast with the somewhat stilted process of grid transfer, which requires the artist to carefully match small units of the composition and look continually from sketch to mural, Willett associates stereopticon transfer with more fluid enlargement of the sketch, which "enables one to keep entirely the character of the artist's individual style." A photograph of the Astoria murals in the Vanderbilt Gallery at the Fine Arts Building (now the Art Students League), where Blashfield painted his largest murals, shows that the painted figures dwarf the artists at work. Stereopticon projection could suggest the distant view and compensate for the distortions experienced when working in physical contact with a massive canvas.

ANNE E. SAMUEL

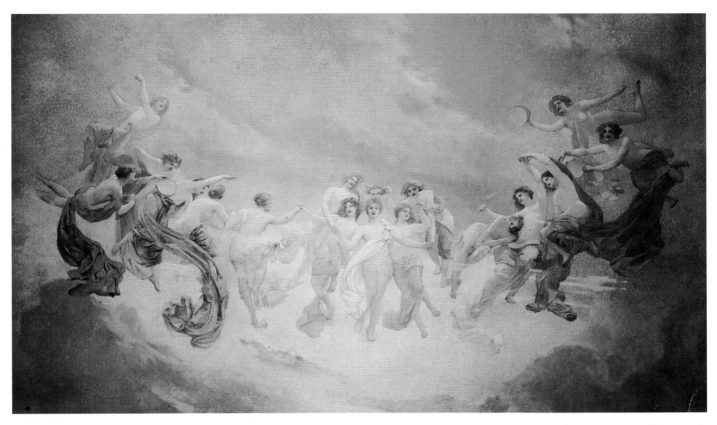

Music and Dance, 1897: Ballroom ceiling, Astoria Hotel, New York City. (Photograph courtesy of the Edwin H. Blashfield papers 1850–1980, Archives of American Art, Smithsonian Institution)

In his notes on this mural, Blashfield complained that the ceiling had been so badly lit, it could hardly be seen. (Description taken from Edwin H. Blashfield notes, AAA microfilm 1117, frame 473.)

Blashfield with assistants working on the Astoria mural in the Vanderbilt Studio of the Fine Arts Building. (Photograph courtesy of the Edwin H. Blashfield papers 1850–1980, Archives of American Art, Smithsonian Institution)

The mural commission for the Astoria Hotel was initially advantageous, as it gave Blashfield's mural painting prominence in New York society. However, as was the case with his other murals for private patrons in Manhattan and commercial buildings elsewhere, escalating real estate values and changing building needs led to the eventual redevelopment of the building site and destruction of the mural. Casualties of this pattern include his lunette *City*

of Pittsburgh Offering Her Steel and Iron to the World, Bank of Pittsburgh, 1895; overmantel *Justice,* Lawyers Club, New York, 1895; murals for a board room in the Prudential Life Insurance Company, Newark, New Jersey, 1901; and *The Uses of Wealth,* Citizens Bank, Cleveland, 1903 (see page 78). All but two of Blashfield's public murals have fared far better. Mina Weiner's chapter describes how and why *Dakota Struggling towards the Light,* South Dakota State Capitol, 1910 (see page 38), came to be blocked from view because of its controversial depiction of Native Americans. *The Call of Missouri,* 1918 (see page 78), has been lost since its removal from the Kansas City Public Library.

Blashfield painted most of his public murals between 1899 and World War I, including mural commissions for the Iowa, Minnesota, South Dakota, and Wisconsin state capitols, as well as for courthouses in New York City; Baltimore, Maryland; Jersey City and Newark, New Jersey; Cleveland and Youngstown, Ohio; and Wilkes-Barre, Pennsylvania. To devise appropriate subjects for a given building and understand the space he was to fill, he would travel to the mural site, visit the building, and, optimally, meet with the building commission members and discuss potential subjects. The subject for his first mural for the Baltimore Courthouse, *Washington Surrendering His Commission,* 1902 (see page 35), was suggested when "several gentlemen in that city invited me to dine with them to consider the subject to be undertaken . . . they went on telling of one and another achievement

City of Pittsburgh Offering Her Steel and Iron to the World, 1895: Lunette, Bank of Pittsburgh, Pittsburgh, Pennsylvania. (Carnegie Library of Pittsburgh)

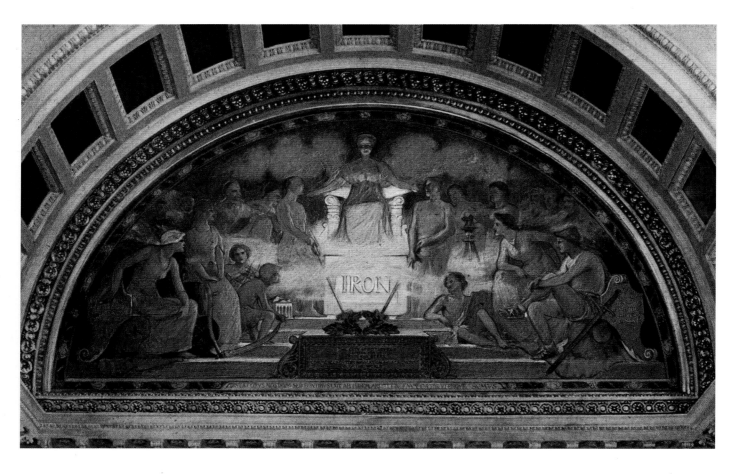

ANNE E. SAMUEL

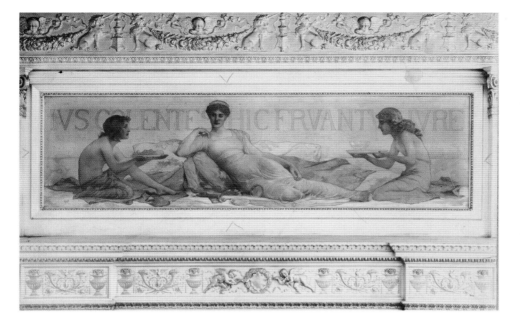

Organized in 1887, the Lawyers Club was one of the oldest and best-known lunch clubs in downtown New York. This painting, completed for the club's initial location in the Equitable Building at 120 Broadway, was probably destroyed by a building fire in 1912.

meet for celebration, and finally decided that the resignation of his commission as commander-in-chief by Washington at Annapolis was their 'great central act of equity,' best worth commemorating in the history of Maryland."[44] Blashfield's second subject for the courthouse paralleled the first with its representation of an event that occurred in the state of Maryland but had national significance. *The Edict of Toleration of Lord Baltimore*, 1904 (see page 79), represents peaceful coexistence between religions, a principle that would gradually gain currency in the other colonies and states.

Iowans responded to Blashfield's mural *Westward*, Iowa State Capitol, 1905 (see page 80), as if it was specific to their state, though it could be equally applicable to other regions settled by pioneers in Conestoga wagons. Some viewers responded sentimentally to the measured, frieze-like composition, focusing on the beautiful woman who walks in front of the wagon, hold-

Blashfield made numerous preparatory sketches prior to painting each mural, delineating its overall placement within the architecture and suggesting individual figures. This sketch is probably the only surviving image of the mural he completed for the Prudential Insurance Company.

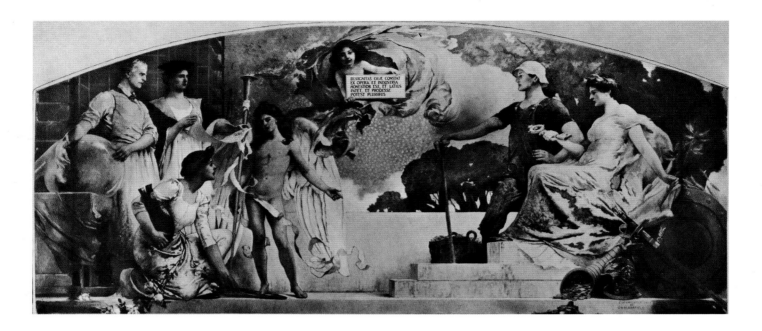

The Uses of Wealth, 1903: Lobby lunette, Citizens Bank, Cleveland, Ohio. (Photograph from *The Works of Edwin Howland Blashfield*, Introduction by Royal Cortissoz, New York: Charles Scribner's, Sons, 1937)

Seated at right is Capital, depicted as a beautiful woman with golden coins emanating from her feet. Figures on the left include a nude sprite representing the genius of civilization, a woman wearing a mortar board symbolizing literature, the figure of a man representing science, and a kneeling young woman symbolizing the arts.

ing a child's hand. Abbie Robbins reminisced about seeing Blashfield install the mural and her emotional response to that woman, who "might have been my mother had she led two children instead of one."[45] In 1932, Iowa's Chief Justice F. F. Faville implied a similar response, beginning his talk on the mural with a tribute to his mother and reference to her pioneer diary.[46]

Whenever possible, Blashfield featured women and children in his compositions. They played an important artistic role; as he explained, "Women and children indeed, especially to-day when feminine costume is still picturesque, are so much more decorative as a factor than most contemporary men

The Call of Missouri (aka *Missouri Watching the Departure of Her Troops*), 1918: Library rotunda mural, Kansas City Public Library, Kansas City, Missouri. (Peter A. Juley & Son Collection, Smithsonian American Art Museum, J0056290)

The central heroic figure represents Missouri in time of war. In the background are Kansas City and wheat fields stretching into the distance. Originally commissioned by the Kansas City Chapter of the Daughters of the American Revolution, the mural's current location is unknown.

ANNE E. SAMUEL

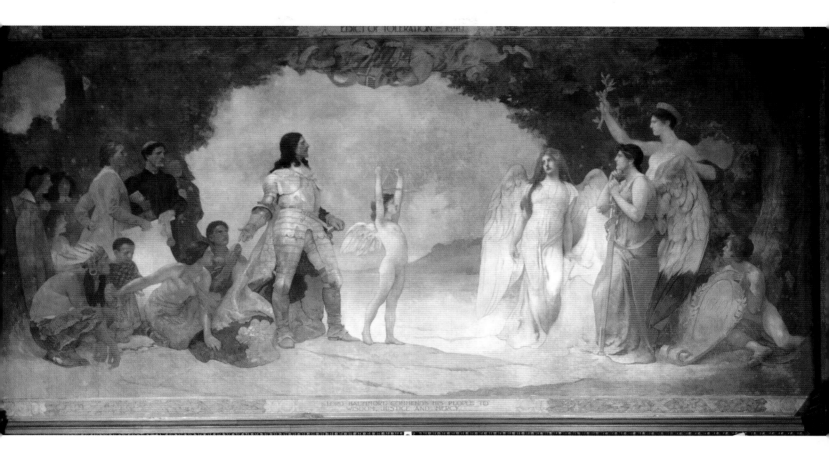

that the artist hates to leave them out of his canvas, and when he has men only, he is reduced to such straits in making the sad-colored modern trousers tolerable."[47] In *Westward,* like many of his murals, Blashfield integrated historic figures, representative of local citizens, with symbolic figures, which tended to be ideal females, clad in decorative garments. In addition to symbolizing the spirits of Civilization and Enlightenment leading the pioneers, at upper left, and the State of Iowa, and the cultivation and modernization that will follow the pioneers, at upper right, the symbolic figures in *Westward* provide decorative points of interest in the upper register of the mural.

If a mural subject required prominent male figures, Blashfield sought historically plausible means to achieve the color effects and variety he desired, whether through military uniforms, clerical robes, or the attire of various social classes. To balance the color composition of *Minnesota, Granary of the World,* Minnesota State Capitol, 1904 (see page 81), Blashfield wanted to include a soldier in gray, but he did not want to run the risk of the figure being misidentified as a Confederate soldier. Channing Seabury, chairman of the building commission, concurred, warning that "our old soldiers would be up in arms if you should introduce anything like a Confederate uniform into your picture."[48] Consultation revealed that Minnesotans wore a light-blue overcoat in the Civil War, which served Blashfield's purposes at the right of the mural, on the man standing slightly behind a nurse in pale pink. Despite the prominent Civil War soldiers, at right, and farmers

The Edict of Toleration of Lord Baltimore, 1904: Courtroom mural, Clarence M. Mitchell Jr. Courthouse, Baltimore, Maryland. (Anne Day, photographer)

The central figure, Lord Baltimore, is surrounded by whites, blacks, Native Americans, a Catholic priest, and a Protestant pastor. A nude boy is holding scales that symbolize equality. At the right, Justice in red is next to a youth holding a shield with the date 1649, the year of the edict. Behind them stands Wisdom, who holds out an olive branch of tolerance.

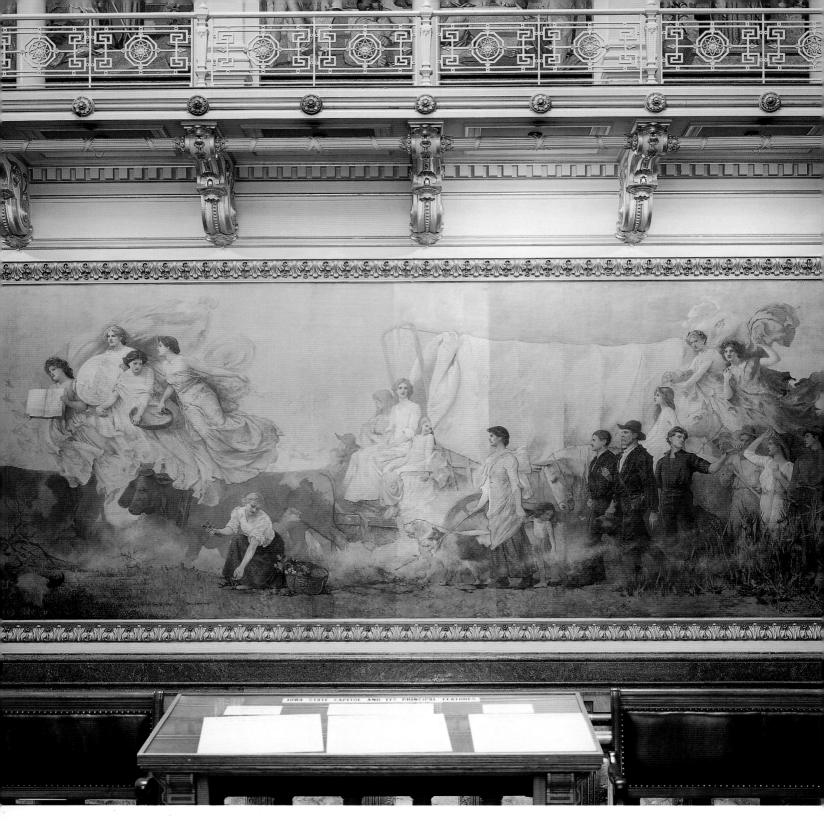

Westward, 1905: Grand staircase landing, Iowa State Capitol, Des Moines, Iowa. (Anne Day, photographer)

This large mural was painted on five pieces of canvas in the Vanderbilt Gallery of the Fine Arts Building and then placed in a frame in situ. Blashfield described the mural as follows: "The main idea of the picture is symbolical presentation of the Pioneers led by the spirits of Civilization and Enlightenment to the conquest by cultivation of the Great West. Considered pictorially, the canvas shows a 'Prairie Schooner' drawn by oxen across the prairie. The family rides upon the wagon or walk at its side. Behind them, and seen through the growth of stalks at the night, come crowding the other pioneers and 'later men.' In the air and before the wagon, are floating four female figures; one holds the shield with the arms of the state of Iowa upon it; one holds a book symbolizing Enlightenment; two others carry a basket and scatter the seeds which are symbolical of the change from wilderness to ploughed fields and gardens that shall come over the prairie. Behind the wagon, and also floating in the air, two female figures hold, respectively, a model of a stationary steam engine and of an electric dynamo to suggest the forces which come with the 'later men.'" (www.legis.state.ia.us/Pubinfo)

ANNE E. SAMUEL

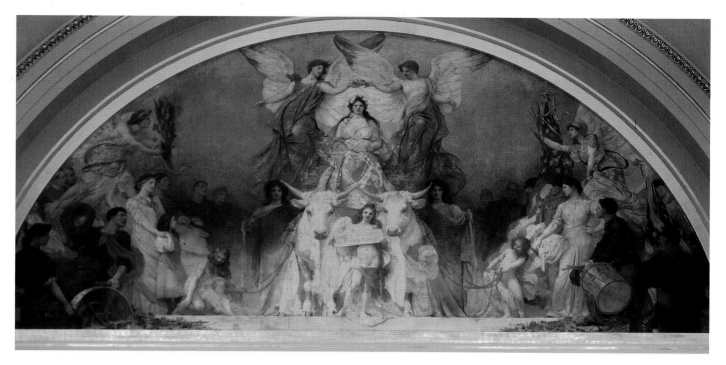

Minnesota, Granary of the World, 1904: Senate chamber lunette, Minnesota State Capitol, St. Paul, Minnesota. (Anne Day, photographer)

The figure of Minnesota sits on a cart enthroned by sheaves of wheat and drawn by white oxen, while the spirits of Agriculture and Patriotism fraternize with farmers of the area. In the medieval tradition, Blashfield included portraits of the architect, Cass Gilbert, and the leader of the State Capitol Commission, Channing Seabury, at the lower left.

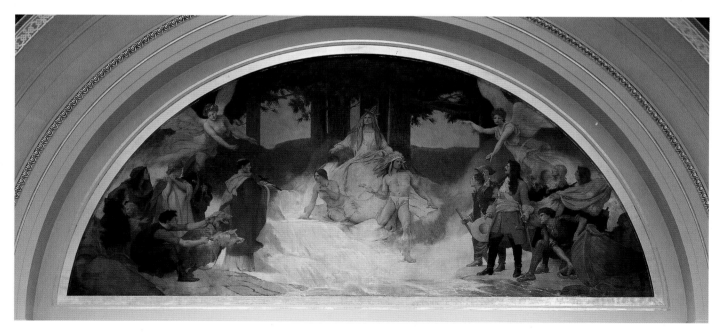

Discoverers and Civilizers Led to the Source of the Mississippi, 1904: Senate chamber lunette, Minnesota State Capitol, St. Paul, Minnesota. (Anne Day, photographer)

The central figure is Manitou or the Great Spirit of the Indians, who is shown guarding the source of the father of the waters. At the right are seventeenth-century explorers; at the left are priests and colonists.

and workmen, at left, representations of local citizens are still subordinate to the central group surrounding the symbolic figure of Minnesota and the pale pink, blue, and white tones that dominate the mural and correspond with the overall palette of the Senate Chamber.

Murals such as *Minnesota, Granary of the World* and *Discoverers of the Mississippi,* installed on the opposite wall, presented complex subjects that created demand from patrons and viewers for descriptions of their content, which Blashfield readily supplied. Nonetheless, he was a strong critic of specific allegory that required extensive knowledge of literature. When he sent descriptions of his planned subjects for the pendentives at the Mahoning County Courthouse, Youngstown, Ohio, 1910, he explained to architect Charles Owsley that "[s]implicity, it seems to me, is absolutely necessary in decoration of public buildings, simplicity of symbolism I mean. I don't believe at all in long winded symbolism or subtile [*sic*] allegory."[49] As an alternative to allegory, he advocated generalized symbolism that draws on broad cultural knowledge. For Youngstown, he represented four periods of the law, in Remote Antiquity, Classical Antiquity, the Middle Ages, and Modern Times. Highly educated citizens could immediately grasp the symbolism surrounding each period, whereas others might be able to associate each figure's attributes with the given period after learning the title of each pendentive. Blashfield's prediction that the four historical eras "present subjects which would appeal to the protestant Christians, the Jew, the Roman Catholic Christian, and the Modern Scientist" implies awareness of diverse viewers.[50]

Pendentives for multilevel rotundas such as the Mahoning County Courthouse, Essex County Courthouse, and Hudson County Courthouse can be examined closely enough to ascertain detailed symbolism on the uppermost floor. However, typically viewers first see pendentives from the rotunda floor. From that vantage point, the pendentives rise from the corner piers and curve and spread upwards to meet the dome above. Upon entering the rotunda of the Essex County Courthouse (see pages 84–85) one can easily read the plaque above each ideal female pendentive figure: Wisdom, Mercy, Power, or Knowledge. The identity and significance of their attributes become more evident at upper levels and with closer scrutiny. The connection between Knowledge and her books or Power and her sword and rods is readily apparent, but familiarity with conventional representation would help explain Wisdom's unraveling of a skein or Mercy's casting a vote in the urn, favoring mercy in the event of a tie vote. From the rotunda floor of the nearby Hudson County Courthouse, 1910 (see page 152), one simply sees ideal female forms, varying from the chaste to the voluptuous, in the pendentive spaces supporting the dome. Viewers must ascend to the upper floor and stand just below the pendentives to discern the specific content of the four personifications of Fame, who hold plaques with portraits of important figures from New Jersey history.

Courthouse visitors are free to circulate through the various levels of the rotunda, attaining near and distant views of the pendentives, but such free-

ANNE E. SAMUEL

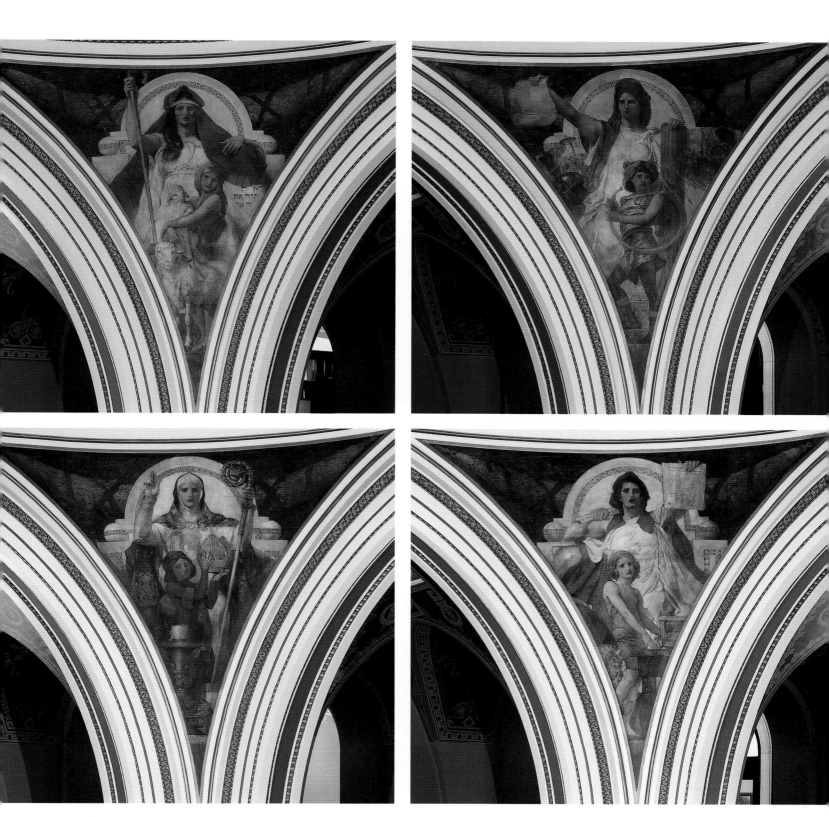

The Law in Remote Antiquity, The Law in Classical Antiquity, The Law in the Middle Ages, The Law in Modern Times, 1910: Main dome pendentives, Mahoning County Courthouse, Youngstown, Ohio. (Anne Day, photographer)

The Law of Remote Antiquity is depicted as a shepherdess wearing a homespun robe, whose left arm rests on a stone tablet with Hebrew lettering representing the Ten Commandments. The symbol of Classical Antiquity wears a Roman costume and holds a codex written in Latin. The Law in Middle Ages is represented by a seated figure dressed in ecclesiastical vestments suggesting that the laws of that period were based on the Christian faith. Modern Times is represented by a figure wearing a liberty cap and holding the Declaration of Independence and *The Rights of Man,* the latter in French, in her left hand. Under her right arm is a ballot box.

Essex County Courthouse rotunda, Newark, New Jersey. (Whitney Cox, photographer)

Mercy and *Power*, two of four pendentives, are visible in this view of the stunning Cass Gilbert-designed rotunda.

dom is routinely denied in courtrooms and legislative chambers. One's status in the proceedings dictates position in the room—and consequently the viewing perspective for murals in that room. Blashfield's early murals with a strong central emphasis, such as *Washington Surrendering His Commission* and the Minnesota Senate Chamber murals, establish a clear hierarchy of desirable and undesirable viewing positions. If one is not opposite the central group, or perhaps one of the subordinate groups at left or right, the mural may appear off balance. More complex figure groupings in murals such as *The Edict of Toleration; Wisconsin, Past, Present and Future,* Wisconsin State Capitol, 1908 (see page 89); and *Justice*, Luzerne County Courthouse, 1909 (see page 86); present a wider range of desirable viewing positions. Each of these murals has a single central figure positioned between two or more figure groups that face one another. Consequently, viewers at the far left of the room could imagine joining the figure group at left and facing the figure group at

ANNE E. SAMUEL

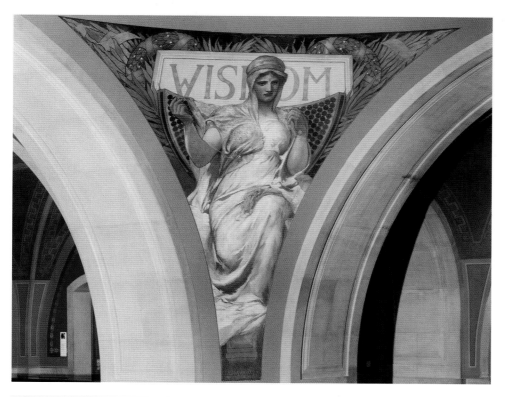

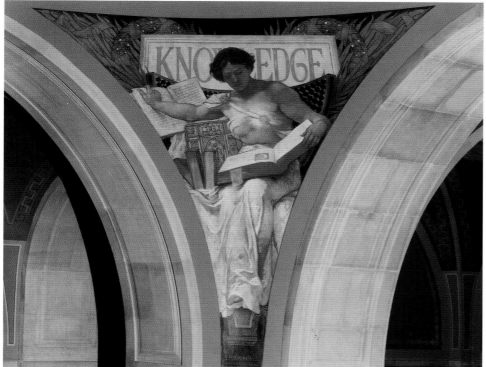

Wisdom and *Knowledge*, 1906-7: Rotunda pendentives, Essex County Courthouse, Newark, New Jersey. (Whitney Cox, photographer)

The pendentives interpret the themes: Wisdom informs the law, Mercy tempers the law, Power supports the law, Knowledge bases the law.

right; the opposite holds true on the other side of the room. The central figure demarcates the central axis in the mural and connects the two groups, seeming to emerge from one in order to communicate with the other.

Such figure relationships are further complicated in *The Graduate*, Great Hall of the City College of the City University of New York, 1908, a massive mural measuring 22 by 45 feet in a room that seats 2,300 people (see page 50).

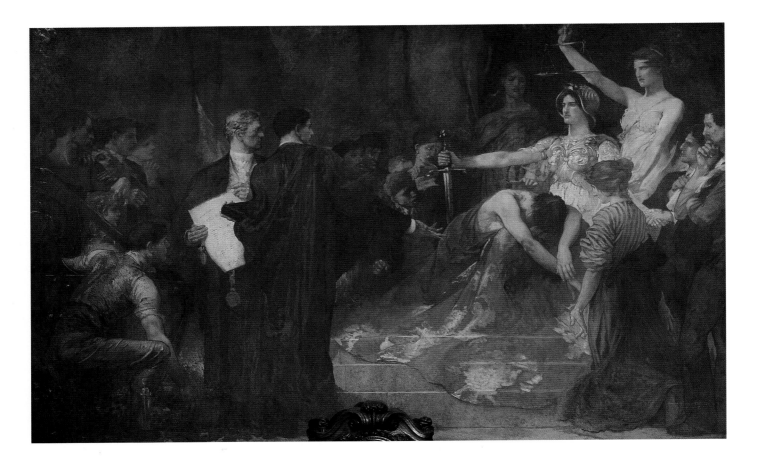

Justice, 1909: Courtroom mural, Luzerne County Courthouse, Wilkes-Barre, Pennsylvania. (Anne Day, photographer)

The Law, symbolized by a female figure seated on the right, is deciding between good and evil. A woman dramatically throws herself across her lap, suggesting that she has been a transgressor. Mercy holds her hand above this distraught figure, perhaps protectively.

It is the only mural that Blashfield painted in situ after the Library of Congress collar. Painting on site was a viable and attractive option because the surface is curved, it would be virtually impossible to find a large enough studio to see the entire mural at once or approximate viewing distance, and the location was relatively convenient to Blashfield's Carnegie Hall studio. The central group surrounding the statue of Wisdom holding the Earth is undoubtedly emphasized, both through their massing and the diamond of illumination that highlights the figure of Alma Mater presenting a diploma to a Graduate. However, the distribution of darkly clad figures at the lower left and right are positioned as potential surrogates for mural viewers, as they turn and face toward the center. Consequently, satisfying lines of vision are suggested, all focused on Alma Mater and the Graduate, from the center or sides of the massive room.

Blashfield complicated a conventional mural composition, the medallion, for his dome mural *Wisconsin,* Wisconsin State Capitol. Although the mural was completed in 1912, continuing construction delayed installation until 1914. It was 35 feet in diameter, and with the intention of having it painted before the building was complete, architect George B. Post advised his building commission that "[w]e know of no one who has had the experience in such work which would lead him to surely make a painting to be seen at a distance of 200 feet which would be entirely satisfactory, with the exception of Mr. Blashfield. . . ."[51]

In this tremendous technical and creative feat, Blashfield demonstrated confidence that the mural would complement the architectural space by

ANNE E. SAMUEL

illustrating the planning and scaling of the composition in *Mural Painting in America* before the mural was installed. To paint the mural, he used the Vanderbilt Gallery, the customary exhibition space for the Architectural League of New York, during the slow summer season. Even with the twenty-seven-foot ceilings, the entire dome mural could not be viewed at once. Because the mural was to be placed in a shallow dome, certain figures were repeated on the flat canvas. On a photograph of the mural, Blashfield noted that "a certain amount of cutting was necessary in order to insure a smooth fit. Several alternative and duplicate figures were painted in order that if one figure were injured in the cutting and fitting, a second figure would be available to take its place."[52] Another studio photograph of the Wisconsin dome illustrates Blashfield's use of photographic enlargement to scale and complete his mural compositions. Beginning with his preliminary drawings, "he expands these drawings by photography to various sizes, whereupon, if the room to be decorated is in any way completed, he applies the photographs themselves, first one size and then another, moving them about like paper dolls

Wisconsin, 1912: Dome crown, Wisconsin State Capitol, Madison, Wisconsin. (Eric Oxendorf, photographer)

Wisconsin, symbolized by a female figure, is surrounded by others bearing fruit, grain, and minerals.

until he has determined the proper scale."[53] This technique may have eased compositional modifications as figures were rescaled and moved independently in the space of the mural canvas.

In November 1912, Blashfield exhibited *Wisconsin* in his studio and experienced one of the drawbacks of this practice, as the mural's relationship to its architectural context was not fully understood. Royal Cortissoz praised the mural, yet questioned "the judgment which has kept the forms rather close together, surmising that when seen from so far below they might make a rather confusing pattern."[54] Blashfield responded to his friend in a letter, explaining that the dome's oculus was only 24 feet in diameter; therefore, "Had I made a more open composition some of my figures would have disappeared behind the oculus opening. . . . Seen in the big round canvas in the Vanderbilt Gallery the figures look huddled toward the centre. Seen in *place* they ought, if my theory is sound, to look like a garland of figures just within the oculus edge."[55] Blashfield's plan for the space was a success, and from the floor of the rotunda, another element of the design

Blashfield with his assistant in the Vanderbilt Studio of the Fine Arts Building moving giant heads for the Wisconsin mural. (Photograph courtesy of the Edwin H. Blashfield papers 1850–1980, Archives of American Art, Smithsonian Institution)

To help determine the appropriate size and perspective for the Wisconsin capitol dome crown mural, the men tested various proportions using giant cutouts. Blashfield is on the left; Vincent Aderente is on the right; Alonzo Foringer is in the center.

ANNE E. SAMUEL

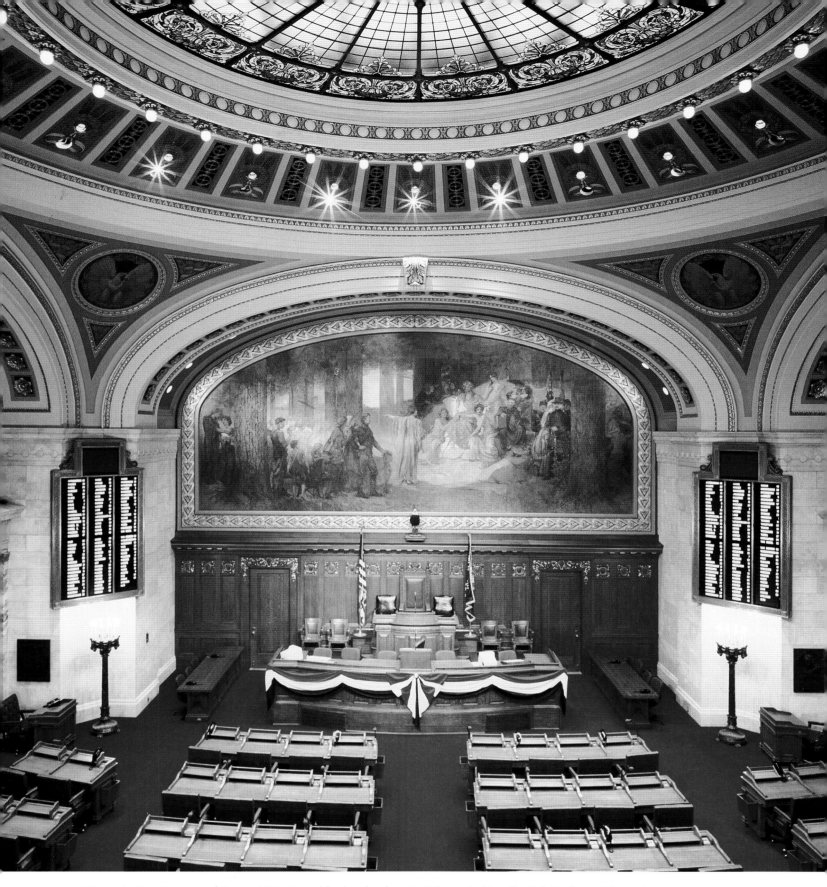

Wisconsin, Past, Present and Future, 1908: Assembly chamber lunette, Wisconsin State Capitol, Madison, Wisconsin. (Eric Oxendorf, photographer)

This mural celebrates the people of Wisconsin among its resources. A female figure symbolizing Wisconsin sits on a rock surrounded by three figures representing Lakes Superior and Michigan and the Mississippi River. On the right, Wisconsin's Past, are images of early explorers and the color guard of Wisconsin Civil War regiment. On the left, Wisconsin Today is accompanied by contemporary workers such as lumbermen, miners, farmers, and their families. At the extreme left, a small figure shielding a Lamp of Progress and listening to a figure representing conservation symbolizes the future.

becomes clear: from a distance of 200 feet, the mural resembles a patriotic rosette, with Wisconsin's white garment and the surrounding tangle of limbs and American flag threading through the subordinate figures. As one ascends through the rotunda, the objects presented as "resources" gradually become apparent.

Blashfield completed the Wisconsin dome mural at an optimistic time, after he had delivered the Scammon Lectures at the Art Institute of Chicago that would be revised into *Mural Painting in America*. However, it was his final mural for a state capitol, and demand for other projects would also diminish. As mural opportunities declined, the outbreak of World War I stimulated broad-based activism from establishment artists such as Blashfield who were too old to serve in the war and had the institutional connections and financial means to volunteer their artistic services. Prior to American engagement in the war, Blashfield contributed art to humanitarian

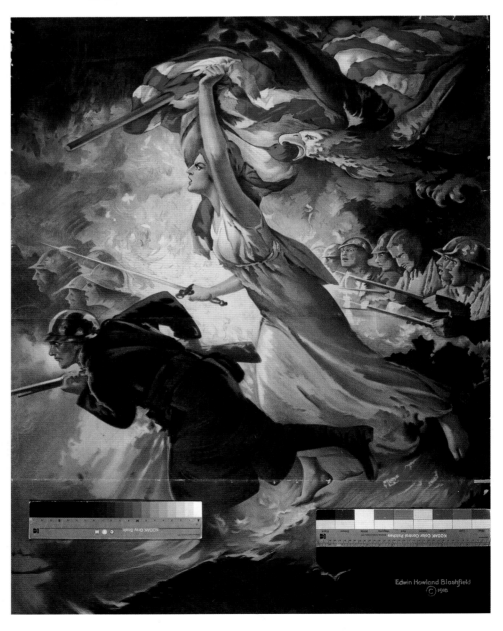

Carry On/Buy Liberty Bonds, 1918: Poster with gray scale and color scale.
(Library of Congress)

ANNE E. SAMUEL

efforts such as Edith Wharton's 1916 *Book of the Homeless,* published to garner sympathy and financial support for civilian refugees in France, and the Committee of One Hundred, a group of American artists that raised money for French artists and their families. The Committee of One Hundred sympathized with the French and Belgians and believed that the United States should come to their aid by entering the war. The prevalence of their sentiment was vividly demonstrated by the Citizens' Preparedness Parade in New York on May 13, 1916. Among the men and women marching—whose numbers exceeded 125,000—was a group of artists, including Blashfield and fellow painters Edward Simmons and J. Alden Weir; sculptors John Flanagan, Daniel Chester French, and Frederick MacMonnies; and illustrators James Montgomery Flagg and Charles Dana Gibson.[56]

The declaration of war in April 1917 prompted swift action from such artists, who exploited their artistic abilities and establishment connections, creating art to instill patriotism and garner support for war efforts. Writing to Royal Cortissoz in 1918, Blashfield estimated that "since the commencement of hostilities I believe I've given fully three fourths of my time to work connected with war funds of one kind or another, making posters, pictures, covers, all sorts of volunteer work."[57] Blashfield's most ambitious war painting, *Carry On,* exemplifies the popularity of patriotic, symbolic imagery during the war and its subsequent fall from favor. The painting followed his signature mural approach, integrating symbolic female figures and historical American types. A militant figure of Columbia, wielding a flag and followed by an eagle, urges on an American soldier in a steel helmet with a fixed bayonet. More charging soldiers fill the background and dissolve into the central fiery light. *Carry On* was featured in the "Avenue of the Allies" display, which filled shop windows along thirty blocks of Fifth Avenue during the Fourth Liberty Loan campaign in October 1918, and was reproduced as a poster that urged viewers to "Carry On! Buy Liberty Bonds to your Utmost!" As the only artwork from the "Avenue of the Allies" to be purchased by the Metropolitan Museum of Art, *Carry On* was sent on a national tour with patriotic fundraising goals and lauded as the "best war picture painted in America."[58] Following the war, it was exhibited at the museum at least until Blashfield's death but was subsequently lost.[59]

Contributions to the war effort were necessary even after the official end of the war, as suggested by Blashfield's poster for the Red Cross Christmas Roll Call of 1918. The impassioned, assertive Columbia of *Carry On* reappears at right, still barefoot in her red cap and loose white gown, joined by a massive American flag. In contrast with the surging movement in *Carry On,* the Red Cross poster presents Columbia

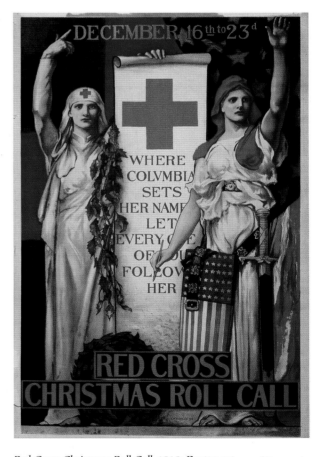

Red Cross Christmas Roll Call, 1918: Poster. (Library of Congress)

and the nurse at left with the monumental stillness and stoicism of the symbolic figures in Blashfield's murals. The nurse subtly combines elements of a historic and a symbolic figure; though she wears a cap with the Red Cross symbol and the white garments associated with nursing, her gown is simplified and extended to the ground, suggesting analogous status with Columbia. Blashfield indicates that the Red Cross acts to support the nation by positioning the nurse slightly behind the scroll she holds behind Columbia, and reiterating this arrangement in the scroll's text: "Where Columbia sets her name, let every one of you follow her."

Blashfield could allow war-related art volunteerism to dominate his time due both to his financial stability and to diminished demand for murals during the war. At war's end, he continued painting murals when offered appealing commissions, but throughout the 1920s he also spent significant time as a leader in arts organizations, notably as the president of the National Academy of Design from 1920 to 1926. Available mural commissions were in less prominent locations than the state capitols and courthouses that dominated his practice in the first decade of the twentieth century. Architectural styles were changing and demand for murals had declined; by 1927, even Cass Gilbert, one of the art form's most devoted advocates, told Blashfield that he had no mural or decorative painting commissions to grant.[60]

Blashfield's most ambitious mural commission of the decade, in size and complexity, was for a Cass Gilbert building, the Detroit Public Library, between 1920 and 1922. He compiled an encyclopedic assembly of approximately 110 writers, artists, and symbolic figures in the library's main stair hall, in five panels installed on three walls. The large lunettes *Poetry* and *Prose* fill the end walls of the barrel-vaulted space with portraits of great writers in loosely chronological order, with literary elders placed higher than more recent figures. Consequently, the four American writers represented—William Dean Howells and Ralph Waldo Emerson in *Prose* and Edgar Allan Poe and Walt Whitman in *Poetry*—appear along the lower register of their respective murals. At the lower left of *Poetry*, the genre is broadly construed with portraits of composers, though one must look to the upright panel *Music* on the adjoining wall to see symbolic representations of various genres of music. *Graphic Arts*, another upright panel on the same wall as *Music*, incorporates a mixture of artist portraits and symbolic figures. *The Joining of the Ways*, the small lunette between the upright panels and above the door to the delivery hall, is the only mural to evoke the regional setting and not the institution's holdings. A symbolic figure of Detroit is joined by Travel by Sea and Travel by Highway, signaling their cooperation with a handshake. A quarter-century after painting the Library of Congress dome, Blashfield again represents a historical overview of the library's scholarly heritage, albeit in a radically different arrangement. Whereas the clear labels and spare, linear arrangement of the *Evolution of Civilization* encourages methodical, comprehensive viewing, the Detroit murals present a dizzying

ANNE E. SAMUEL

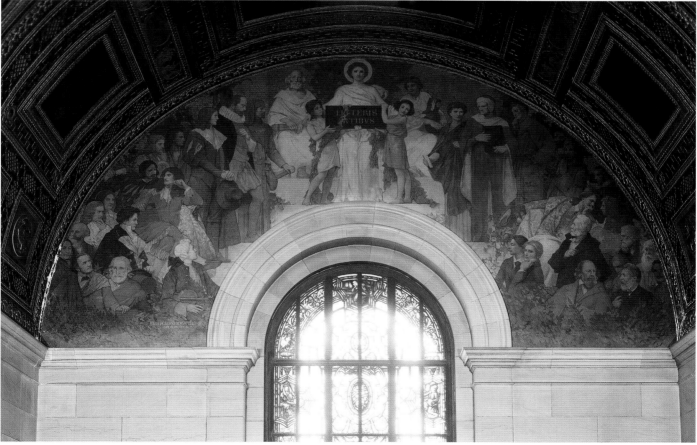

array of figures, partial figures, and faces, which might send curious viewers to reference diagrams that the library compiled and published. Alternatively, viewers might simply notice different figures on each trip through the stair hall, paralleling how they would likely use the library's printed resources. The dense assembly of literary figures suggests complex exchanges of ideas and inspiration among them, and elides the overt distinctions between nationalities and epochs highlighted in the Library of Congress collar.

Concurrent with his work on the Detroit murals, Blashfield returned to a mural form in which he had previously specialized, the pendentive, designing mosaics of the four Evangelists for the Cathedral of St. Matthew the Apostle, Washington, DC (designs completed 1922; mosaics executed 1922–26). The pendentives beneath the center dome would frame views of two of Blashfield's earlier mosaic designs, *The Angels of the Passion* for the

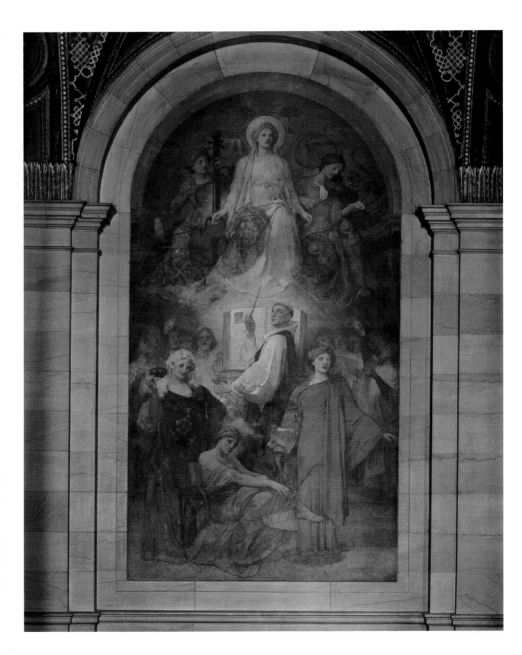

Music, 1921-22: Panel, Detroit Public Library, Detroit, Michigan. (Anne Day, photographer)

Figures symbolizing classical music (above) and ecclesiastical music (below), light opera (left) and grand opera (right), and dance (seated) decorate this panel.

ANNE E. SAMUEL

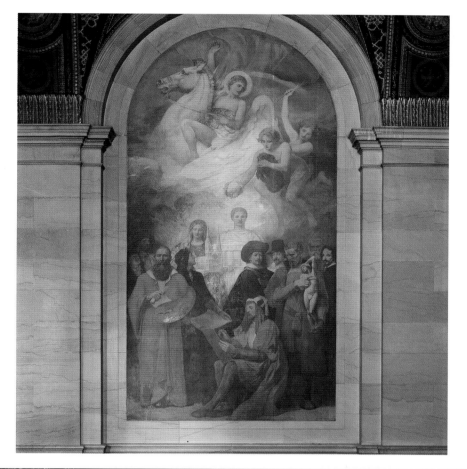

Graphic Arts, 1921-22: Panel, Detroit Public Library, Detroit, Michigan. (Anne Day, photographer)

In the center, a man and a woman who symbolize Greek and Gothic architecture hold models of the Parthenon and the Cathedral of Chartres, respectively. Behind them a genius riding Pegasus flies upward. A group of artists populates the rest of the panel. From the left are Giorgione, Donatello, Titian, Raphael, Rembrandt, Rubens, Michelangelo, Tintoretto, Velásquez, and Dürer, seated.

The Joining of the Ways, 1921-22: Lunette, Detroit Public Library, Detroit, Michigan. (Anne Day, photographer)

This small lunette chronicles Detroit; the youthful figure at left represents the Great Lakes region, and the woman on the right leaning on a gear wheel is modern industry. Standing behind the two is the symbolic figure of Detroit holding the shield of the city.

Saint Mark with Lion, 1921: Charcoal and pencil on paper, 40 x 26 inches, Williams College Museum of Art. Gift of Grace Hall Blashfield and Mrs. William Cary Brownell 38.5.1. (Williams College Museum of Art)

(opposite)
Saint Mark with the Lion, 1922–26: One of four mosaic pendentives designed by Edwin H. Blashfield, Cathedral of Saint Matthew the Apostle, Washington, DC. (Anne Day, photographer)

Saint Luke with the Winged Bull, 1922–26: One of four mosaic pendentives designed by Edwin H. Blashfield, Cathedral of Saint Matthew the Apostle, Washington, DC. (Anne Day, photographer)

Saint John with the Eagle, 1922–26: One of four mosaic pendentives designed by Edwin H. Blashfield, Cathedral of Saint Matthew the Apostle, Washington, DC. (Anne Day, photographer)

Saint Matthew with his Angel, 1922–26: One of four mosaic pendentives designed by Edwin H. Blashfield, Cathedral of Saint Matthew the Apostle, Washington, DC. (Anne Day, photographer)

sanctuary lunette and *Saint Matthew Enthroned*, a vertically oriented panel just above the altar (designed 1914, mosaics executed 1914–18). In the pendentives, Matthew, Mark, Luke, and John are each seated atop several steps and identified by their traditional attributes as well as by a decorative plaque at the base of each mosaic. Blashfield follows his established method of unifying a pendentive group with repeating decorative motifs, such as the plaques and his trademark massive wings that extend to fill the upper edges of the pendentives, suggesting a connected circle of figures.

The majority of Blashfield's late mural commissions were smaller in scale. Several works installed in church altar areas had the dimensions of large Salon paintings, though the fact that they would be most frequently seen at a great distance by seated congregants required consideration of viewing distance and simplified compositions, key issues in mural design.

ANNE E. SAMUEL

Representative works include *The Good Shepherd,* Church of Saint Luke, Atlanta, 1913, and *The Good Shepherd,* Bethesda Church, Salisbury, Maryland, c. 1924.

Other small-scale mural commissions afforded intimate viewing distances and warranted more complex compositions. For the Union League Club in Chicago, Blashfield included detailed symbolism in the overmantel *Patria* (1926). The central figure of Columbia stands serenely, holding a copy of the Constitution, as massive American flags billow down to her left and right, and handmaidens of Loyalty present a shield inscribed "Patria" at her feet. Justice, at left, presents her scales, and Fortitude, her shield; both suggest peacetime vigilance with their casually placed swords. Another commis-

The Good Shepherd, 1924: Choir of Bethesda United Methodist Church, Salisbury, Maryland. (Anne Day, photographer)

ANNE E. SAMUEL

Patria, 1926: Overmantel, Union League Club, Chicago, Illinois. (Photography courtesy of the Union League Club)

The mural interprets the club's motto, "Welcome to Loyal Hearts: 'We join ourselves to no party which does not carry the flag and keep step to the music of the Union.'" Columbia holds the Constitution in her left hand. Seated at her right is a figure depicting Justice; at her left is Fortitude. At the bottom, two figures representing Loyalty hold a shield decorated with symbols of peace.

sion in Chicago, for the Elks National Memorial Headquarters building, entailed two vertical panels, *Charity* and *Fraternity* (see page 101), and the lunette *Fraternal Justice* for a small lobby leading from Memorial Hall to the Grand Reception Room. The vertical panels' lower figure register is at the viewer's level, allowing close scrutiny of symbolism and brushwork.

A residential mural patron, Everett Morss, MIT class of 1885, funded Blashfield's final large-scale murals, for the Walker Memorial at the Massachusetts Institute of Technology. His contribution was publicized only after his death, at which time MIT President Karl T. Compton attributed the gift to "Mr. Morss' enjoyment of the mural decorations in his own home, which led him to wish for something of the same sort for the Technology students

Fraternal Justice, 1927: West corridor lunette, Elks National Memorial, Chicago, Illinois. (Anne Day, photographer)

This splendid classical building was erected by the fraternal organization as a memorial to those Elks who had died in World War I. It was rededicated in 1946 to those brothers who died in World War II, and again in 1976 as a memorial to those who died in the Vietnam War.

ANNE E. SAMUEL

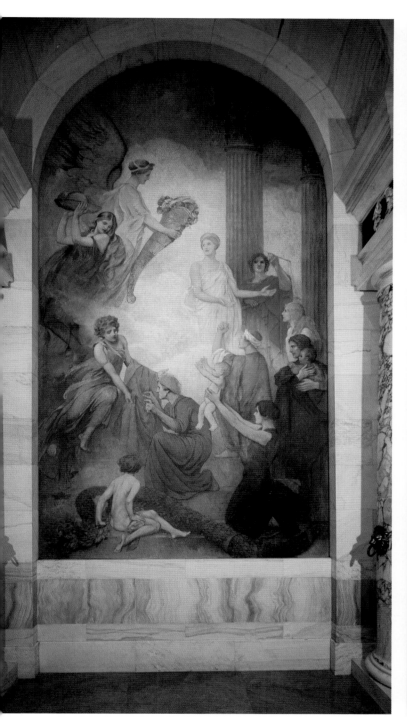

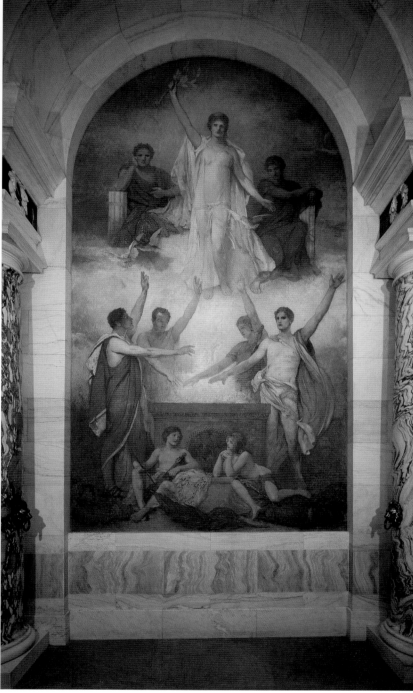

Fraternity, 1927: Panel, Elks National Memorial, Chicago, Illinois. (Anne Day, photographer)

Charity, 1927: Panel, Elks National Memorial, Chicago, Illinois. (Anne Day, photographer)

and alumni. . . ."[61] A member of the class of 1869, Blashfield seems to have contributed to his alma mater by creating a mural that was significantly larger and more complex than he would typically render for the sum paid, $10,000.[62] In January 1924, the north wall panel *Alma Mater* was dedicated, and it was augmented by two more murals on the south wall in 1930. On the north wall, the enthroned Alma Mater is joined by representations of learning through the written word and through experiment, and is flanked by groups of figures symbolizing various fields of study. Although the composi-

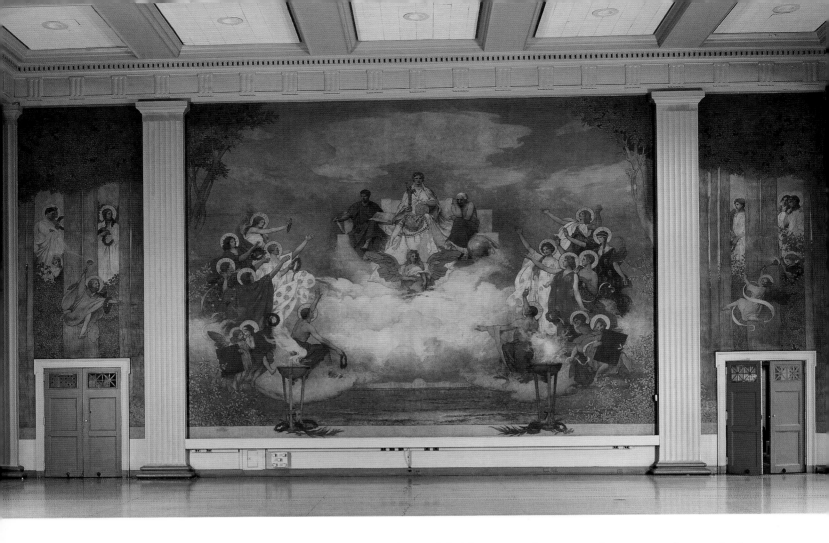

Alma Mater, 1923: North wall mural, Morss Hall, Walker Memorial, Massachusetts Institute of Technology, Cambridge, Massachusetts. (Anne Day, photographer)

The central figure, Alma Mater, holds Victory in her right hand and rests her left hand on the university seal. The seal of the State of Massachusetts lies on her lap. The world, in the form of a terrestrial globe, is at her feet. A misty suggestion of the Charles River and the Massachusetts Institute of Technology buildings can be seen in the center foreground.

tion is rather formal, Blashfield apparently saw exuberance or humor in it; according to H. J. Carlson, he joked that *Alma Mater* might be called "A College Yell for Alma Mater."[63] The murals on the north wall, *Humanity Led from Chaos into Light by Knowledge and Imagination* (see page 104) and *Good and Bad Uses of Science*, are more overtly dramatic. The latter mural is a significant departure for Blashfield, as the negative alternative to institutional aspirations is made visible. On the center podium, a scientist stands between "two great jars containing beneficent and maleficent gases or constructive and destructive possibilities." The gases swirl upward dramatically, and although Hygeia, crowning the scientist, is more prominent than her evil counterparts, one can still discern the "Dogs of War" and the figure of Famine at right.[64] The course of future scientific achievements would be determined by the students congregating in the Walker Memorial and viewing Blashfield's mural.

In the 1930s, mural painting experienced a resurgence thanks to federal funding initiatives. Blashfield was in his eighties, an elder statesman, largely ignored by administrators of government mural programs and dismissed by champions of modernist and realist murals.[65] He ceased painting murals in 1933, because of concerns about the physical rigors of the art form.[66] Copious unpublished reactions to new tendencies in mural painting express appreciation for the enthusiasm and productivity of the Works Progress Administration (WPA) and contemporary mural programs, but criticized the

ANNE E. SAMUEL

Good and Bad Uses of Science, 1930: South wall panel, Morss Hall, Walker Memorial, Massachusetts Institute of Technology, Cambridge, Massachusetts. (Anne Day, photographer)

The artist believes that chemistry has given mankind almost unlimited power, and he raises the question: Will this power be used to build up or demolish civilization? At the foot of the panel is an inscription from Genesis: "Ye shall be as gods, knowing good and evil."

artists' and administrators' lack of interest in coordination with architecture and rejection of Italian Renaissance or American Renaissance precedent. Blashfield's central critique was that many artists painting murals had not learned the lessons of traditional wall painting, and did not care to do so: "Mural painting today is offered by the Federal Government more opportunity than any other branch of art, but Mural Painting demands more kinds of knowledge than any other form of painting. To a mural painting, a foundation is as necessary as to a tall tower. Yet today the trend is away from fundamentals and the models cited often as the best are artists who do not draw, do not compose, do not create good color."[67]

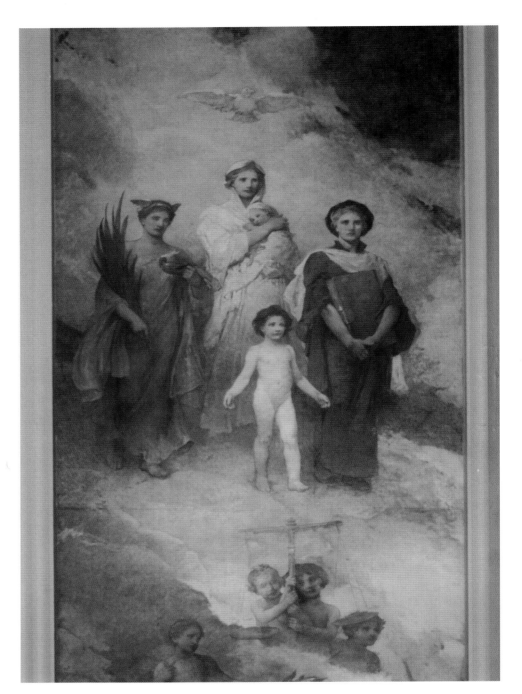

Humanity Led from Chaos into Light by Knowledge and Imagination, 1930: South wall panel, Morss Hall, Walker Memorial, Massachusetts Institute of Technology, Cambridge, Massachusetts. (Anne Day, photographer)

Humanity, represented by a mother and her children, is being led forward from chaos to light.

Due to Blashfield's remarkable longevity, with an artistic career spanning over sixty years, he was both a central figure in the rise of the American Renaissance mural movement and a witness to its decline. Blashfield's experience as a muralist was typical for his generation, as he adapted academic training in figure painting to new mural opportunities in Beaux-Arts buildings. He embraced modern mural practices, such as stereoscope enlargement and marouflage, and integrated modern American figures into murals that pay tribute to tradition through composition and technique. Concurrently, he and his contemporaries established professional practices in the field, including collaborative exchanges with patrons and architects and pro-

ANNE E. SAMUEL

motion of murals in the New York art world and across the country. Despite his individual reputation, as a muralist Blashfield was committed to the notion of mural painting as a collective endeavor, rooted in tradition. He believed that the best results would be attained when artist, architect, decorator, and patron respectfully cooperate, and the muralist skillfully integrates artistic lessons from the history of wall painting with subjects and symbols that speak to contemporary audiences.

NOTES

1. Edwin Howland Blashfield, *Mural Painting in America* (New York: Charles Scribner's Sons, 1913), p. 311.

2. Edwin Howland Blashfield, "Address Given at Annual Meeting of the Mural Painters, 26 April 1910," in National Society of Mural Painters Papers, Archives of American Art, frames 1172, 1173, and 1174.

3. Ibid, frame 1167.

4. Edwin Howland Blashfield, "Leon Bonnat," in *Modern French Masters: A Series of Biographical and Critical Reviews by American Artists, with Thirty-Seven Wood-Engravings and Twenty-Eight Half-Tone Illustrations*, ed. John Charles Van Dyke (London: T. Fisher Unwin, 1896), p. 49.

5. Ibid., p. 50.

6. Edwin H. Blashfield Papers, Archives of American Art, Smithsonian Institution. Notes by Edwin H. Blashfield on verso of reproduction of *Group of Soldiers*, roll 1117, frame 162.

7. Alfred Trumble, *Representative Works of Contemporary American Artists* (New York: Charles Scribner's Sons, 1887; reprint, *The Art Experience in Late Nineteenth Century America* (New York: Garland Publishing, 1978).

8. "New Pictures at Schaus Gallery," *New York Times*, November 29, 1878, p. 5.

9. Edward Strahan, "The National Academy of Design Concluding Notice," *Art Amateur* 1, no. 2 (1879), p. 28.

10. "New Pictures at Schaus Gallery," p. 5.

11. Ibid.

12. C. M. Hilliard, "Letter from Paris," *Daily Evening Transcript*, July 27, 1880, p. 4. In this article, the title given to *The Music Lesson* is *Roman Lady Teaching some Children to Play the Lute* [*sic*].

13. Edwin Howland Blashfield, "Letter to His Mother, 1 August 1890, in Travel Letter Scrapbook, Page 76," in Edwin Howland Blashfield Papers, The New-York Historical Society.

14. Blashfield, *Mural Painting in America*, p. 187.

15. C. M. Fairbanks, "Illustration and Our Illustrators," *The Chautauquan* 13, no. 5 (1891), p. 597.

16. Edwin Howland Blashfield, "Letter to Edward Burlingame, September 6, 1886," in Archives of Charles Scribner's Sons, Author Files I, Box 15. Used by permission of the Princeton University Library.

17. Edwin Howland Blashfield, "Draft of Biography of Evangeline Wilbour Blashfield," Edwin Howland Blashfield Papers, The New-York Historical Society.

18. Marc Alfred Simpson, "Reconstructing the Golden Age: American Artists in Broadway, Worcestershire, 1885 to 1889." Yale University, 1993. 366. Lucia Millet's letters to her family, as quoted by Simpson, offer a rough chronology of the Blashfields' time in Broadway. After a preliminary visit, they came to Broadway in mid-July and stayed through September 20. See Lucia Millet to her family, July 12, 1886, and September 19, 1886, Sharpey-Schafer gift, Archives of American Art.

19. Edwin Howland Blashfield, "Letter to Edward Burlingame, 8 November 1886," in Archives of Charles Scribner's Sons, Author Files I, Box 15. Used by permission of the Princeton University Library.

20. John A. Wilson, *Signs and Wonders Upon Pharaoh: A History of American Egyptology* (Chicago: University of Chicago Press, 1964), pp. 102–3, 232.

21. Charles Edwin Wilbour, *Travels in Egypt December 1880 to May 1891*, ed. Jean Capart (Brooklyn, NY: Brooklyn Museum, 1936), p. 426; letter written on March 16, 1887.

22. Martha N. Hagood and Jefferson C. Harrison, *American Art at the Chrysler Museum: Selected Paintings, Sculpture, and Drawings* (Charlottesville: University of Virginia Press, 2005), p. 118.

23. "Art Notes," *The Critic*, no. 232 (1888), p. 286; and "Sketches of Egypt," *New York Times*, June 5, 1888.

24. *Paris 1889: American Artists at the Universal Exposition* (Philadelphia: Pennsylvania Academy of the Fine Arts in association with H. N. Abrams, 1989), p. 115.

25. M.G.H., "Talks with Decorators. Mr. E.W. [sic] Blashfield on the Arrangement of Rooms," *Art Amateur* 19, no. 4 (1888), p. 91.

26. "American Art in Paris," *New York Times*, July 13, 1891.

27. Susan Elizabeth Earle, "Puvis de Chavannes and America: His Artistic and Critical Reception 1875–1920" (Institute of Fine Arts, New York University, 1998), pp. 82, 132–33.

28. Blashfield, *Mural Painting in America*, pp. 263–64.

29. Blashfield, "Jean-Paul Laurens," in *Modern French Masters*, p. 88.

30. "Furniture and Decoration," *Art Amateur* 12, no. 2 (1885), p. 40.

31. Edwin Howland Blashfield, in Edwin H. Blashfield Papers, Archives of American Art, Smithsonian Institution Roll 1117, frame 447.

32. Pauline King, *American Mural Painting: A study of the important decorations by distinguished artists in the United States* (Boston: Noyes, Platt & Company, 1902), p. 249.

33. Royal Cortissoz, "Painting and Sculpture in the New Congressional Library I: The Decorations of Mr. Edwin H. Blashfield," *Harper's Weekly* 40 (1896), p. 35.

34. Edwin Howland Blashfield, "Mural Painting," in *A Dictionary of Architecture and Building*, ed. Russell Sturgis (New York: The Macmillan Company, 1901), volume II, pp. 981–97. For Vasari's use of this norm, see Thomas Puttfarken, *The Discovery of Pictorial Composition: Theories of Visual Order in Painting, 1400–1800* (New Haven: Yale University Press, 2000), pp. 123–68.

35. Blashfield, "Mural Painting," p. 982.

36. Edwin Howland Blashfield, "Letter to Bernard Green, 18 November 1896," in Buildings and Grounds Subseries I, Records of the Library of Congress, Manuscript Division.

37. Blashfield, "Mural Painting," p. 982; and A. A. Hopkins, "The Great Scaffolds of the Congressional Library, Washington, DC," *Scientific American* 75, no. 20 (1896), pp. 357, 364.

38. King, *American Mural Painting*, p. 46.

39. David Hockney, *Secret Knowledge: Rediscovering the Lost Techniques of the Old Masters* (New York: Viking Studio, 1991); Mark Tucker and Nica Gutman, "Photographs and the Making of Paintings," in *Thomas Eakins*, ed. Darrel Sewell (Philadelphia: Philadelphia Museum of Art, 2001), pp. 225–38; Ulrich Pohlmann, "Another Nature; or, Arsenals of Memory: Photography as Study Aid, 1850–1900," in *The Artist and the Camera: Degas to Picasso*, ed. Dorothy M. Kosinski (New Haven: Yale University Press, 1999), p. 43; Gabriel P. Weisberg, *Beyond Impressionism: The Naturalist Impulse* (New York: Harry N. Abrams, Inc., 1992), p. 25; and Hector MacLean, *Photography for Artists* (Bradford: Percy Lund & Company, Ltd, 1896; reprint, The Literature of Photography series, New York: Arno Press, 1973), p. 14.

40. Stephan Oettermann, *The Panorama: History of a Mass Medium* (New York: Zone Books, 1997), p. 55.

41. A.R.W. [Arthur R. Willett], "Enlarging Mural Decorations," *Harper's Weekly* 41 (1897), p. 1122.

42. "The New Astoria Hotel," *New York Times*, October 16, 1897, p. 9.

43. Willett, "Enlarging Mural Decorations," p. 1122.

44. Blashfield, *Mural Painting in America*, pp. 179–80.

45. Abbie W. Robbins, "Letter to Edgar R. Harlan, 10 July 1919," in Edgar R. Harlan correspondence, State Historical Society of Iowa, Des Moines.

46. Blanche Wingate, "Sidelights," *Sunday Register*, October 2, 1932.

47. Blashfield, *Mural Painting in America*, p. 197.

48. Channing Seabury, "Letter to Edwin H. Blashfield, 22 September 1904," in State Capital Commissioners Board. Letters Sent. Minnesota, State Archives.

49. Edwin Howland Blashfield, "Letter to Charles F. Owsley, 12 October 1909," in Owsley-McKelvey Family Collection, Box 1 Correspondence, Charles F. Owsley, Mahoning Valley Historical Society, Youngstown, Ohio.

50. Ibid.

51. George B. Post, "Letter to Lew F. Porter, 28 October 1911," in Wisconsin. Capitol Commission: General Files, 1903–1927, Wisconsin Historical Society Archives.

52. Leonard N. Amico, *The Mural Decorations of Edwin Howland Blashfield, 1848–1936* (Williamstown, Mass.: Sterling and Francine Clark Art Institute, 1978), p. 43.

53. Anne Lee, "Our Dean of Mural Painters Toils On," *New York Times Magazine,* December 9, 1928, pp. 12, 13, 20.

54. [Royal Cortissoz], "Matters of Art: A Painting for the State Capitol of Wisconsin," *New-York Tribune*, November 10, 1912, p. 6.

55. Edwin Howland Blashfield, "Letter to Royal Cortissoz, 13 November 1912," in Royal Cortissoz Collection. Beinecke Rare Book and Manuscript Library, Yale University.

56. "Every Calling in the Line," *New York Times*, 14 May 1916.

ANNE E. SAMUEL

57. Edwin Howland Blashfield, "Letter to Royal Cortissoz, 25 May 1918," in Royal Cortissoz Collection. Beinecke Rare Book and Manuscript Library, Yale University.

58. A. E. Gallain, "Letter to Edwin H. Blashfield, 15 March 1919," in Edwin Howland Blashfield Papers, The New-York Historical Society.

59. "Edwin Blashfield, Noted Artist, Dies," *New York Times*, October 13, 1936.

60. Explained in Edwin Howland Blashfield, "Letter to Vincent Aderente, 15 September 1927," in Vincent Aderente Papers. Burton Historical Collection, Detroit Public Library.

61. Karl T. Compton, "Letter to Edwin H. Blashfield, 17 February 1934," in Massachusetts Institute of Technology, Office of the President. Records, 1930–1959.

62. Everett Morss, "Letter to Dr. S.W. Stratton, 4 January 1924," in Massachusetts Institute of Technology, Office of the President. Records, 1897–1930.

63. H. J. Carlson, " 'The Blashfield Decoration' Address at Mural Dedication," in Massachusetts Institute of Technology, Office of the President. Records, 1897–1930.

64. J.R.K., *The Blashfield Murals in Walker Memorial, Massachusetts Institute of Technology* (Cambridge, Mass.: The Technology Press, 1935).

65. For example, see Edward Bruce and Forbes Watson, *Art in Federal Buildings, an Illustrated Record of the Treasury Department's New Program in Painting and Sculpture* (Washington, DC: Art in Federal Buildings Incorporated, 1936).

66. "Blashfield, at 85, Quits His 'Trade,'" *New York Times,* September 19, 1933, p. 19.

67. Edwin Howland Blashfield, "[Objections to Federal Mural Program Criteria and Historical Context]," in Edwin Howland Blashfield Papers, The New-York Historical Society.

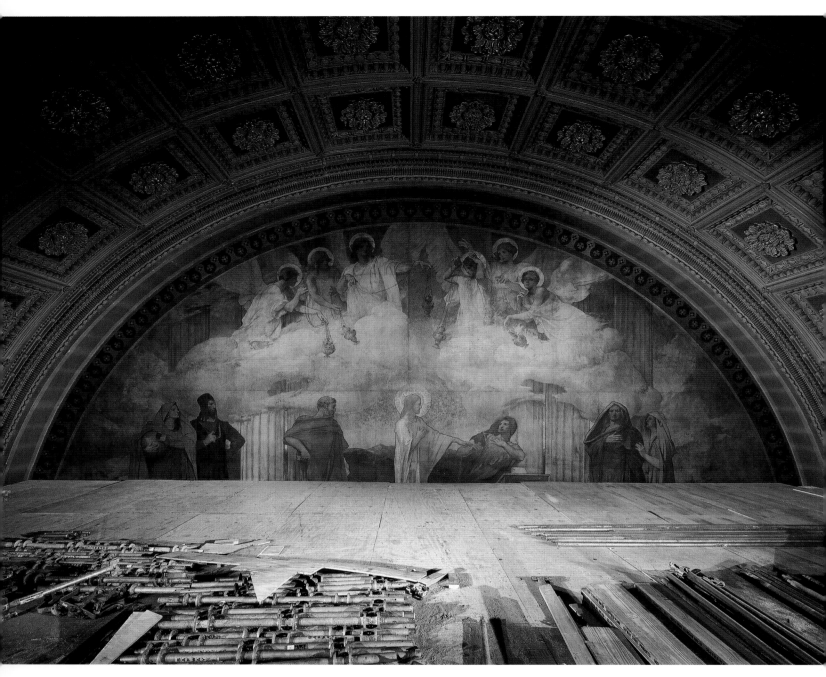

The Calling of Saint Matthew, 1925: West transept lunette as seen from the conservator's scaffold, Cathedral of Saint Matthew the Apostle, Washington, DC. (Whitney Cox, photographer)

Observations from a Conservator's Perspective

GILLIAN BRITTA RANDELL

*Our present practice in mural painting in America is composite in origin.
Our technic [sic] was acquired in the main in Paris ateliers, and it is applied
to the creation of wall paintings which derive largely from study of the Ital-
ian work of the Renaissance, and which in turn is in some cases, modified by
admiration for the art of Puvis de Chavannes.[1]*

The process of conserving paintings requires investigation and analysis that
often yield rich empirical information about the artist's working technique and
materials. The conservator is provided an intimate, tactile, and prolonged
audience with the art object that is not afforded most viewers. This is especially
true when the conservator can examine a mural in detail from scaffolding.

The following discussion of seven Blashfield murals includes paintings
from three different locations, spanning a twenty-seven-year period of the
artist's work, and is a circumstantial rather than representative sampling of his
works. These paintings represent several different aspects of Blashfield's work,
compositions appropriate for both civic and ecclesiastic venues, and coincide
with scheduled conservation projects rather than providing a comprehensive
view selected for pertinent stylistic examples or conservation concerns.

From the perspective of a conservator specializing in murals, the most
striking aspect of Edwin Howland Blashfield's work is his ability to incorpo-
rate the rich layering of paint, most often associated with easel painting tech-
nique, into a monumental scale. Most murals are intended to be viewed from
a distance, not scrutinized in minute detail—appreciated, in part, for their
command of an architectural space. The magnitude of the space often dic-
tates the need for multiple hands and an economical application of paint.

The implied distance of the viewer encourages the artist to use trompe l'oeil techniques to create a successful illusion, employing shading and perspective. Blashfield integrates these devices but also builds depth and richness by varying his application of paint in both flat washes and highly textured multiple opaque layers. Texture in murals is not unique to Blashfield, but his rich and buttery application of opaque paint strikes the viewer both from afar and when viewed in close proximity; a small detail of a Blashfield mural works as an abstract painting in its own right.

As mentioned in previous chapters, Blashfield had studied in Paris with both Léon Bonnat and Jean-Léon Gérôme. He benefited from exposure to their artistic differences: "here were two artists, one of whom never let a brush-mark show upon his smooth and sometimes almost monochromatic canvases; the other of whom painted with broad strokes, loaded pigment, strong colors."[2] During his extensive European travels, Blashfield had the opportunity to examine the works of other great artists, becoming familiar with their individual approaches to the application of oil to canvas, their mastery of color and texture, and their brushstrokes. In his book *Mural Painting in America,* he reveals his understanding and admiration for masters of the past. He wrote: "Rembrandt was perhaps the first artist who frankly entertained himself with pigment . . . which could be thickened or thinned, spread heavily or not, in planes or lumps, parsimoniously or abundantly, with a hand which caressed, kneaded. . . ."[3] Blashfield continues celebrating other artists. "In Spain, Velasquez . . . the monarch of all brush workers."[4] "Tiepolo performed with the brush point, whether in oil or fresco, feats of *disinvoltura,* which for downright skillfulness have, perhaps, been unequalled in the history of art."[5] He states that "as far as the masters of transparent color are concerned, I am on my knees to Veronese and Pinturicchio."[6] Then Blashfield indicates that in the current period there was a freedom and variety in the handling of surface,[7] a comment that leads a conservator to consider all these techniques when approaching Blashfield's work.

In addition to technique, like many of his contemporary European-trained artists, Blashfield was influenced by the compositional principles implemented by the Italian Renaissance and particularly praised Pietro Perugino for his insights about painting integrated interiors, treating each room as a whole, as a piece of architectural completeness. He noted that one's decoration should "cling to the walls of a building like a great drapery."[8]

As explained in Mina Weiner's chapter, from the 1890s until the 1920s, the City Beautiful movement was responsible for the advent of many neoclassical murals in public buildings, specifically courthouses and capitols, where their didactic subject matter was meant to elevate an impoverished urban environment and advance a moral society. The ideals of this movement were integrated into the discipline that would later become urban planning. Blashfield, a founding member of the National Society of Mural Painters, promoted a pictorial vibrancy and a collective enthusiasm among muralists and

their patrons that are a clear reflection of the City Beautiful philosophy during the period termed the American Renaissance. Working with fellow members of the society in both the Appellate Division, First Judicial Department Courthouse in Manhattan and the Essex County Courthouse in Newark, New Jersey, Blashfield created an impressive catalogue of paintings that illustrate tenets of the progressive movement and incorporate the use of classical and Beaux-Arts elements that seek to blend artwork with architecture.

Power of the Law acts as part of a triptych with two other like-sized panels on the east wall of the Appellate Courthouse: Edward Simmons's *Justice of the Law* and Henry O. Walker's *Wisdom*. Blashfield worked in tandem with the architect James Brown Lord and ten painters to create a mural series with complementary scale and a unified civic theme. In the series, the hands of the distinct artists, all members of the Mural Painters Society, are discernable and individually attributed by panel; the series is a well-orchestrated, visually harmonious collection of murals.

In the center foreground of *Power of the Law*, Law draws her sword on behalf of the Court of Appeals; she is flanked by idealized figures such as black-cloaked judges, Roman magistrates, and an early Anglo-Saxon

Triptych, Appellate Division, First Judicial Department Courthouse, New York City. (Whitney Cox, photographer)

From left to right: *Justice of the Law* by Edward Simmons, *Wisdom* by Henry O. Walker, *Power of the Law* by Edwin H. Blashfield, 1899.

bishop, representing practitioners of Common, Roman, and Canon Law. The floating female figures crown Law with a wreath symbolizing power. The two children in the lower corners of the painting bear shields with the seal of the Court of Appeals. Across the escutcheons, unraveling scrolls state "uphold the right" and "prevent the wrong." This iconography credits a Roman and European provenance in both the subject matter and its composition. The children represent the legacy of these traditions within the contemporary American court. In a *New York Times* article (December 21, 1899), Blashfield's mural is cited for the "strength of draughtmanship [*sic*] and his rich and subdued color. The composition is especially noticeable for its dignity."

Consistent with his working practices and utilization of marouflage, a French mural painting technique described at length in Anne Samuel's chapter, Blashfield painted the mural in his New York City studio and installed the canvas on location. It appears that, in this case, no final adjustments were necessary on site. *Power of the Law* is a relatively small mural (126 inches high by 118 inches wide) located at eye level to the viewer, similar to the installation of a large-format easel painting. Larger mural canvases were often augmented or adjusted after installation to conceal seams, accommodate the topography of the substrate, adapt the palette to the existing light, or change the perspective.

The application of the paint in Blashfield's *Power of the Law* is similar to that of Edward Simmons's adjacent painting but with more variation in texture. Blashfield's palette is relatively more vibrant than that of Walker's flanking mural *Wisdom*, which displays muted colors and scumbled (mottled opaque glaze) paint application. In some areas of the background, Blashfield's heavily applied turquoise paint has an appearance similar to encaustic paint, creating the impression of a high-contrast mosaic. In *Power of the Law* there is interesting visual play between the weave of the fabric, in the more thinly painted areas depicting the figures, and the thickly applied impasto of the background texture.

Architect Cass Gilbert commissioned murals by seven painters for the Essex County Courthouse in 1906–7. Among the muralists were Blashfield, Will Low, Walker, Charles Y. Turner, and Kenyon Cox, who had all worked on the Appellate Courthouse in Manhattan. Blashfield's pendentives depicting the iconic figures Wisdom, Power, Knowledge, and Mercy are located in the rotunda. They were painted in an oleaginous medium on canvas and attached directly to the plaster substrate. The murals can be viewed from four stories below or in relatively close proximity from the fourth floor corridor. The idealized figures are composed of many layers of opaque paint, with fine brushwork in burnt sienna or blue outlines that define the contours of the figures from a distance. Blashfield's mentors Jean-Léon Gérôme and Léon Bonnat emphasized figures by outlining their idealized forms in murals. Viewed from the scaffolding, the minute detail of the composition is

GILLIAN BRITTA RANDELL

impressive in its delicate rendering. Though unnecessary to create an effective image, the attention to detail attests to Blashfield's dedication to his craft. The extent of his efforts to create highly finished murals in which no area is insignificant differentiates Blashfield from most muralists.

In 2004 the murals in the Essex County Courthouse were conserved as part of the restoration of the entire courthouse, which had been vacant for many years. The female figures in the rotunda were in relatively good condition, but were obscured with a heavy accumulation of surface dirt and grime—specifically a heavy coating of nicotine staining that darkened the tonality of Blashfield's original palette. The canvases were delaminating or separating along seams and required reattachment and minimal plaster consolidation. Areas where seams or incisions in the canvas had been painted over after installation had undergone color shifts and no longer matched the adjacent original paint.

The paint that masked the seams and incisions made during the installation of the paintings was probably original. Blashfield and his assistants char-

Detail: *Knowledge*, rotunda pendentive, Essex County Courthouse, Newark, New Jersey. (Gillian Britta Randell)

This photograph shows a small area of the pendentive that had been cleaned, in sharp contrast with the rest of the figure yet to be worked on. The book's lettering reveals Blashfield's attention to detail even when the work will be seen from a distance.

acteristically worked on the murals after they had been installed. However, over time, this original paint has become discolored. Visually disconcerting passages were inpainted in easily reversible conservation paint.

Blashfield was acutely aware of the crucial relationship between artist and assistant. He wrote, "We shall seek for our assistants of the day, as they become leaders of the morrow. . . ."[9] Vincent Aderente (1880–1941) was Blashfield's assistant for over three decades, from approximately 1897 to 1930, collaborating on and executing many of Blashfield's designs. Blashfield was especially pleased with his assistant's ability as evidenced in his work on the murals at the Cathedral of Saint Matthew the Apostle.[10] Both *The Calling of Saint Matthew* and *The Martyrdom of Saint Matthew,* located in the transepts of the cathedral, were designed by Blashfield, and major sections were painted by Vincent Aderente under Blashfield's supervision. Both names appear on each canvas. When working on the space, conservators were able to distinguish the work of each artist. Aderente, whose independent work is evident elsewhere in the cathedral, approached the canvas in a lighter style with no percussive brushwork and favored less bold colors and a less generous use of paint.

The large lunettes in the transepts were commissioned by architect C. Grant LaFarge in 1919 and executed over a span of seven years. In keeping with Blashfield's usual methodology, the lunettes were painted in oil on canvas in his New York studio and then installed on site. *The Calling of Saint Matthew* is constructed out of fifteen pieces of canvas, assembled in roughly three tiers. The widest width of the canvas is 134 inches and the longest run is 251 inches. The murals began as studies; from these études the composition was enlarged and transferred to canvas, the artist and assistant adjusting proportions and adding detail. Once the murals were installed in the cathedral, they were integrated into the surrounding space by painting over seams, augmenting the palette, especially in the background, and redefining certain figures. Expressionistic brushwork, similar to that of the pointillists, softens the spatial relationship between the figures and their setting.

Blashfield wrote of his mentor Léon Bonnat's technique, "With a big strong brush loaded with color he was beating the bright strong blue of the sky with regular drum-like strokes . . . it seemed almost like hammering, and compelled my admiration of its vigor."[11] This percussive brushwork is well illustrated in the application of paint in *The Calling of Saint Matthew*. The texture is exuberant and the highly contrasted colors are boldly applied.

When the conservation project commenced in 2003, both *The Calling* and *The Martyrdom* were in stable condition but had a dull appearance, having accumulated surface dirt and grime over a period of seventy years. Once the current condition of the murals had been documented with photographs and schematic drawings, microsamples were taken for technical analysis to determine the composition of the degraded presentation layer.

Conservation scientist Kate Helwig of the Canadian Conservation Insti-

tute analyzed the samples and determined that there was an early synthetic surface coating on the murals. Helwig used incident light and fluorescence microscopy to document the layer structures of the murals, from the presentation layer to the canvas. Individual layers were analyzed by Fourier transform infrared (FTIR) spectroscopy and in some cases polarized light microscopy (PLM) or X-ray diffraction (XRD). The analysis confirmed that the paint is composed of an oleaginous medium and identified the primary support as flax. This cross section shows that the mural has a complex layer structure. The primary coating is a white ground, followed by a second white layer and a thin orange-red layer. A number of pigmented paint layers and a thick varnish layer proceed in the stratum. The first white ground layer is composed of zinc white in a drying oil medium. The second fine layer was found to consist predominantly of lead white in a drying oil, resembling the progressive layers. The thick varnish layer is an oil-modified alkyd resin containing hydromagnesite, which was used as a matting agent. Oil-modified alkyd coatings only became commercially available in the early 1930s. It is probable that Blashfield selected the coating and directed that all three lunettes were varnished, roughly five years later, when the final lunette was installed in the cathedral. The varnish had undesirable properties, including a low glass-transition temperature, which caused it to soften at relatively low temperatures, degrading and becoming embedded with dark particulate.

Detail: *The Calling of Saint Matthew.* (EverGreen Painting Studios, Inc.)

This study photograph provides a close-up of Blashfield's percussive application of paint.

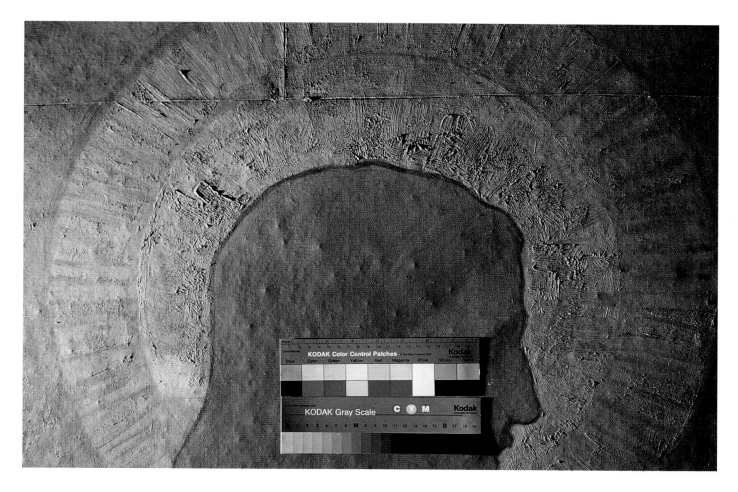

The degraded alkyd varnish was acting like a black veil, obscuring details and darkening Blashfield's brilliant original palette.

A cross section was taken from *The Calling of Saint Matthew*; the paint was friable or crumbly and delaminating from the underlying figuratively painted area. Helwig used scanning electron microscopy/energy dispersive spectroscopy (SEM/EDS) analysis to determine that post-historic over-paint was present on the top of the surface coating. This nonoriginal paint contained titanium white that was not found in the palette of the original colors. Cross sections of this area confirmed that the original paint had become degraded and that a restoration had been previously executed.

This cross section revealed a gray delaminating layer. On top of this layer is an oil-modified alkyd layer, followed by a thin black layer, and then the incomplete white presentation layer. The thin black layer is probably dirt, consistent with layers found on other murals in the series. The thin, uneven layer has been applied over the varnish and dirt layer, which indicates that it is a post-historic over-paint.

Pigments and fibers were also examined using polarized light microscopy. This process helped identify early restoration of *The Calling of Saint Matthew* and illustrated the artist's method of building up layers of paint to achieve an appearance of unctuous painterly richness. The following pigments were identified: barium sulphate, calcium carbonate, zinc white, an organic red pigment, an organic brown pigment, lead white, iron oxide yellow, and ultramarine.

Although varnished, the lunettes appeared very matte. Cross sections were taken to determine the composition of the surface coating and to help explain its matte qualities. The absorbency of the ground layer was also considered as a factor in the matte appearance of the murals. The ground was determined to be composed of zinc white, zinc soaps, and a drying oil. These materials are not consistent with the composition of nineteenth-century

Photomicrograph: *The Martyrdom of Saint Matthew*, lunette, Cathedral of Saint Matthew the Apostle, Washington, DC. (Canadian Conservation Institute)

GILLIAN BRITTA RANDELL

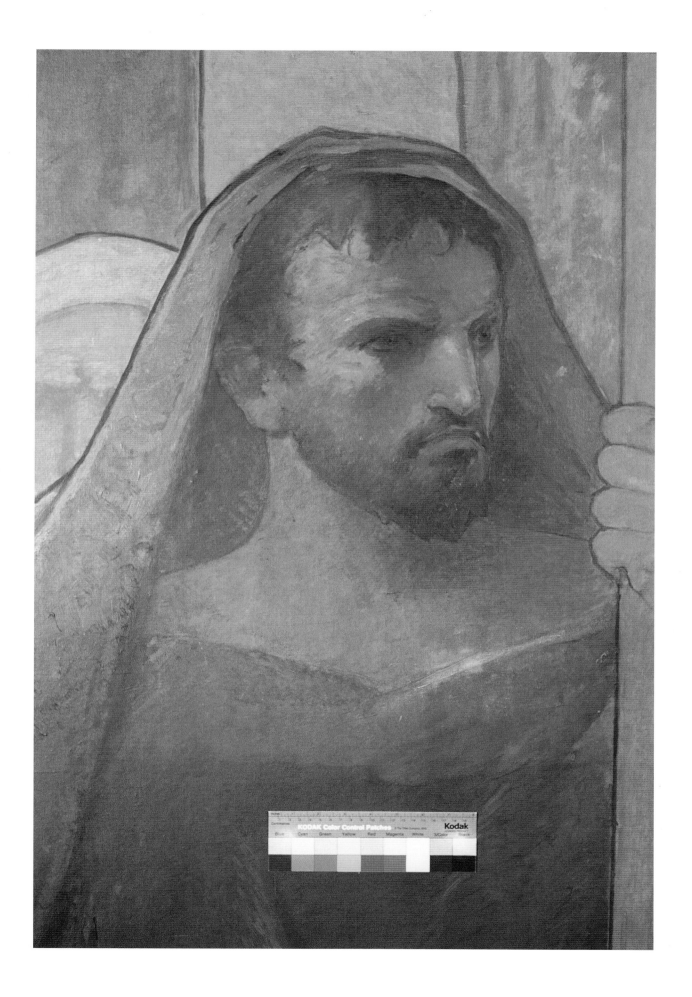

absorbent ground recipes, which were generally composed of a protein medium rather than a drying oil. The paint layers were identified to have a drying oil medium. The thick varnish layer contains an oil-modified alkyd resin containing hydromagnesite, which was used as a matting agent. Therefore, the matte appearance is due to the matting agent rather than an absorbent ground, which suggests that the artist intended the murals to have a matte appearance, and that it was not an accidental result of the materials used.

This cross-section photograph (see page 116) shows that the artist applied a warm red *imprimatura* layer to the white ground prior to applying several layers of thick blue paint and several thin red layers to create a rich, complex appearance. The red *imprimatura* layer influences the color temperature of the mural, giving it a warm appearance. Where the cross section illustrates well-delineated layers, this is an indication that the artist worked in distinct layers, not blending the color on the canvas in a "wet into wet" technique. In both of these Saint Matthew lunettes, the paint is composed of a multilayered oleaginous medium constituting a pigment-rich paint system. The paint and ground layers appear to have been applied in a traditional manner, using artist-grade materials and sound techniques.

The paint and ground layer continue to be well bonded to the primary support. The paint was applied with a brush in opaque layers with little glazing. In *The Calling* some areas of the paint are more vehicularly rich because more diluent was added to change the consistency of the medium. Overall, the paint is applied more thickly in *The Martyrdom*, but the nimbuses around the central figures depicting Christ and Saint Matthew in both lunettes are very textural. Prominent figures are highly worked with obvious and rich multiple applications of paint, much closer to the application of paint in an easel painting than what is normally found in a mural. The foreground of the murals, however, is less highly worked with fewer layers of paint.

These Blashfield murals are good examples of the artist's materials, techniques, and style, and indicate that the artist was successful in creating murals that were not only visually impressive but also soundly executed, remaining stable into the twenty-first century.

NOTES

1. Edwin H. Blashfield, *Mural Painting in America* (New York: Charles Scribner's Sons, 1913), p. 261.

2. Edwin Howland Blashfield, "Léon Bonnat," in *Modern French Masters: A Series of Biographical and Critical Reviews of American Artists*, ed. John Charles Van Dyke (London: T. Fisher Unwin, 1896), p. 47.

3. Blashfield, *Mural Painting in America*, p. 295.

4. Ibid., p. 295.

5. Ibid., p. 296.

6. Ibid., p. 300.

GILLIAN BRITTA RANDELL

7. Ibid., p. 302.

8. Ibid., p. 264.

9. Ibid., p. 167.

10. Letter to Vincent Aderente. Edwin Howland Blashfield Papers, Archives of American Art, Smithsonian Institution.

11. Blashfield, *Mural Painting in America*, p. 239.

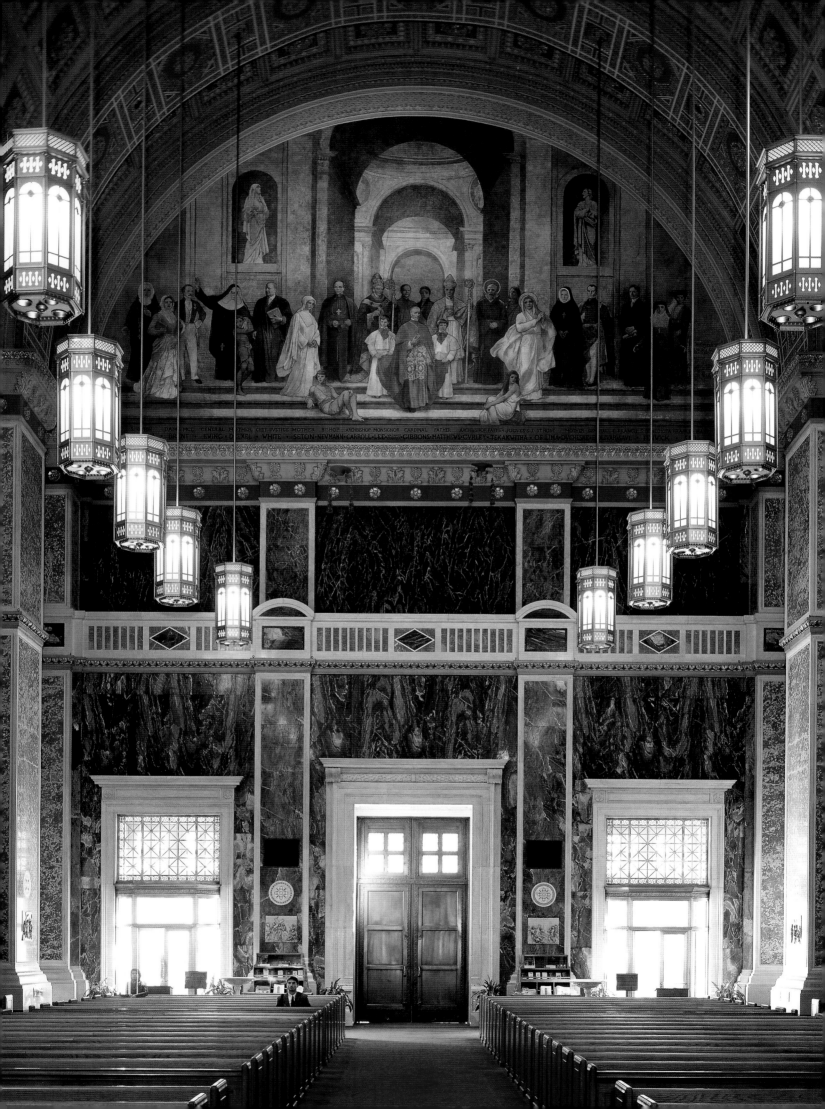

4

The Legacy of Edwin Howland Blashfield, Dean of American Mural Painters

JEFF GREENE

Decoration or decorative art is the art of embellishing the background of life. It is the art of making necessary things beautiful; of using design, form, color to render more pleasing our buildings, clothing, furniture, utensils, in sum our general surroundings. Such is decoration in its largest sense. More strictly defined, a decorative treatment is one which is essentially fitted to its purpose, to its locality . . . and to its environment.[1]

Edwin Howland Blashfield was celebrated by the *New York Times* as the dean of the American mural painters.[2] He combined great talent with a collaborative approach and a civic mission that was new and inspiring for American artists. In 1895, he helped found the National Society of Mural Painters, along with such luminaries of American art as John LaFarge, Edwin Austin Abbey, and Kenyon Cox. As the Society's thirty-seventh president, and a mural painter, I will consider Blashfield's legacy and how his influence has persevered during the past century. In this brief essay, I am able to mention only a few of those whose work carries the imprint of Blashfield's brilliant and civic-minded approach to mural painting.

My observations and reflections are made through the eyes of one who has been trained to see and understand how art is created and who has been involved in numerous commissions for the creation and conservation of public murals. I feel particularly fortunate to have been a part of the conservation and restoration of several historic interiors graced with Blashfield murals, including the Appellate Division, First Judicial Department Courthouse in New York City; the Essex County Courthouse in Newark, New Jersey; and the Cathedral of Saint Matthew the Apostle in Washington, DC.

(opposite) Vincent Aderente (1880–1941), *Saintly and Eminent Personages of the Americas,* 1931: Lunette over main door, Cathedral of Saint Matthew the Apostle, Washington, DC. (Anne Day, photographer)

Both Blashfield's and Aderente's names appear on the other two lunettes in Saint Matthew's main sanctuary, but only Aderente's is inscribed on this mural. The organization of the painting is based on Raphael's *School of Athens.*

Through this unique association with Blashfield, I have become intimately acquainted with his working method and perhaps even his problem-solving thought process.

Blashfield's life and history are handled in depth in other chapters of this book. Suffice it to say, his talents were broad; he first studied engineering, then went on to easel painting and illustration, and then the field of public art, designing not only murals but also mosaics and stained glass. Not all of his civic-minded art ended up on walls; his artwork entitled *Science Presenting Steam and Electricity to Commerce and Manufacture* appears on the 1896 two-dollar bill.

During the Victorian era in which Blashfield was born, there was much "frescoing," as mural decoration was called, but prior to the American Renaissance there were not many seminal figures that could be thought of as American mural painters on the same plane as Blashfield. One exception that would have risen to this level and inspired a young Blashfield is William Morris Hunt, who encouraged him to study abroad. As with many of his peers and the visionaries who would become the minds and hands of the American Renaissance, Blashfield's artwork reveals the influence of his Beaux-Arts mentors Léon Bonnat and Jean-Léon Gérôme as well as other great artists, including Eugène Delacroix (who taught Bonnat), Paul Jacques Aimé Baudry, and Pierre Puvis de Chavannes, all in Paris. He also shared a productive ideological fraternity with other American artists studying in Paris during the same period, including H. Siddons Mowbray, Charles Sprague, John Singer Sargent, and even Thomas Eakins. As noted in preceding chapters, his classical training in the Beaux-Arts tradition profoundly influenced Blashfield's approach to mural painting and his dedication to formalistic principles of composition, perspective, color, scale, proportion, rhythm, and pattern. He carried some of the larger tenets of classicism back

Science Presenting Steam and Electricity to Commerce and Manufacture, c. 1895. (Photograph courtesy of the Edwin H. Blashfield papers 1850-1980, Archives of American Art, Smithsonian Institution)

Originally designed for the fifty-dollar bill, this image was actually used on the two-dollar bill of the 1896 series. The central figure, Science, presents two children, one symbolizing Steam holding a lever that controls a gear and the other Electricity carrying coils of wire wound into an electromagnet, to figures representing Commerce and Manufacture.

JEFF GREENE

to America, where he expounded upon such concepts as integrating art into architectural spaces and painting allegorical subject matter to elevate and inspire the civic realm.

Mina Weiner's chapter explains how Blashfield found his calling with his involvement in the 1893 World's Columbian Exposition in Chicago. After that experience, he no longer considered himself only an easel painter, but rather a Mural Painter, with capital letters. As an artist with some training in engineering, he brought a unique vision and skill set to his work. He was able to both execute and articulate a cohesive approach to mural painting that is philosophically sound as well as technically beautiful.

In addition to Blashfield's decorative paintings, his legacy includes numerous lectures, articles, and books, in particular *Mural Painting in America,* in which he combines his encyclopedic knowledge of European art history and his personal experiences of studying and painting in the classical tradition, to provide a blueprint for the development of an American art. He establishes a raison d'être for mural painting that even today, nearly a century later, remains valid. Blashfield believed that "of all the branches of art, it [mural painting] has become the most complicated in its organization."[3] He considered murals to be not merely architectural decoration, but an art form incorporating the entire grammar and vocabulary of architecture and painting and representing the ultimate poetic expression of the building arts, supported by all the accompanying elements. Blashfield understood that in order to accomplish this high ideal, in which the whole could be greater than the sum of its parts, enormous cooperation and coordination were required. He wrote, "It is only through this mutuality of effort pushed and perfected that the highest individuality of expression in decoration is attained."[4]

Relating the development of a building to a military campaign, Blashfield equated the architect to a commander-in-chief who chooses and leads his army of muralists, plain painters, and sculptors, while consulting with the authorities. He elevated the architect as "betwixt and between a man and a miracle in his capacity for all-round knowledge."[5] Explaining that a mural must be site-specific and contextual—that is, designed particularly for the individual space—he urged that participating artists take into account the architectural style and color palette, the distance and angles from which their work would be viewed, as well as the purpose of the building, which he considered in terms of theme.

In his mural work as well as his writing, Blashfield directs the artist's gaze beyond the canvas, to a larger calling. Paraphrasing the artist Rodin, Blashfield wrote, "We in America are upon the edge of a renaissance whose importance we can hardly calculate."[6] He discussed the value of murals and architectural decoration in creating a civic culture in America, and the importance of properly commissioning mural work for public buildings, using high standards rather than making awards based on committee consensus, regional bias, or low bid (some things never change). He described the

type of education an artist must have in order to create murals of the first order and the skill required to manage the complexities of working with other artists, architects, and crews on large public projects.

As he explored the techniques of mural integration, Blashfield shaped the relationship of the viewer within the context of a complex architectural space through sophisticated perspective and the relationship between illusionist space and real architectural space. This is evident in the way he handled his compositions and color palettes to fit within an architectural context and in the way he orchestrated the relationship of the surrounding decoration. The scale and rhythm of his figures and his use of decorative ornamental texture and pattern is in perfect harmony with the architecture that frames it. A wonderful example of this is his late work at the Detroit Public Library, where he manipulates multiple horizon lines in such paintings as *The Poets and Musicians* and *Music* (see pages 93–94), so that as viewers experience the works from differing vantage points, there is a consistent psychological effect of monumentality. This is purposefully accomplished by placing the horizon low in relation to the figures in the murals and in relation to where the murals are located in the building's architecture, thereby making viewers feel humble as they look up at the paintings.

This same technique was utilized across the street at the Detroit Art Institute by an artist of a different era, style, and culture, the Mexican painter Diego Rivera (1886–1957), in 1932–33. Given the proximity of the locations and the earlier installation of Blashfield's work, is it possible that Rivera was influenced by Blashfield? Rivera also demonstrates his understanding of one of the first principles of mural painting by skillfully using multiple horizon lines to control viewers' perception, no matter what their vantage point. However, where Blashfield strives for a sympathetic and harmonious relationship with the classical detailing of the surrounding architecture, Rivera seems to enjoy playing off the tension and contrast between his stylized forms and the symmetry of the existing architecture. The aesthetics, working methods, and politics of these two artists were entirely different, but I think they shared the belief that the power of mural painting could be harnessed to benefit society.

Blashfield offered high standards of intellectual content and artistic merit to inspire his contemporaries as well as future generations of mural painters. During the fertile period of artistic activity in which Blashfield worked, the American Renaissance, there is outstanding mural work in the same vein by artists including John LaFarge, Edwin Austin Abbey, Kenyon Cox, Elmer Garnsey, H. Siddons Mowbray, Louis C. Tiffany, and C. Y. Turner, to name just a few. Many of these artists were also collaborators with Blashfield, working alongside one another in an unprecedented way. I am sure there were conflicts among men of such stature, but Blashfield had a reputation for generosity and fair-mindedness, always striving for the highest ideals.

Underpinning his artistic accomplishments is his philosophical world-view, in which mural painters have a high civic duty and man is a hero in the collaborative effort of creating murals to uplift civic culture. At the same time, Blashfield understood how to make his monumental paintings accessible to the general public. Although the content and compositions may be intellectually rigorous, the murals remain emotionally available. The sentiment is not saccharine; the adroit handling of the paint allows the images to be enjoyed on a visceral level simply for their beauty and narrative. Blashfield wrote, "Besides having pattern, color and style, the decoration in a building which belongs to the public must speak to the people—to the man in the street. It must embody thoughts and significance and that so plainly that he who runs may read."[7]

He believed strongly in the evolution of art and architecture "from the creations of the past and the needs of the present [resulting in a style that is] fresh, original, stimulating, beautiful and American."[8] Blashfield understood that "we must be modern, and we must be American. No matter how saturated we are with the art of the past, and the more the better, we must fasten our souvenir to the living present; no matter how much we love the pale ideal landscape of the primitive painters, or the noble spacious mythological fairy-land of Poussin, the glory of Claude's sunsets, we must use our memory of them as frame to some such happenings as live for Americans of today."[9] Therefore, he encouraged his students and other artists to learn how to "treat decoratively the marking events of our history, past or contemporaneous, of our Puritans and Dutch, our Revolutionary heroes, our Argonauts of '49, our pioneers and colonizers and soldiers of the Civil War, our inventors and organizers, our men in the streets and in the fields of to-day; the special kinds of celebrations that should find place in particularly suited portions of our public buildings."[10]

Blashfield's inspiring ideals have informed the practice of mural painters, including some whose message and working style are distinctly different from those of Blashfield himself. It is interesting to construct a subjective time line of some of the mural painters who may be heirs to Blashfield's influence and demonstrate a lineage down to the present day.

I begin with Charles Holloway (1859–1941), who was roughly a contemporary, but at eleven years younger represents the next generation of American mural painters. Both his monumental paintings at the Allen County Courthouse in Fort Wayne, Indiana (see page 127), and his proscenium mural for Louis Sullivan's Auditorium Theatre in Chicago can be considered to embody the same breadth of artistic ambition that Blashfield championed.

A close examination of the side panels of Blashfield's *Alma Mater*, at the Massachusetts Institute of Technology in Cambridge, Massachusetts, reveals that he knew how to create wonderful decorative texture and pattern. I presume that his experience as a stained-glass and mosaic designer served him in good stead in this capacity. One detects a relationship in the art of Jules

JEFF GREENE

Charles Holloway (1895-1941), *Law and Order*, 1902: Allen County Courthouse, Fort Wayne, Indiana. (Ferguson Advertising, Fort Wayne, Indiana)

Guerin (1866–1946), whose work can be seen at the Lincoln Memorial, the Louisiana Statehouse, and the Chicago Civic Opera House and who is generally associated with the development of the Art Deco style and with his brilliant use of pattern and texture. Similar decorative sensibilities and a tendency toward stylization can also be seen in Violet Oakley's (1874–1961) work at the Pennsylvania State Capitol. Ms. Oakley, one of the first women commissioned for the mural decoration of a major public building, completed forty-three murals for the Pennsylvania State Capitol. The more two-dimensional graphic devices may derive in part from illustration and how a reader sees an image on a page. Blashfield also uses the graphic devices of silhouetted figures and halos, which is at once a modernist approach and akin to what people later did in Art Deco.

John Warner Norton (1874–1934) is interesting in terms of one artist's evolution. His early works of 1913 for the Chicago Park District's Fuller Park Fieldhouse, *Explorers in American History*, share Blashfield's classical sensibilities, incorporation of American subjects, and masterful understanding of the use of silhouette and positive and negative space as a compositional device. Yet by the 1933 Century of Progress International Exposition in Chicago, Norton was working in a completely geometric Art Deco style. Unlike Norton, Blashfield was suspicious of the rapidly changing modern trends in the art world and never forsook his classical roots, although he did

(opposite) Detail: *Alma Mater*, 1923: North wall mural, Morss Hall, Walker Memorial, Massachusetts Institute of Technology, Cambridge, Massachusetts. (Anne Day, photographer)

Violet Oakley (1874-1961), Unity, detail, unveiled 1906: Pennsylvania State Capitol Building, Harrisburg, Pa. (Photograph: Jim Sheridan © 2007 travelphotobase.com)

In this central panel of a triptych that is high on the wall behind the dais of the Senate Chamber, the blue-robed figure of Unity presides over the end of the war

(opposite) Edwin Howland Blashfield with assistants. (Peter A. Juley & Son Collection, Smithsonian American Art Museum, J0044089)

Blashfield (left) and assistants Vincent Aderente (center) and Alonzo E. Foringer (right) are dwarfed by the Wisconsin State Capitol dome crown mural.

seem to absorb modernist graphic influences, as can be seen in the boldness and innovation of his mosaic designs for Saint Matthew's Cathedral.

Despite Blashfield's late start as a muralist, he argued that mural painting required apprenticeships. He stressed that the preferred way to learn the craft was by being an assistant, like many of his generation who had worked with LaFarge and Hunt. Blashfield described mural painting as a science requiring exact knowledge, the fruit of experience, and proven capacity; talent is not enough. He wrote that "an inexperienced artist should be given only a minor part in any decorative enterprise. There under an experienced director, he would acquire experience which would enable him in time to assume the major role and become a director in turn."[11] He was most instructive and supportive of his own assistants, generously allowing two of them, Vincent Aderente and Alonzo E. Foringer, to inscribe their names alongside his on many of their jointly completed projects.

Vincent Aderente (1880–1941), an assistant for many decades, developed a style and working method so similar to his mentor's that when I first saw his murals at the Boston Opera House, I thought they were Blashfield's. Not only could Aderente paint like his mentor, the line of authorship was often blurred when they shared commissions. Together they created seamless interiors, as can be seen in the relationship between the mosaics and lunettes by Blashfield and the painting, *Saintly and Eminent Personages of*

JEFF GREENE

the Americas (see page 120), by Aderente, probably under Blashfield's supervision, in St. Matthew's Cathedral.

Blashfield was a master draftsman. I have examined his work in the dome crown of the Wisconsin State Capitol in Madison and the oculus ring at the Library of Congress, and have closely observed his use of hard and soft edges, as well as exaggerated outline, on many of his larger mural works, both to create atmospheric space and to compensate for the effects of viewing works from afar. Up close a bold outline can be seen surrounding major figures. But from a distance, this mural painter's trick disappears, leaving only the appropriate amount of emphasis.

Similarly, Eugene Savage (1833–1966), Ezra Winter (1899–1949), Dean Cornwell (1892–1960), and Barry Faulkner (1881–1966), titans of mural painting during the late 1920s through the 1930s, when mural painting reached its second zenith, display the same skillful command of draftsmanship. Although all of these artists worked in representational styles somewhat different from Blashfield's, one sees in their best work, such as Winter's *Fountain of Youth* for Radio City Music Hall in New York City, the same heroic sensibility and masterful line.

Blashfield's understanding that murals that adorn architecture must be integrated and supported by decorative elements is echoed in the work of his successors. Hildreth Meiere (1892–1961) was a master at this aspect of the mural painter's craft. As a relatively young woman, she was given the unprecedented license to decorate the Nebraska State Capitol in the early twentieth century. She is largely associated with prominent New York City projects, including her Art Deco work for Rockefeller Center, mosaics at Temple Emanu-El, and stained glass at Saint Bartholomew's Church. She clearly understood the function of decoration in architecture and followed the principles that Blashfield helped codify and so brilliantly employed in his own work.

The muralists of the Works Progress Administration (WPA) need to be considered, as some of Blashfield's intentions are present in the whole concept of the WPA public art. As noted in both Mina Weiner's and Anne Samuel's chapters, while the program produced many exceptional murals, Blashfield was not particularly supportive of the works. He contended that modern muralists could introduce innovative subjects and styles and still adhere to the timeless compositional and painting principles followed by American Renaissance muralists and generations of artists in Europe. He cautioned against paintings based on what he called "trivial" subjects, which were those he considered not significant enough for the noble aspirations of mural painting in public buildings. However, I do believe that the authorities behind the WPA mural program, as well as many of the participating artists, shared in Blashfield's belief that mural painting in public spaces could make a difference in the quality of life and culture in America. In this regard, one might say that every WPA post office mural across the United States is part of Blashfield's legacy.

(opposite) R. H. Ives Gammell (1893-1981), *Laughed in the Morning's Eye, Hound of Heaven Series,* Panel 14, 1955-56: Maryhill Museum of Art, Goldendale, Washington. (Maryhill Museum of Art)

This painting is part of a pictorial sequence composed of twenty-three panels by R. H. Ives Gammell illustrating a religious poem by the English poet Francis Thompson.

JEFF GREENE

It is a little more challenging to trace Blash-field's influence after the Second World War, a period when modernism was on the rise and clas-sicism and mural painting were in relative hiber-nation. However, there are a couple of lineages that are worthy of note. Robert Hale Ives Gam-mell (1893–1981) aspired to be a mural painter, but he is best known as an easel painter, a teacher, and an iconoclastic classicist. Gammell may have had a unique opportunity to study Blashfield's work, as one of the artist's residential murals was installed in 1895 in a Providence home belonging to Robert Ives Gammell. Because of the strong similarity of their names, it is believed that the homeowner and the artist must have been related. Like Blashfield, R. H. Ives Gammell was keenly aware of the compositional possibilities of static and dynamic tension and the use of positive and negative space, as can be seen in his series of paintings entitled *Hound of Heaven*. The allegor-ical subject matter also exemplifies Blashfield's noble aspirations and his sense of the sacred and profane. One of Gammell's more talented stu-dents, Richard Lack, started an atelier in the Twin Cities that is often credited with keeping classical realism alive during the long winter of mod-ernism. The atelier produced a number of first-rate contemporary mural painters.

Edward Laning (1906–1981); Allyn Cox (1896–1982), son of Kenyon Cox; and Dean Fausett (1913–1998) all were active muralists from the 1930s until the early 1980s. I met all of these artists when I first joined the National Soci-ety of Mural Painters in 1978. While these men may not be considered of the same caliber as Blashfield, I know from personal conversations with them that they were influenced by and aspired to the same civic achievements as Blash-field, and worked on important commissions in the New York Public Library (Laning) and the U.S. Capitol (Cox), to name just two.

One of the most interesting hybrids of cross-fertilization in the world of murals is the Philadel-phia mural movement started by Jane Golden in

the 1980s. Although the direct inspiration for the program seems to have been the community mural movements that began in Chicago and Los Angeles in the 1970s and early 1980s, that were largely based on the socialist ideals and aesthetics of the Mexican mural movements, the Philadelphia program has also benefited from the classical formal training of the artists who attended the Pennsylvania Academy of the Fine Arts and other local art schools. For example, Michael Webb has produced several superb metaphorical murals with a sense of civic responsibility, such as the Beasley Building mural at 12th and Walnut Streets that, echoing Blashfield's work, combines classic and contemporary figures.

Today, the field of classical mural painting is not as vigorous as in the past, but there are many excellent mural painters who owe something to Edwin Howland Blashfield's legacy. Toward the end of the twentieth century, there was a great upswing in architectural decoration with the rediscovery and repopularization of architectural trompe l'oeil by muralists such as Richard Haas and Graham Rust. Simultaneously, architects and designers began to take an interest in the function of ornament, texture, and decoration in tradi-

Michael Webb, b. 1947, *Beasley Building Mural*, 1997: 12th and Walnut Streets, Philadelphia, Pennsylvania. (Photograph courtesy of Michael Webb)

Webb surrounds a classic representation of Madonna and Child with contemporary references.

JEFF GREENE

tional architecture, and this trend continues. Currently, there are several artists who could be considered to be working in a manner that reflects Blashfield's influence. Fresco artist Ben Long certainly has the draftsman's hand and ambitious grand vision that Blashfield championed, as seen in his monumental fresco series for the Bank of America Corporate Center in Charlotte, North Carolina. Long acquired the technique of fresco painting in the traditional manner during an almost eight-year apprentiship in Florence, Italy with maestro Pietro Annigoni. Long also seems to have inherited Blashfield's sense of the sacred, as seen in numerous religious works for various churches in the south. While Blashfield was not deterred by the organization of large casts of allegorical figures and their accompanying decoration, as exemplified by the Church of the Saviour in Philadelphia (now sadly completely out of balance due to the recent whitewashing of the supporting decoration), Long prefers the iconographic simplicity of individual figures. In 2001, Ben Long was awarded the prestigious Arthur Ross Award for Excellence in the Classical Tradition by Classical America, New York.

Fifty years ago, a generation of artists may have disregarded the lessons

Ben Long, b. 1945, Frescoes *Making/Building; Chaos/Creativity; Planning/Knowledge*, 1992: Bank of America Corporate Center, Charlotte, North Carolina. (Photograph courtesy of the artist)

Each of the three frescoes that dominate the main lobby of the Bank of America Corporate Center is 23 by 18 feet.

that Blashfield had so eloquently illustrated and taught. Today, we recognize the enormous debt that American mural painters owe to Edwin Howland Blashfield, whether for his insightful writing about the integration of art and architecture, his advancement of technical composition, his painterly execution, or his extraordinary command of color. His pedagogy is still available for all those who possess a desire to learn and see more. Fortunately, many of his works are still standing as a testimony to his insight and achievement. It requires only a keen eye, an analytical mind, and the patience to look closely at examples of his work. This is best accomplished by standing in the spaces he helped conceive and absorbing and experiencing the artist's intentions firsthand. But more than this, and to the benefit of millions, is the legacy of his insistence that art can and should ennoble the human experience on a large scale in the public arena. Blashfield's expression of great optimism about the future of American mural painting continues to be an inspiration. He wrote, "Rembrandt said, Holland! Rubens, Flanders! Giorgione, Italy! Will our painters say, America? Assuredly, yes, in time."

NOTES
1. "A Definition of Decorative Art," in *Brochure of the Mural Painters: A National Society*, 1916.
2. Anne Lee, "Our Dean of Mural Painters Toils On," in *New York Times Magazine*, December 9, 1928.
3. Edwin H. Blashfield, *Mural Painting in America* (New York: Charles Scribner's Sons, 1913), p. 25.
4. Ibid., p. 133.
5. Ibid., p. 76.
6. Ibid., p. 162.
7. Ibid., pp. 175–76.
8. Ibid., p. 159.
9. Ibid., p. 198.
10. Ibid., p. 199.
11. "A Definition of Decorative Art," in *Brochure of the Mural Painters*, p. 9.
12. Blashfield, *Mural Painting in America*, p.14

Chronological List of Known Murals

Note: Measurements are given height by width. Blashfield probably worked with assistants on projects other than those noted here. However, names are given only where inscriptions or documentation were available. Murals listed are extant unless otherwise noted.

1886 Residence of Hamilton McKown Twombly, 684 Fifth Avenue and 51st Street, New York, NY (J. B. Snook, architect)
Three ceiling panels: *Allegory of Good and Bad Dreams.*
The house was sold in 1926. The murals were destroyed with the structure.

1892 Entrance dome: *The Arts of Metalworking: The Goldsmith's Art, The Armourer's Craft, The Iron Worker, The Craftsman in Brass.* The dome was 25 feet in diameter. Painted in situ and destroyed with the majority of the fair's temporary architecture. Assistant on the project: Arthur R. Willett.

1892–93 World's Columbian Exposition, Manufactures and Liberal Arts Building, Chicago, IL (George B. Post, architect)

1894 Residence of Collis P. Huntington, southeast corner of Fifth Avenue and 57th Street, New York, NY (George B. Post, architect)
Murals: *Cupid with Bow and Arrows* (65 inches by 36$\frac{1}{2}$ inches). Central figure, *Terpsichore* (77$\frac{7}{8}$ inches by 32 inches), *Dancing Female Figures* (94$\frac{7}{8}$ inches by 191$\frac{1}{8}$ inches).
Mrs. Huntington died in 1924. Her son Archer M. Huntington saved three Blashfield murals, along with ten by Elihu Vedder (1836–1923) and gave them to the Yale University Art Gallery in 1926.

1895 Residence of Robert Ives Gammell, Providence, RI
Music room ceiling: *Allegory.* Approximately 13 feet by 18 feet. Relocated and restored by the Gammell family in 1925.
While researching for this book, this mural, previously believed to have been destroyed, was located in a private residence.

1895 Bank of Pittsburgh, Pittsburgh, PA (George B. Post, architect)
Lunette mural, 9 feet by 19 feet, main banking hall: *City of Pittsburgh Offering Her Steel and Iron to the World.* Destroyed with the structure in May 1944.

1895 Lawyers Club, Equitable Building, 120 Broadway, New York, NY
Dining room overmantel: *Justice.* Approximately 3 feet by 10 feet. Destroyed by fire.

1895–96 Library of Congress, Washington, DC (John L. Smithmeyer and Paul J. Pelz architects)
Beginning in 1892, architect Edward Pearce Casey began to supervise the interior work, including the sculptural and painting decoration by more than fifty artists.
Dome collar: approximately 10 feet high and 140 feet in circumference. *Evolution of Civilization; Human Understanding.* Twelve figures. 125 feet above the floor. Painted in situ. Oculus: *Human Understanding.* 160 feet off the floor.
Assistant on the project: Arthur R. Willett.

1896–97 Residence of William K. Vanderbilt, 660 Fifth Avenue, New York, NY (Richard Morris Hunt, architect)
Lunette, 10 feet by 18 feet, for the Gothic dining room: *Sword Dance; Fortitude and Vigilance.* Destroyed with the structure c. 1924.

1897 Waldorf=Astoria Hotel, Fifth Avenue and 33rd Street, New York, NY (H. J. Hardenbergh, architect)
Ballroom ceiling mural, approximately 45 feet by 65 feet: *Music and Dance.* Decorative side panels. Destroyed with the structure in 1929. The ceiling was completed in the Astoria Hotel just before that hotel was joined with the Waldorf to create the Waldorf=Astoria. The huge combined building was located on the site currently occupied by the Empire State Building.
Assistant on the project: Vincent Aderente (1880–1941).

1898 Residence of George W. Childs Drexel, Philadelphia, PA (Robert Peabody, architect)
Present-day Curtis Institute of Music.
Three ceiling murals. Central medallion, 11 feet in diameter; eight historic figures representing a field of study or virtue. Two side panels, 4 feet 6 inches by 12 feet each: *Prose* and *Poetry* (aka *Epic* and *Dramatic Poetry*)
Decorated 1863 pianoforte: On permanent loan to the Curtis Institute from the Philadelphia Museum of Art. Side panels: *Music*—sacred, pastoral, dramatic, and military. *Classical Music* is portrayed on the lid.

1899 Residence of Adolph Lewisohn, 9 West 57th Street, New York, NY (Arnold W. Brunner, architect)
Mural: Music room ceiling, *The Genius of Music*. Hall panel: *Dance*. Mrs. Lewisohn (Emma) died in 1916, and in 1919 Adolph moved to 881 Fifth Avenue. The murals were probably destroyed with the structure.

1899 Appellate Division, First Judicial Department Courthouse, New York, NY (James Brown Lord, architect)
First-floor courtroom east wall contains a triptych by three separate artists: Edward Simmons, Henry O. Walker, and Edwin Blashfield. Blashfield's *Power of the Law* on the right is $10^1/_2$ feet by $9^1/_2$ feet.

1901 Prudential Life Insurance Company, 745 Broad Street, Newark, NJ (George Post & Sons, architects)
Lunettes: *Thrift Driving the Wolf from the Door; Prudence Binding Fortune;* Boardroom ceiling and eight medallions: *Industry and Thrift Leading People to Security*. Destroyed with the structure.

1902 Baltimore Courthouse, Baltimore, MD (Wyatt & Nolting, architects); renamed the Clarence M. Mitchell Jr. Courthouse
The murals were commissioned by the Municipal Art Society of Baltimore.
Courtroom 451 mural, 11 feet by 35 feet: *Washington Surrendering His Commission* (aka *Washington Laying Down His Command at the Feet of Columbia*), 1902; Courtroom 417 mural, 11 feet by 35 feet: *The Edict of Toleration of Lord Baltimore Commending his People to Wisdom, Justice and Mercy* (aka *Religious Toleration*), 1904.
Assistants on the *Washington* mural: Vincent Aderente and Alonzo E. Foringer.
It is assumed that they assisted on *The Edict of Toleration* as well.

1903 Citizens Bank, Cleveland, OH (Hubbell & Benes, architects)
Lunette in lobby, 9 feet by 27 feet: *The Uses of Wealth* (aka *Capital, Supported by Labor, Offering the Golden Key of Opportunity to Science, Literatures, and Art*).
The mural that had been relocated to the Cleveland Institute of Art along with Kenyon Cox's bank mural was later destroyed with that structure.

1904 Minnesota State Capitol, St. Paul, MN (Cass Gilbert, architect)
Senate Chamber lunettes, each 14 feet by 31 feet: *Minnesota, Granary of the World* and *Discoverers and Civilizers led to the Sources of the Mississippi* (aka *Headwaters of the Mississippi*). Governor's suite 7 feet by 15 feet mural: *The Fifth Minnesota Regiment at Corinth* (aka *The Battle of Corinth*), 1912. Assistants on both projects: Vincent Aderente and Alonzo E. Foringer (1877–1948).

1905 Iowa State Capitol, Des Moines, IA (Cochrane & Piquenard, Bell & Hackney, architects)

Grand staircase landing on east side of the Capitol between the first and second floors, mural, 14 feet by 40 feet: *Westward*.

Assistants on the project: Vincent Aderente and Alonzo E. Foringer.

1906 Church of Our Saviour, Philadelphia, PA (Charles M. Burns, architect)

Semi-dome in chancel of the Drexel Memorial to Anthony J. Drexel (1826–1893). Blashfield had also designed decorative painting around the mural that was completed by his assistant Alonzo E. Foringer. The decorative painting was destroyed during a recent renovation.

1906 Congregational Church of South Dennis, Cape Cod, MA

Panel left of the altar: *The Adoration*. A study in color with gilded relief, completed in 1906 for the Church of the Saviour in Philadelphia, was donated to the Congregational Church after the artist's death in 1936 by his widow.

1906–7 Essex County Courthouse, Newark, NJ (Cass Gilbert, architect)

Four rotunda pendentives: *Wisdom, Mercy, Power, Knowledge*.

Each 10 feet 6 inches by 5 feet 6 inches at the upper margin.

Assistant on the project: Vincent Aderente.

1907–8 Great Hall, City College/City University of New York, St. Nicholas Avenue, New York, NY (George Post & Sons, architects)

Lunette, 22 feet by 44 feet: *The Graduate*.

Painted in situ. Assistants on the project: Vincent Aderente and Alonzo E. Foringer.

1908 Wisconsin State Capitol, Madison, WI (George Post & Sons, architects)

Assembly Chamber lunette, 16 feet 6 inches by 37 feet: *Wisconsin, Past, Present and Future*. Capitol rotunda granite dome, 24 feet in diameter and 200 feet above the pavement: *Wisconsin* (aka *The Resources of Wisconsin*). The dome mural was completed in 1912 and installed in 1914.

Assistants on both projects: Vincent Aderente and Alonzo E. Foringer.

1909 Luzerne County Courthouse, Wilkes-Barre, PA (McCormick & French, architects)

Mural behind the judges' bench in Courtroom 3, 9 feet by 16 feet: *Justice*.

1909 U.S. Courthouse, Post Office, and Custom House, Cleveland, OH

Renamed the Howard M. Metzenbaum Courthouse in 2002 (Arnold W. Brunner, architect)

Mural in circuit courtroom, 11 feet by 25 feet: *The Law*.

Assistants on the project: Vincent Aderente and Alonzo E. Foringer.

1910 Mahoning County Courthouse, Youngstown, OH (Owsley, Boucherle, and Owsley, architects)

Pendentives to main dome: *The Law in Remote Antiquity; The Law in Classical Antiquity; The Law in the Middle Ages; The Law in Modern Times*. Each 12 feet high.

Assistants on the project: Vincent Aderente and Alonzo E. Foringer.

1910 Hudson County Courthouse, Jersey City, NJ, Renamed the William J. Brennan Courthouse in 1985 (Hugh Roberts, architects)
Triangular pendentives to the central dome, each 9 feet high: *Four Fames—Alexander Hamilton, John Stevens, Abraham Zabriskie, and Richard Varick.*
Assistants on the project: Vincent Aderente and Alonzo E. Foringer. In addition, the dome decoration was carried out by Aderente and Foringer under Blashfield's supervision.

1910 South Dakota State Capitol, Pierre, SD (C. E. Bell, architect)
Mural in the Governor's Room, 8 feet by 9$\frac{1}{2}$ feet: *Dakotah* (aka *Dakota Struggling towards the Light* or *Spirit of the West*), officially retitled in 1980s as *Only by Contemplating Our Mistakes Do We Learn.* Removed from public view c. 1997.

1912 Mercersburg Academy, Mercersberg, PA
Mural, 14 feet by 11 feet: *The Victor* (aka *The Athlete*).
Assistants on the project: Vincent Aderente and Alonzo E. Foringer.

1913 Residence of Mrs. Charles Keith, Kansas City, MO (Shepard, Farrar & Wiser, architects)
Overmantel mural, 31$\frac{1}{3}$ inches by 62$\frac{1}{2}$ inches: Scene from Scott's *Lord of the Isles.* Private collection.

1913 Church of Saint Luke, Atlanta, GA
Behind the high altar: *The Good Shepherd.*
Assistants on the project: Vincent Aderente and Alonzo E. Foringer.

1914 Residence of Everett Morss, Boston, MA
Seven panels, including *Music, Hospitality,* and *Books.*
The house and murals were destroyed, but one panel and two roundels were transferred to private collections.

1914–26 Cathedral of Saint Matthew the Apostle, Washington, DC (Chester Grant LaFarge, architect)
Construction of the cathedral began in 1893.
Mural east transept: *The Martyrdom of Saint Matthew,* 1925–26. Mural west transept: *The Calling of Saint Matthew,* 1925. Each 25 feet high at apex by 50 feet wide. The transept murals were designed by Blashfield and were executed by assistant Vincent Aderente under Blashfield's supervision. Cartoon for mosaic, 35 feet by 13 feet: *Saint Matthew and the Angel* (aka *Saint Matthew Enthroned*). Cartoon for lunette mosaic, 25 feet by 45 feet: *The Angels of the Crucifixion* (aka *Angels of the Passion*). These mosaics behind the main altar were designed by Blashfield in 1914 and executed from 1914 to 1918 by the Decorative Stained Glass Company under the supervision of Grace Edith Barnes, an assistant to John LaFarge. Cartoons for four mosaic pendentives supporting the dome, each approximately 50 feet high with 40-foot wingspans, designed by Blashfield in 1921: *Saint Matthew with his Angel; Saint Mark with the Lion; Saint Luke with*

the Winged Bull; Saint John with the Eagle. The pendentive mosaics of the four evangelists were executed under the direction of Salvatore Lascari, a Fellow of the American Academy in Rome, with two assistants from the academy, 1922–26. All the tesserae were made in Murano, Italy.

1918 Kansas City Public Library, Kansas City, MO (Architects: William F. Hackney and Charles A. Smith, with Adriance Van Brunt as consultant)
Library rotunda mural: *The Call of Missouri* (aka *Missouri Watching the Departure of her Troops* or *The Trumpets of Missouri*).
Mural's location is unknown.

1921–1922 Detroit Public Library, Detroit, MI (Cass Gilbert, architect)
Lunette over doorway leading from the grand stairway to the delivery room, approximately 3¹/₂ feet by 9 feet: *Joining of the Ways* (aka *Detroit at the Meeting of the Land and the Water Ways*), 1922; panels, 1921–22, each 6 feet by 18 feet: *Music, The Graphic Arts*; lunettes, 1921–22, each 13 feet by 26 feet, over north window, *Prose Writers*; over south window, *Poets And Musicians.* Assistant on the project: Vincent Aderente.

1923 The Liberty Trust Company, Allentown, PA
Mural, 9 feet by 12 feet: *Proclaim Liberty Throughout the Land* (aka *The Liberty Bell*).
This mural was believed to have been destroyed with the building, but we recently found that it had been relocated in 1976 to Room 200 of the old Lehigh County Courthouse. Assistant on the project: Vincent Aderente.

1923 Walker Memorial, Morss Hall, Massachusetts Institute of Technology, Cambridge, MA (Welles Bosworth, architect)
North wall mural: *Alma Mater*, 1923; south wall right panel: *Humanity Led from Chaos into Light by Knowledge and Imagination*; south wall left panel: *Good and Bad Uses of Science*, 1930. Assistant on both projects: Vincent Aderente.

1924 Church of the Virgin, Chappaqua, NY
Saint Ann and the Virgin, The altarpiece is no longer in the church, and the mural was not located. Painted in memory of Sister Anna Scott and Evangeline Wilbour Blashfield.

1924 Bethesda United Methodist Church, Salisbury, MD
Choir: *The Good Shepherd.*
Assistant on the project: Vincent Aderente.

1926 Union League Club, 65 West Jackson Avenue, Chicago, IL (William Bryce Mundie, architect)
Overmantel, 12 feet by 7 feet 10 inches: *Patria.*
Assistant on the project: Vincent Aderente.

1927 Elks National Memorial, N. Lakeview Avenue, Lincoln Park, Chicago, IL (Egerton Swarthout, architect)
Lunette in west corridor: *Fraternal Justice;* panels: *Fraternity and Charity.* Assistant on the project: Vincent Aderente.

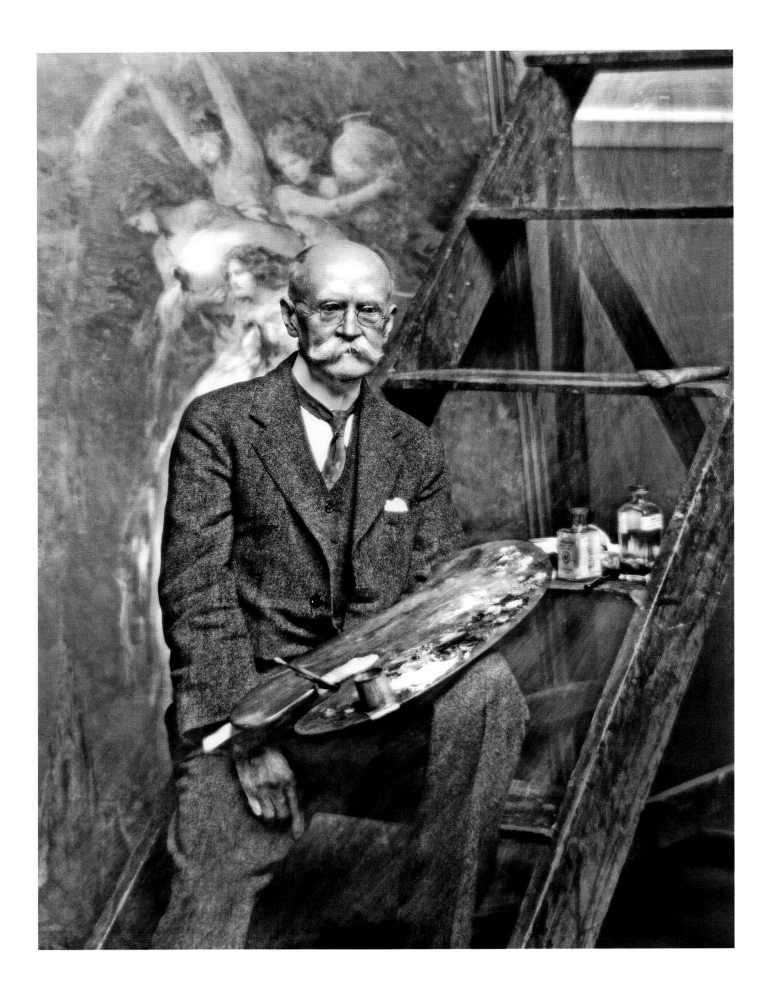

Edwin Howland Blashfield: A Chronology

1848 October 15. Born in Brooklyn, New York, to William Henry Blashfield and Eliza Dodd Blashfield.

1861–65 Lives with maternal grandparents in Boston and attends the Boston Latin School.

1865 Enters the Massachusetts Institute of Technology with the class of 1869, but does not complete studies there.

1867–70 Student of Léon Bonnat affiliated with the École des Beaux-Arts in Paris.

1869 Several works are accepted for exhibition at the Bigelow, Kennard & Company gallery in Boston. In subsequent years, his works are exhibited at the Architectural League of New York; Brooklyn Art Association; Century Association; National Academy of Design; Boston Museum of Fine Arts; Chrysler Museum in Norfolk, Virginia; Indianapolis Museum of Art; Nashville Parthenon; Pennsylvania Academy of Fine Arts; Philadelphia Museum of Art; and other American venues, as well as exhibitions in London, Dublin, Glasgow, and Paris.

1871 Opens a studio at 6 Astor Place in New York City.

1874–80 Exhibits and continues to study with Bonnat in Paris.

1876 Admitted to Salon of Paris with a painting called *Un Jeune Poete* (*A Young Poet*), giving him access to the Salon and to the Royal Academy.

1881 Marries Evangeline Wilbour (1858–1918), writer and daughter of journalist and Egyptologist Charles Edwin Wilbour and Charlotte Beebe Wilbour.

Establishes a studio in the Sherwood at 58 West 57th Street in New York City as an easel painter, portraitist, and illustrator. Retains this studio until 1898.

(opposite) Edwin Howland Blashfield in his studio, 1930–33. (Peter A. Juley & Son Collection. Smithsonian American Art Museum, J0001213)

The artist is standing in front of his easel painting *Rain* (1930).

1882 Becomes a member of the National Academy; academician in 1888. Becomes a member of the newly formed Society of American Painters in Pastel.

1885 Teaches at the Art Students League.

1886 Spends the summer in Broadway, England, where he befriends Francis Millet, John Singer Sargent, Edwin Austin Abbey, Sir Lawrence Alma-Tadema, and Frederic Leighton.

1889 Designs the Washington Inauguration Centennial Souvenir Booklet cover.
Exhibits *Portrait of the Artist's Wife* at the Universelle Exposition, Paris, and wins the bronze medal.
Joins the Art Students League faculty.

1890 Designs medal for the Architectural League of New York, illustrated in its 6th Annual Exhibition catalogue.

1892 With his wife, helps found the Municipal Art Society in New York City.

1892 Invited by Francis Millet to be a participating artist in the World's Columbian Exposition in Chicago. Designs figures for pendentives for one of eight domes in George B. Post's Manufactures and Liberal Arts Building.

1895 Among the founders of the National Society of Mural Painters.
Elected president of the Society of American Artists, succeeding William Merritt Chase.
Serves on a joint committee composed of members of the National Sculpture Society and the Architectural League of New York to decide the site and form for the Soldiers and Sailors Monument in New York City.

1897 Listed among the incorporators of the American Academy in Rome.
Publication of Vasari's *Lives of Seventy of the most Eminent Painters and Architects,* Evangeline and Edwin Howland Blashfield with A. A. Hopkins, ed., New York: Charles Scribner's Sons.

1900 Publication of *Italian Cities, Volumes I* and *II,* Evangeline and Edwin Howland Blashfield, New York: Charles Scribner's Sons, 1900.

1908 Elected to the American Academy of Arts and Letters.

1909–1914 President of the National Society of Mural Painters. Serves as honorary president from 1914 until his death in 1936.

1911 Wins Gold Medal, Architectural League of New York.
Wins Carnegie Prize, National Academy of Design, for painting *Life,* which had been shown in the National Academy of Design Winter Exhibition, 1911.

1912 Presents Scammon Lectures at the Art Institute of Chicago. These become the basis for his 1913 publication, *Mural Painting in America.*
Appointed by President William Howard Taft to the National Commission of Fine Arts; reappointed by President Woodrow Wilson.

1913 Publication of *Mural Painting in America.* New York: Charles Scribner's Sons.

1915 Elected president of the National Institute of Arts and Letters.

1916 Elected president of the Fine Arts Federation.

Elected a director of the American Academy of Arts and Letters.

Receives an honorary degree from Columbia University.

1918 Death of Evangeline Wilbour Blashfield.

1920–26 Serves as president of the National Academy of Design.

1921 Appointed to Advisory Committee for the National Gallery in Washington, DC.

1928 Marries Grace Hall (1877–1947), painter, writer, and lecturer, at the Church of the Ascension in New York City.

1933 Receives President's Medal for "distinguished service to the fine arts" from the National Academy of Design.

Closes his Carnegie Hall Studio, 40 West 59th Street, New York.

1936 October 12, dies in South Dennis, Cape Cod, Massachusetts.

2002–3 Municipal Art Society establishes the Evangeline Blashfield Award and rededicates *Abundance*, the fountain at the Queensborough Bridge Market, to her memory.

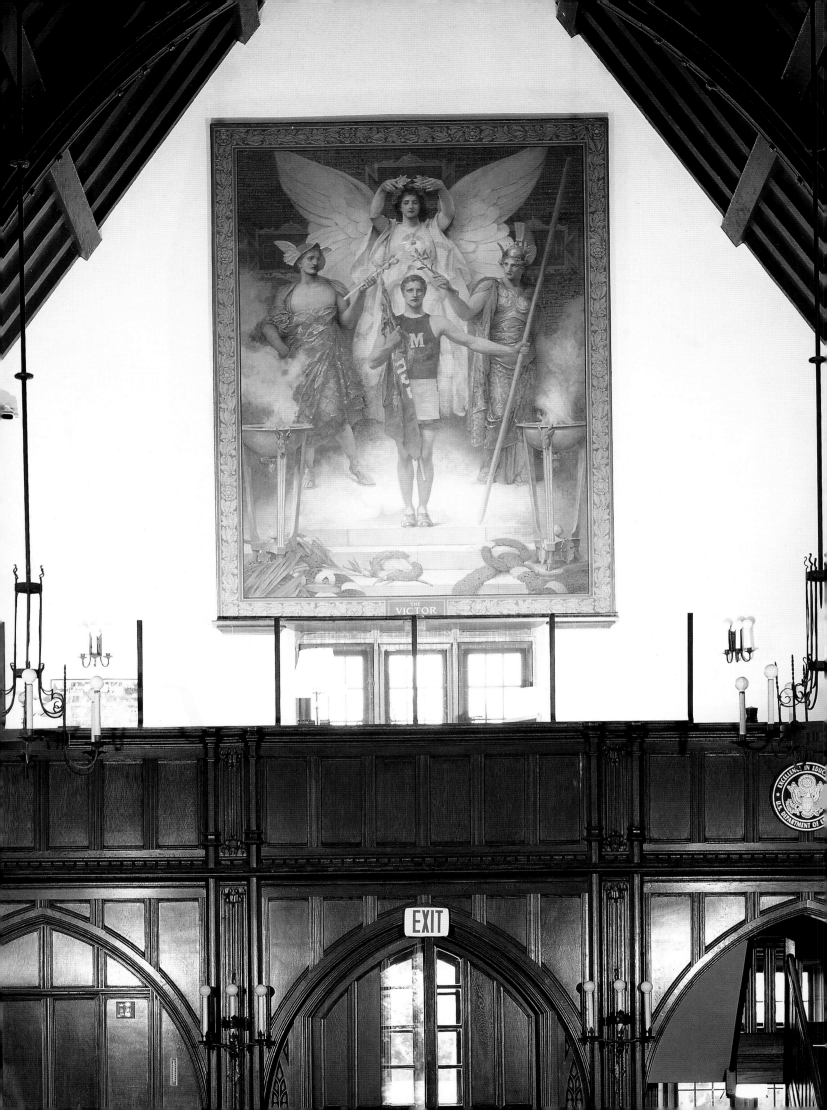

THE
VICTOR

EXIT

Selected Bibliography

American Academy of Arts and Letters, Herbert Adams, Nicholas Murray Butler, William Lyon Phelps, and Walter Damrosch. *Commemorative Tributes to Hassam and Blashfield,* New York, 1938.

"American Artists in France 1850–70." *American Art Journal* 5, no. 2 (November 1973): pp. 32–49.

Appelbaum, Stanley, *The Chicago World's Fair of 1893: A Photographic Record.* New York: Dover Publications, Inc., 1980.

Beaux-Arts Architecture in New York: A Photographic Guide. Photographs by Edmund V. Gillon Jr. Text by Henry Hope Reed. New York: Dover Publications, 1988.

Blashfield, Edwin Howland. "The Actual State of Art Among Us." *National Arts Review* (March 1910).

———. "Considerations on Mural Painting." *The American Architect* 103, no. 1957 (1913): pp. 73–87.

———. "The Ethics and Politics of Mural Painting." Paper presented at the Proceedings of the First Annual Convention of the American Federation of Arts, July 1910.

———. "Fellowship in Art." *The American Magazine of Art* 13, no. 8 (1922): pp. 269–71.

———. "The Field of Art—A Decorated Piano." *Scribner's Magazine* XX (October 1896): pp. 517–20.

———. "Four Decorations Symbolic of Law." *Century illustrated monthly magazine* (April 1910).

———. "Jean-Paul Laurens." In *Modern French Masters: A Series of Biographical and Critical Reviews by American Artists, with Thirty-Seven Wood-Engravings and Twenty-Eight Half-Tone Illustrations,* edited

(opposite) *The Victor,* 1912: Mercersburg Academy, Mercersburg, Pennsylvania. (Anne Day, photographer)

Like many of Blashfield's murals, this painting combines real portraits and symbolic figures. An Olympic winner wearing the blue track jersey of Mercersburg Academy dominates the center. Above him is the Angel of Victory; to his left is the Greek god Hermes; to his right is the Greek goddess Athena. The features of the academy's first headmaster, Dr. William Mann Irvine, appear on the face of the athlete; his daughter Camille is the face of the Angel. *The Victor* was a gift to the school from E. W. Bok, editor of *Ladies' Home Journal.* Originally mounted in the Main Hall Annex (now Swank Hall), the mural is currently in the great room of Traylor Hall, the administration building.

by John Charles Van Dyke, pp. 83–90. London: T. Fisher Unwin, 1896.

———. "John Singer Sargent Recollections." *North American Review* 220, no. 827 (1925): pp. 641–53.

———. "John W. Alexander Recorder, Creator, Dreamer, and Friend." *American Magazine of Art* 7, no. 9 (1916): pp. 345–48.

———. "Léon Bonnat." In *Modern French Masters: A Series of Biographical and Critical Reviews by American Artists, with Thirty-Seven Wood-Engravings and Twenty-Eight Half-Tone Illustrations*, edited by John Charles Van Dyke, pp. 47–56. London: T. Fisher Unwin, 1896.

———. "Mural Painting." In *A Dictionary of Architecture and Building*, edited by Russell Sturgis. New York: The Macmillan Company, 1901.

———. "Mural Painting in America." *Scribner's Magazine* 54 (1913): pp. 353–65.

———. *Mural Painting in America*. The Scammon Lectures, delivered before the Art Institute of Chicago, March 1912, and since greatly enlarged. New York: Charles Scribner's Sons, 1913.

———. An Open Letter. *Century illustrated monthly magazine* (February 1889).

———. "A Painter's Reminiscences of a World's Fair." *New York Times Magazine* (March 18, 1923).

———. "The Painting of To-Day." *Century illustrated monthly magazine* 87 (1913–14): pp. 837–40.

———. "The Rehabilitation of Pinturicchio." *Scribner's Magazine* 34, no. 1 (1903): pp. 125–28.

———. "Rome as a Place of Schooling for a Decorative Painter." *The American Architect and Building News* (1903): pp. 51–53.

———. "A Word for Municipal Art." *Municipal Affairs* 3 (1899): pp. 582–93.

Blashfield, Edwin Howland, and Evangeline Wilbour Blashfield. "Afloat on the Nile." *Scribner's Magazine* 10 (1891): pp. 663–81.

———. "The Art of Ravenna." *Scribner's Magazine* 12 (1892): pp. 37–55.

———. "Castle Life in the Middle Ages." *Scribner's Magazine* 5 (1889): pp. 3–26.

———. "A Day with the Donkey-Boys." *Scribner's Magazine* 11 (1892): pp. 32–50.

———. "In Florence with Romola." *Scribner's Magazine* 2 (1887): pp. 693–721.

———. "The Florentine Artist." *Scribner's Magazine* 13 (1893): pp. 165–84.

———. *Italian Cities*. New York: Charles Scribner's Sons, 1900.

———. *Italian Cities*. New York: Charles Scribner's Sons, 1902.

———. "The Man at Arms." *Scribner's Magazine* 3 (1888): pp. 161–80.

———. "The Paris of the Three Musketeers." *Scribner's Magazine* 8 (1890): pp. 134–55.

———. "Pictorial Art on the Stage." *Century illustrated monthly magazine* 35 (1887–88): pp. 533–46.

———. "Siena: The City of the Virgin." *Scribner's Magazine* 20 (1896): pp. 397–417.

Blaugrund, Annette. *Paris 1889: American Artists at the Universal Exposition.* Philadelphia: Pennsylvania Academy of the Fine Arts in association with H. N. Abrams, 1989.

Bogart, Michele Helene. *Artists, Advertising, and the Borders of Art.* Chicago: University of Chicago Press, 1995.

The Brochure of the Mural Painters, a National Society Founded 1895. New York: The Society, 1916.

Cartwright, Derrick R. "J. Alden Weir's Allegorical Figure of 'Goldsmith's Art' for the Dome of the Manufactures and Liberal Arts Building." *University of Michigan Museums of Art and Archaeology Bulletin,* vol. IX (1989–91), pp. 58–77.

Cary, Elizabeth Luther. "The Scholarship of Edwin Howland Blashfield." *American Magazine of Art* VIII, no. 1 (November 1916): pp. 3–8.

"Cathedral of Saint Matthew the Apostle, Washington, DC." Brochure published by the Cathedral.

Clark, Eliot, *History of the National Academy of Design, 1825–1953.* New York: Columbia University Press, 1954.

Cole, John Young, Henry Hope Reed, and Herbert Small. *The Library of Congress: The Art and Architecture of the Thomas Jefferson Building.* 1st ed. New York: W. W. Norton & Company, 1997.

"Daniel H. Burnham on the Chicago World's Fair, 1893: An interview with the late Daniel H. Burnham." *Architectural Record* (January 1913).

"DAR—Missouri, Kansas City Chapter." *American Art News* (July 13, 1918).

Fink, Lois Marie. *American Art at the Nineteenth-Century Paris Salons.* Washington, D.C.: National Museum of American Art, 1990.

Flinn, John J. *Official Guide of the World's Columbian Exposition.* Chicago: John Anderson Publishing Company, 1893.

Gilbert, Cass. "An Address on the presentation of the President's Medal of the National Academy of Design to Edwin Howland Blashfield," January 4, 1934.

Gilmartin, Gregory F. *Shaping the City: New York and the Municipal Art Society.* New York: Clarkson Potter, 1995.

Hitchcock, Ripley, ed. *World's Columbian Exposition, The Art of the World,* vols. 1 and 2, New York: D. Appleton & Co., 1895.

Humphrey, Grace. "The Blashfield Windows: The Annunciation and the Resurrection," First Presbyterian Church, Chattanooga, TN. *International Studio* (September 1916).

Kelly, Florence Finch. "Edwin H. Blashfield Mural Painter." *Broadway Magazine* (n.d.) 73–80.

King, Pauline. *American Mural Painting. A Study of the Important Decorations By Distinguished Artists in the United States.* Boston: Noyes, Platt & Company, 1902.

Knafft, Ernest. "An American Decorator: Edwin H. Blashfield." *International Studio* (March 1901): 26–36.

Lee, Anne. "Our Dean of Mural Painters Toils On." *New York Times Magazine*, December 9, 1928.

Lowe, David Garrard. *Beaux Arts New York*. New York: Whitney Library of Design, An Imprint of Watson-Guptill Publications, 1998.

Mather, Frank Jewett Jr. "Edwin H. Blashfield and Mural Painting in America." *Friends of the Lawrence Art Museum, Williams College* (October 23, 1938).

"'Mural Painting in America,' Some notes of talk with E. H. Blashfield." *Arts and Decoration* (December 1914): 60–61, 76.

Murray, Richard. "Painted Words: Murals in the Library of Congress." In *The Library of Congress: The Art and Architecture of the Thomas Jefferson Building*, edited by John Young Cole and Henry Hope Reed. New York: W. W. Norton & Company, 1997.

"Obituary: Edwin Howland Blashfield, October 15, 1936." *Art Digest*.

"Patria." *Union League Club*, Chicago, IL, 1960.

Rogers, G. Kenneth. "A History of the Congregational Church of South Dennis," The Sea Captain's Church, brochure, 1992.

Samuel, Anne. "Blashfield's Washington Surrendering His Commission: A Colonial Revival *Sacre Conversazione*." Paper presented at The Colonial Revival in America Conference, cosponsored by the National Park Service and the Departments of Architectural History and Landscape Architecture, University of Virginia, Charlottesville, VA, November 2000.

Schaffer, Kirsten; edited by Scott J. Tilden; photographs by Paul Rocheleau. *Daniel H. Burnham: Visionary Architect and Planner*. New York: Rizzoli, 2003.

Sturges, Russell. "A Review of the Work of George B. Post." *Architectural Record, Great Architects Series*, no. 4, June 1898.

Sullivan, Louis. *The Autobiography of an Idea*. New York: Press of the American Institute of Architects, 1924.

Van Hook, Bailey. "From the Lyrical to the Epic: Images of Women in American Murals at the Turn of the Century." *Winterthur Portfolio* 26, no. 1, Spring 1991.

Van Hook, Bailey, *The Virgin & the Dynamo*. Athens, OH: Ohio University Press, 2003.

Vasari, Giorgio, Edwin Howland Blashfield, Evangeline Wilbour Blashfield, and Albert A. Hopkins. *Lives of Seventy of the Most Eminent Painters, Sculptors and Architects*. New York: Charles Scribner's Sons, 1896.

Walton, William. "The Mural Painting in the Great Hall of the College of the City of New York, 'The Graduate.'" *Scribner's Magazine*, July 1908.

Works of Edwin Howland Blashfield. With an Introduction by Royal Cortissoz. New York: Charles Scribner's Sons, 1937.

CATALOGUES

The American Pupils of Jean Leon Gerome. Catalogue for an exhibition by Barbara Weinberg, Amon Carter Museum, Fort Worth, TX, 1984.

The American Renaissance 1876–1917. Catalogue for an exhibition at the Brooklyn Museum, New York: The Brooklyn Museum, distributed by Pantheon Books, 1979.

Catalogue of a Collection of Drawings and Studies by Edwin Howland Blashfield, October 12 to November 8, 1909. Buffalo Fine Arts Academy, Albright Art Gallery, 1909.

Catalogue of Drawings, Studies & Photographs of Mural Decorations by Edwin H. Blashfield, January 5–24, 1909. Art Institute of Chicago, 1909.

Catalogue of an Exhibition of the Works of Edwin Howland Blashfield, American Academy of Arts and Letters, 1927.

Heroes in the Fight for Beauty: The Muralists of the Hudson County Court House. Catalogue for an exhibition by Cynthia Sanford. Jersey City, NJ: Jersey City Museum, 1986.

Minnesota State Capitol: The Art and Politics of a Public Building, Neil B. Thompson. St. Paul: Minnesota State Historical Society, 1974.

The Mural Decoration of Edwin Howland Blashfield. Catalogue for an exhibition by Leonard Amico. April 1–May 7, 1978. Sterling and Francine Clark Art Institute, Williamstown, MA.

Temple of Justice: The Appellate Division Courthouse: An Exhibition Sponsored by the Architectural League of New York and the Association of the Bar of the City of New York, June 24–July 22, 1977. New York: The House of the Association, 1977.

Works of Edwin Blashfield, Mrs. Mary Fairchild Low, Mr. William Low. City Art Museum, St Louis, MO, 1911.

MISCELLANEOUS

DeWitt McClellan Lockman Interviews and Biographical Sketches. Archives of American Art, Smithsonian Institution.

Edwin H. Blashfield Papers 1850–1980. Archives of American Art, Smithsonian Institution.

Edwin Howland Blashfield Papers and Correspondence. The New-York Historical Society.

Richard Murray research material regarding mural painting in the United States, 1970–2006, Archives of American Art, Smithsonian Institution.

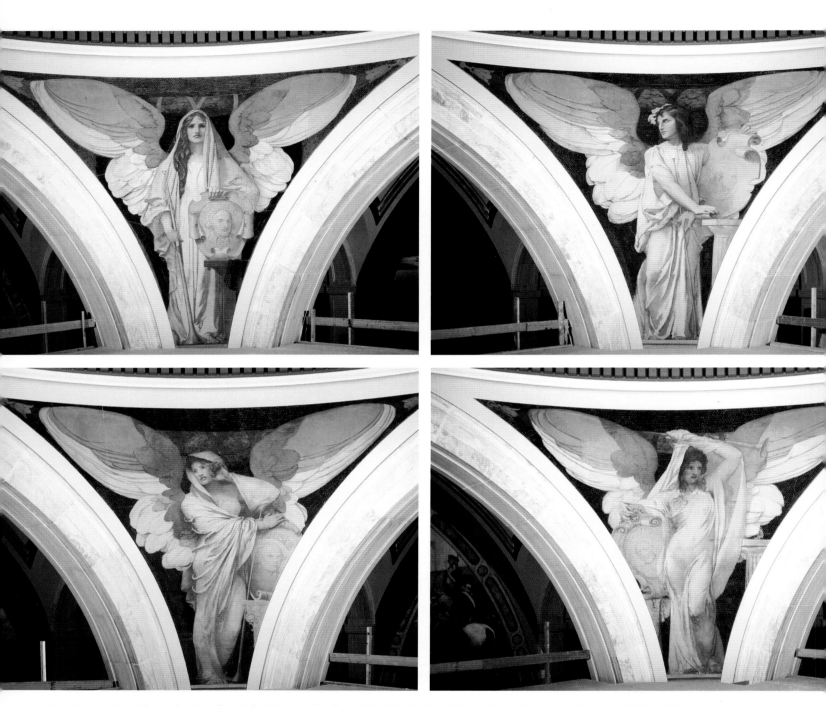

Four Fames, 1910: Alexander Hamilton, John Stevens, Abraham Zabriskie, Richard Varick. Central dome pendentives, William J. Brennan Courthouse, Jersey City, New Jersey. (Photograph: © Peter Mauss/Esto)

Portraits of four individuals who are part of New Jersey history appear in simulated bas relief on the shields held by winged female figures representing fame. Alexander Hamilton (1755 or 57–1804), the first Secretary of the Treasury, tried to develop the manufacturing industry around Passaic Falls. He met his death in a duel that took place in Hoboken. John Stevens (1749–1838), an inventor, is considered to be the father of the American railroad. He tested his ideas for a locomotive on his Hoboken estate. Abraham Zabriskie (1807–1873) practiced law in Jersey City, served as a state senator, was chancellor of the state of New Jersey, and was a framer of the charter of Jersey City. Richard Varick (1752–1831) was born in Hackensack and is buried there. He was one of General Washington's Revolutionary War officers, held various leadership positions in New York State, and was one of the founders of the town of Jersey, later to become Jersey City.

Acknowledgments

Many people were sources of support, information and images for this comprehensive study of Edwin Howland Blashfield.

Mina Rieur Weiner thanks her husband, Stephen A. Weiner, who faithfully served as her initial editor and critic; first reader Barbara Schwartz Fishman; John Blatteau, who contributed images and advice during many months of documentation; and generous adviser Seth Weine. She acknowledges the research assistance provided by the Archives of American Art in New York City, especially Joy Weiner, and the help provided by the staffs of The New-York Historical Society Library, New York Public Library, and the Thomas J. Watson Library at the Metropolitan Museum of Art.

Anne E. Samuel is indebted to the archives and mural sites where she did research; to Michael Leja, Margaret Werth, and Leith Kuhn; and to the late Richard N. Murray, a pioneering scholar in American Renaissance mural painting who introduced her to Blashfield.

Gillian Britta Randell salutes talented conservators and technicians Susan Edwards, Blanka Kielb, Elizabeth Kolligs, and Kumiko Hisano.

Jeff Greene is grateful for the contributions of Emily Sottile, Matthew Westerby and Patty Zimmerman, all at EverGreene Studios.

Anne Day thanks her photography assistants Linda Brinkley, Mike Jones, Morrigan McCarthy, and Mandy Vogel.

In addition to the photographers credited for their work, we are indebted to many individuals who either helped us secure publishable images or eased the way for Anne Day to take photographs at their sites.
John Arnett, State Capitol, Des Moins, Iowa
David Augustus, Elks Club, Chicago, Illinois

Wendy Herlock Baker, Andrew L. Thomas, and Michael Barnes, Smithsonian American Art Museum, Washington, DC

Bill Berndt, Allentown, Pennsylvania

Abby Aldrich Gray, Baltimore, Maryland

Carol Herrity, Lehigh County Historical Association, Allentown, Pennsylvania

Lauren Holden, Delaware Museum of Art, Wilmington, Delaware

Linda Hollingsworth and Lamont Murray, Cathedral Church of The Saviour, Philadelphia

Cathy Hubbard and Sean Duesler, Wilkes Barre, Pennsylvania

Molly Hutton-Marder, Chrysler Museum, Norfolk, Virginia

Daniel W. Jackson, Jackson County Historical Society, Kansas City

Blaine Marshall, The Library of Congress, Washington, DC

Monsignor Ronald Jameson and Francisco Gonzales, Cathedral of Saint Matthew the Apostle, Washington, DC

Lee Kavanagh, *Kansas City Star*

Kristin Law, Hermitage Museum and Gardens, Norfolk, Virginia

Library of Congress Rights and Reproductions, Washington, DC

Nick Limansky and Denise Kelley, Church of the Ascension, New York, New York

Judge Brooke Murdock, Clarence M. Mitchell, Jr. Courthouse, Baltimore

Carol Ness, Janelle Boulka and Sven Lindquist, State Capitol, St. Paul, Minnesota

Sara Nyman, Kansas City Public Library

Ellen Oster and Erica Stoller, ESTO, New York

Gilbert Pietrzak, Carnegie Library of Pittsburgh, Pittsburgh, Pennsylvania

Robert Regula and Jessica Boland, Mahoning Courthouse, Youngstown, Ohio

Matthew Reitzel, South Dakota Historical Society, Pierre, South Dakota

Patti Richards and Kerri Mills, MIT, Cambridge, Massachusetts

Marianne Richter, Union League Club of Chicago

Jenifer Rycerz, Curtis Institute, Philadelphia, Pennsylvania

Ellis Simon, City College of the City University of New York

Donald Steele, Kansas City, Missouri

Heather Sullivan, Mercersburg, Pennsylvania

Al Tannler, Pittsburgh Historical and Landmarks Foundation

Rachel Tassone, Williams College Museum of Art, Williamstown, Massachusetts

Rev. Dale Vroman, Bethesda Church, Salisbury, Maryland

Conrad Welsing, Detroit Public Library

Simon Wills, Christie's, New York, New York

About the Contributors

MINA RIEUR WEINER, a museum consultant, has organized exhibitions for numerous New York City museums including *John Koch: Painting a New York Life* for the New-York Historical Society. She resides in Sands Point, New York.

ANNE E. SAMUEL has a Ph.D. in Art History from the University of Delaware and wrote her dissertation on Blashfield's murals. A resident of Saint Davids, Pennsylvania, her research focuses on American art, architecture, and visual culture.

GILLIAN BRITTA RANDELL received her M.A. in the Conservation of Fine Art from the University of Northumbria, Newcastle-upon-Tyne, England. She is the principal paintings conservator of New York Fine Art Conservation. Miss Randell lives in Brooklyn, New York.

JEFF GREENE is the founder and president of EverGreene Studios. He is considered an expert on architectural murals and decorative ornament, both modern and historic. He currently resides in New York City.

Index

Page numbers in *italic* refer to captions. Each mural or painting cited, by name and by location, is a work by Blashfield unless indicated otherwise in parentheses.

A

Abbey, Edwin, 47, 60, 121, 124
Abundance, cartoon for, 39, 40
Abundance, The Evangeline Wilbour Blashfield
 Memorial Fountain, 39, *40*
Aderente, Vincent, 46, *88*, 114, *121, 128,*
 128–30
Adoration, The, 138
Allegory, 33, 66–68, 136
Allegory of Good and Bad Dreams, 27, 28, 135
Alma Mater, 99–102, *102,* 125, *127,* 140
American Academy in Rome, 45, 46
American Academy of Arts and Letters, 46
American design
 American Renaissance, 23–24, 27–29, 43, 51,
 66, 104, 124
 Blashfield's beliefs and contributions, 19, 60,
 125, 134
 early modernist movement, 48–51
 formation of national arts societies and associ-
 ations, 44–45
 New York artists and, 45
 World's Columbian Exposition and, 24–26,
 27–29, 43–44
 see also mural painting in America
American Federation of Fine Arts, 44
Anderson, Mary, 32, *32*
Angels of the Crucifiction, 43, 94–96, 139
Angels of the Crucifixion, cartoon for angel, *44*
Angel with the Flaming Sword, 51, 63, 63–64
Annigoni, Pietro, 133
architectural design, mural painting and, 70, 123,
 124
Architectural League, 46
Armory Show. *see* First International Exhibition
 of Modern Art
Art Deco, 49, 127
Arts of Metalworking, The, 27, 70, *71,* 135
Atwood, Charles, 24

B

Battle Scene (drawing), 20, *21*
Baudry, Paul Jacques Aimé, 122
Beasley, *Building Mural* (Webb), *132*
Beaux, Cecilia, 46
Beaux-Arts classicism, 20, 24, 26, 29–31, 45, 51,
 122
Beckwith, J. Carroll, 26
Berenson, Bernard, 46
Blashfield, Edwin Howland, *51, 88, 128, 143*
 accomplishments, 19, 46, 51–52, 104–5,
 110–11, 121, 122–24, 133–34, 144,
 145
 on American art, 19, 60, 125, 134
 artistic study and training, 20–22, 55–56,
 64–66, 110, 122, 143
 assistants, 114, *128,* 128–30
 chronology of known murals, 135–41
 classicism of, 23–24, 47–48, 122–23
 correspondence, 46
 criticism of modernism, 102–3
 cultural and historical milieu, 22–23, 45, 46,
 48–51, 124, 127–28, 130
 on decoration, 121
 on democratic use of art, 22, 23, 125
 drawings and illustrations, 58–60
 early life, 20, 143
 easel paintings, *51, 55, 56,* 56–58, *59, 61,*
 61–64
 on education and training of artists, 21, 47,
 128
 influence on American mural painting, 125–33
 later years, 51, 102–3
 late small-scale murals, 96–99
 municipal art movement and, 38–41
 on mural painting, 55
 mural painting methods and techniques,
 31–32, 70, 72–74, 76, 77, 86–90,
 109–18, 130

New York residence, 22, 143
painting style, 35, 63, 64, 78–82, 92–94, 124
patriotic themes in work of, 35–37, 91
personal life and relationships, 22, 47, 60–61
personal qualities, 47, 124–25
professional development, 27, 92, 143–45
on Puvis, 65
representations of women, 32, 78–79
residential murals, 66–69
travels in Egypt, 60–62
travels in Europe, 21–22, 60, 110
travels in U.S., 37–38
use of allegory, 82
viewing positions for murals of, 82–86, 124
World's Columbian Exposition, 24–27, 25, 69–70, 71, 123
World War I and, 90–92
Blashfield, Eliza Dodd, 20
Blashfield, Evangeline Wilbour, 22, 38–39, 58, 60–61, 65. see also Portrait of Evangeline Blashfield
Blashfield, Grace Hall, 51
Blashfield, William Henry, 20
Bok, E. W., 147
Bonnat, Léon, 20–21, 55–56, 110, 114, 122
Book of the Homeless (Wharton), 91
Books, 30, 139
Boston Latin School, 20
Brunner, Arnold, 29, 46
brushwork, 110, 112, 114. see also paint materials and application
Burnham, Daniel Hudson, 24, 31
Butler, Nicholas Murray, 44, 46

C

Calling of St. Matthew, The, 108, 114, 115, 116, 118, 139
Call of Missouri, The, 76, 78, 140
Carlson, H. J., 102
Carry On/Buy Liberty Bonds, 90, 91
Casey, Thomas Lincoln, 32
Century Association, 45, 46
Charity, 99, 101, 141
Chicago Art Institute, 47
Christmas Bells, 51
churches, 41–43
City Beautiful movement, 29–31, 110–11
City of Pittsburgh Offering Her Steel and Iron to the World, 75–76, 76, 136
classicism
 Blashfield's, 23–24, 47–48, 122–23
 World's Columbian Exposition design, 24–25
 current interest, 51, 132–33
 early modernism and, 48–49, 131
Cleveland, Ohio
 Citizens Bank, 76, 78, 137
 Howard Metzenbaum Courthouse, 4, 37, 39, 138
Codman, Henry, 24
Colonial Revival movement, 35
Columbian Exposition. see World's Columbian Exposition
Committee of Public Information, 46
Compton, Karl T., 99
Cornwell, Dean, 130
Cortissoz, Royal, 46, 69, 88
Court of Honor, World's Columbian Exposition, 25

Cox, Allyn, 131
Cox, Kenyon, 26, 47, 72, 112, 121, 124, 131
Cupid with Bow and Arrows, 66, 135
Curtis Institute of Music, see Drexel residence, Philadelphia

D

Dakota Struggling Toward the Light. see Spirit of the West
Dance, 66, 67, 137
Dancing Female Figures, 66, 135
decoration, 130
DeKay, Charles, 27, 46
Delacroix, Eugène, 122
Discoverers and Civilizers Led to the Source of the Mississippi, 81, 82, 83, 137
Drexel, George W. C., 68, 68–69, 69, 136
Drexel Memorial semi-dome, 41
Drexel residence, 68, 68–69, 69, 136
Durand, Asher, 45

E

Eakins, Thomas, 122
Edict of Toleration of Lord Baltimore, 4, 77, 79, 84, 137
Emperor Commodus Leaving the Arena at the Head of the Gladiators, 56, 56–57
Evolution of Civilization, 31, 55, 70, 73, 136
Explorers in American History (Norton), 127

F

Fairbanks, C. M., 60
Faulkner, Barry, 130
Fausett, Dean, 131
Faville, F. F., 78
Faxon, William, 32
Female Figure (Terpsichore), 66, 67
Fifth Minnesota Regiment at Corinth, The, 11, 36, 37, 137
Fine Arts Federation of New York, 44, 46
First Court of Temple of Ramses III, 61, 61–62
First International Exhibition of Modern Art, 48–49
Flagg, James Montgomery, 91
Flanagan, John, 91
Foringer, Alonzo E., 88, 128
Fortitude, 66, 136
Fountain of Youth (Winter), 130
Four Fames, 152
Fraternal Justice, 99, 100, 141
Fraternity, 99, 101, 141
French, Daniel Chester, 46, 91
Fuga, 51

G

Gallatin, A. E., 46
Gammell, R. H. Ives, 130, 131
Gammell, Robert Ives, 33, 136
Gardner, Isabella Stewart, 46
Garnsey, Elmer, 124
Genius of Music, The, 66, 137
Georgia, Atlanta, Church of Saint Luke, 98, 139
Gérôme, Jean-Léon, 20, 56, 57, 110, 122
Gibson, Charles Dana, 91
Gilbert, Cass, 46, 48, 81, 84, 92, 112
Golden, Jane, 131–32
Good and Bad Uses of Science, 102, 103, 140

Good Shepherd, The, 139, 140
Graduate, The, 50, *51,* 85–86, 138
Graphic Arts, 92, 95, 140
Green, Bernard, 72
Guerin, Jules, 125–27

H
Haas, Richard, 132
Hall, Grace, 51, *51,* 145
Hamilton, Alexander, *152*
Hartmann, Sadakichi, 46
Hassam, Childe, 46
Helwig, Kate, 114–15
Henri, Robert, 48
Hilliard, C. M., 57
Hoffman, Malvina, 46
Holloway, Charles, 125
Hopkins, A. A., 65
Hospitality, 30, 139
Hounds of Heavens (Gammell), 131
Hugo, Victor, 60–61
*Humanity Led from Chaos into Light by Knowl-
 edge and Imagination,* 102, *104,* 140
Human Understanding, 70, 71–72, 136
Hunt, Richard Morris, 24–25, 29, 39, 122
Hunt, William Morris, 20
Huntington, Collis P., 66, 67, 69, 135

I
Illinois, Chicago
 Civic Opera House (Guerin), 127
 Elks National Memorial Headquarters,
 98–99, *100, 101,* 141
 Fuller Park Fieldhouse (Norton), 127
 Louis Sullivan Theatre (Holloway), 125
 Union League Club, 98, *99,* 140
 World's Columbian Exposition, 24–29, 43–44,
 63, 69–70, *71,* 123, 135
Indiana, Fort Wayne, Allen County Courthouse
 (Holloway), 125, *127*
Industry and Thrift Leading People to Security,
 77, 137
Ingres, Jean Auguste Dominique, 56
Institute of Arts and Letters, 46
Institute of Classical Architecture & Classical
 America, 51
Iowa, Des Moines, State Capitol, *4,* 77–79, *80,*
 137–38
Irvine, William Mann, *147*
Italian Cities (Blashfield), 65–66, 144

J
Joining of the Ways, 92, 95, 140
Justice, 76, 77, 84, 136, 138
Justice of the Law, (Simmons), *111*

K
Keith, Charles, *29,* 139
Kensett, John, 45
King, Pauline, 69, 72–73
Knowledge, 85, 113, 138

L
Lack, Richard, 131
LaFarge, Chester Grant, 41, 114
LaFarge, John, 41–43, 46, 121, 124
Laning, Edward, 131

Laughed in the Morning's Eye, (Gammell), *131*
Laurens, Jean-Paul, 64
Law, The, 4, 39, 138
Law and Order (Holloway), *127*
Law in Classical Antiquity, 83, 138
Law in Modern Times, 4, 83, 138
Law in Remote Antiquity, 83, 138
Law in the Middle Ages, 83, 138
Lewisohn, Adolph, 66, *67,* 137
Leyendecker, J. C., 46
Lincoln, Abraham, *31,* 32
Lind, Charles Walker, 21
Lives of the Artists (Vasari), 65
Long, Ben, 133, *133*
Lord of the Isles (The Meeting), 29, 139
Louisiana Statehouse (Guerin), 127
Low, Will, 46, 112

M
MacLean, Hector, 74
MacMonnies, Frederick, 91
magazine illustrations, 58–60
*Making/ Building; Chaos/ Creativity; Planning/
 Knowledge* (Long), *133*
Manship, Paul, 46
marouflage, 72–74
Martyrdom of St. Matthew, 114, 116, 118, 139
Maryland
 Baltimore, Clarence M. Mitchell Courthouse,
 4, 35, *35,* 43, 76–77, *79,* 84, 137
 Salisbury, Bethesda United Methodist
 Church, 98, 140
Massachusetts, Boston
 Morss residence, *30,* 99–101, 139
 Opera House (Aderente), 128
 Trinity Church (LaFarge), 41–43
Massachusetts Institute of Technology, 20,
 99–102, *102, 104,* 125, *127,* 140
McKim, Charles Follen, 24, 25, 31
McKim, Mead & White, 24
Meiere, Hildreth, 130
Melchers, Gari, 47
Mercy, 138
Michigan, Detroit
 Art Institute (Rivera), 124
 Public Library, 92, *92, 94,* 95, 124, 140
Millet, Francis D., 24, 26, 46, 60
Minnesota, Granary of the World, 19, 32, 79–82,
 81, 137
Minnesota, St. Paul, State Capitol, *11, 19,* 32, 36,
 37, 43, *81,* 137
Missouri, Kansas City
 Keith residence, *29,* 139
 public library, 76, *78,* 140
modernism
 Blashfield and, 127–28, 130–31
 early 20th century vanguard artists, 48–49
money, design for $50 bill, 60, 122, *122*
Morss, Everett, *30,* 99–101, 139
Mowbray, H. Siddons, 122, 124
municipal art, 38–41
mural painting in America
 architectural design and, 70, 123, 124
 Blashfield's contributions and accomplish-
 ments, 19, 46, 51–52, 104–5, 122–24
 European influences, 64–66, 109
 historical development, 41–43, 49–50

Mural Painting in America (Blashfield), 47, 110, 123, 144
Music, detail of pianoforte side medallions, *69,* 136
Music, 30, 139
Music and Dance, 74, 75
Music Lesson, 57–58, *58*

N

National Academy of Design, 45, 46, 92
National Commission of Fine Arts, 46
National Gallery of Art Commission, 46
National Sculpture Society, 44, 46
National Society of Mural Painters, 44, 46, 121
Nebraska State Capitol (Meiere), 130
New Jersey
 Jersey City, Hudson County (William J. Brennan) Courthouse, 82, 139, *152*
 Newark, Essex County Courthouse, 82, *84, 85,* 112–14, 121, 138
 Newark, Prudential Life Insurance Company, 76, *77,* 137
New York, Chappaqua, Church of the Virgin, 140
New York City
 Appellate Division, First Judicial Department Courthouse, *34, 111,* 111–13, *113,* 121, 137
 arts community of Blashfield's era, 45
 Astoria Hotel, 74–75, 136
 City College, *50,* 51, 85–86, 138
 Huntington, C.P., residence, 66, *67*
 Lawyers Club, 76, *77,* 136
 Lewisohn, A., residence, 66, *66, 67*
 Municipal Art Society, 38–39, 44–45
 New York Public Library (Laning), 131
 Queensborough Bridge Market, 39, 40, *40*
 Radio City Music Hall (Winter), 130
 residential murals by Blashfield, 27, *28,* 66, *67,* 135, 136, 137
 Rockefeller Center (Meiere), 130
 Saint Bartholomew's Church (Meiere), 130
 Temple Emanu-El (Meiere), 130
 Twombley, H. M., residence, *27, 28,* 66
 Vanderbilt, Wm. K., residence, *65,* 66
North Carolina, Charlotte, Bank of America Corporate Center (Long), 133, *133*
Norton, John Warner, 127

O

Oakley, Violet, 46, 127, *128*
Ohio
 Youngstown, Mahoning County Courthouse, *4,* 82, *83,* 138
 see also Cleveland, Ohio
Olmsted, Frederick Law, 24, 31
Only by Contemplating Our Mistakes Do We Learn. see Spirit of the West
On the Ramparts, 59, 59–60
Owsley, Charles, 82

P

paint materials and application, 115–18. *see also* brushwork
Paris Salon, 56, *56,* 63
Patria, 98, *99,* 140
pendentives, 82, 94–96

Pennsylvania
 Allentown, Lehigh County Courthouse, 35, *36,* 140
 Harrisburg, State Capitol (Oakley), 127, *128*
 Mercersberg Academy, 139, *147*
 Pittsburgh, Bank of Pittsburgh, 75–76, 136
 Wilkes-Barre, Luzerne County Courthouse, 138
 see also Philadelphia, Pennsylvania
Perugino, Pietro, 110
Philadelphia, Pennsylvania
 Beasley Building (Webb), 132, *132*
 Church of the Saviour, 41, *41,* 133, 138
 Drexel residence, present day Curtis Institute of Music, *68,* 68–69, *69,* 136
 mural movement of 1980s, 131–32
photography, 74, 87–88
Pinturicchio, 110
Players Club, The, 24, 45
Poetry, 68, 92, 136
Poets and Musicians, 124, 140
Portrait of Evangeline Blashfield, 51, 62, 62–63
Post, George B., 25, 26, 29, 86
Power, 138
Power of the Law, 34, 111, 111–12, 137
Proclaim Liberty Throughout the Land, 35, *36,* 140
Prose, 68, 92, 136
Prose Writers, 140
Prudence Binding Fortune, 137
Puvis de Chavannes, Pierre, *64,* 64–65, 122
Pyle, Howard, 46

R

Rain, 143
Ramsey, Milne, 21
Red Cross Christmas Roll Call, 91, 91–92
Reid, Robert, 26
Reinhart, Charles S., 26
Rhode Island, Providence, Gammell residence, *33,* 66–68, 136
Richardson, Henry Hobson, 41–43
Rivera, Diego, 124
Robbins, Abbie, 78
Robert Swain Peabody, 25
Root, Elihu, 46
Root, John Wellborn, 24
Ross Award for Excellence in the Classical Tradition, 133
Rust, Graham, 132

S

Saint Ann and the Virgin, 140
Saint-Gaudens, Augustus, 24, 31
Saint John with Eagle, 96, 139–40
Saint Luke with Winged Bull, 96, 139–40
Saintly and Eminent Personages of the Americas (Aderente), *121,* 128–30
Saint Mark with Lion, 96, 139–40
Saint Matthew and Angel, 43, 139
Saint Matthew with his Angel, 96, 139–40
Sargent, John Singer, 60, 122
Savage, Eugene, 130
scaffolding, 72, 73
Science Presenting Steam and Electricity to Commerce and Manufacture, 122, 122

Seabury, Channing, 79, *81*
Shirlaw, Walter, 26
Simmons, Edward, 26, 91
Society of American Artists, 46
Society of Beaux-Arts Architects, 44
South Dakota, Pierre, State Capitol, 36–37, *38*, 139
South Dennis, Massachusetts, Congregational Church of, 138
Spirit of the West, 36–37, *38*, 139
Sprague, Charles, 122
Staughton, Charles, 39
Stearns, John Goodman, Jr., 25
Steichen, Edward, 48
Stieglitz, Alfred, 48
Stevens, John, *152*
stereopticon projection, 74
Strahan, Edward, 57
Sullivan, Louis, 25
Sword Dance, 65, 66, 136

T
Terpsichore, 135
Terry, Ellen, 32, 46
Thrift Driving the Wolf from the Door, 137
Tiepolo, 110
Tiffany, Louis C., 124
Turner, Charles Y., 112, 124
Twombly, Hamilton McKown, 27, *28*, 66, 135

U
Unity (Oakley), *128*
Uses of Wealth, The, 76, *78*, 137

V
Vanderbilt, William K., *65*, 66, 136
Varick, Richard, *152*
Vasari, Giorgio, 65, 70
Velasquez, 110
Veronese, 110
Victor, The, 139, *147*
Vigilance, 66, 136

W
Walker, Henry O., 110, *111*, 112
Ward, John Quincy Adams, 46
Washington, DC
 Cathedral of St. Matthew the Apostle, 41–43, *42–44*, 94–96, *108*, 114–18, 121, *121*, 128–30, 139–40
 Library of Congress, *31*, 31–32, *55*, 70–72, 136
 Lincoln Memorial (Guerin), 127
 U.S. Capitol (Cox), 131
Washington, Goldendale, Maryhill Museum of Art (Gammell), *130*
Washington Surrendering His Commission, *4*, 35, *35*, 76–77, 84, 137
Webb, Michael, 132
Weir, J. Alden, 26, 91
Westward, 4, 77–79, *80*, 137–38
Wharton, Edith, 46, 91
Wilbour, Charles Edwin, 22, 60–61
Wilbour, Charlotte Beebe, 22, 62–63
Wilbour, Evangeline. *see* Blashfield, Evangeline Wilbour
Willett, Arthur R., 72, 74
Winter, Ezra, 130
Wisconsin, 86–90, 138
Wisconsin, Madison, State Capitol, 84, 86–90, *128*, 138
Wisconsin, Past, Present and Future, 84, *89*, 138
Wisdom, 85, 138
Wisdom of the Law, (Walker), *111*
Works Progress Administration, 49–50, 102–3, 130
World's Columbian Exposition, 24–29, 43–44, 63, 69–70, 123, 135
World War I, 46, 49, 90–92

Y
Yale University Art Gallery, 66, 135

Z
Zabriskie, Abraham, *152*
Zukowski, Karen, 62–63